# YESTERDAY'S TOMORROW

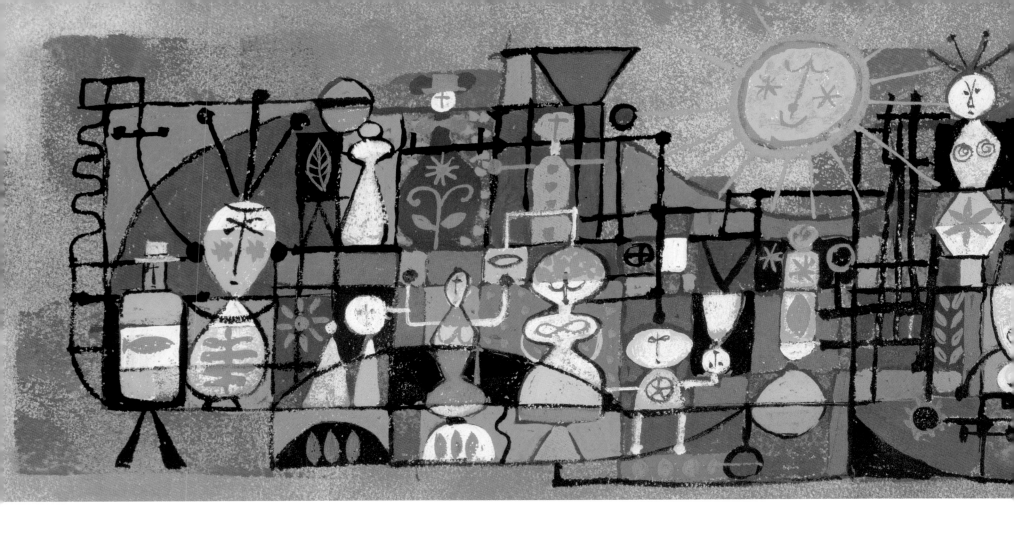

DISNEY'S MAGICAL MID-CENTURY

# YESTERDAY'S

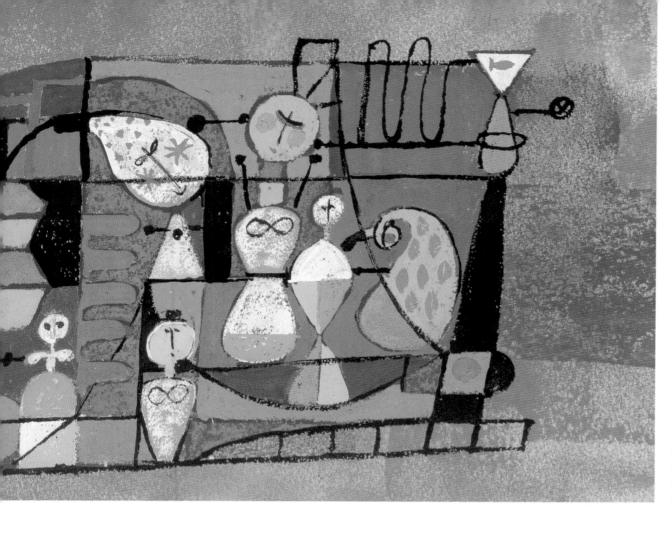

Mary Blair's concept for the Adventure Through Inner Space exit mural at Disneyland.

# TOMORROW

## DON HAHN

### DISNEY EDITIONS

LOS ANGELES • NEW YORK

Also by Don Hahn

*Before Ever After*
*Brain Storm*
*Animation Magic*
*Alchemy of Animation*
*Drawn to Life*
*Disney's Animation Kit*

For information address Disney Editions, 1101 Flower Street, Glendale, California 91201.

Im  Design by Hans Teensma / Impress

ISBN 978-1-4847-3764-4
FAC-029191-19294
Printed in Malaysia
First Hardcover Edition, November 2017
10 9 8 7 6 5 4 3

TOWER OF THE FOUR WINDS

NEW YORK WORLD'S FAIR • 1964 • 1965

**To Emilie**

Roland Crump's Tower of the Four Winds,
1964–65 New York World's Fair.
Artwork by Paul Hartley.

Paper collage and a transportation illustration created for *Walt Disney's Magazine.*

# CONTENTS

# 1
# THE LAST OF THE PIONEERS

*We, the last of the pioneers and the first of the moderns, will not live to see this future realized. We are happy in the job of building its foundations.*

—Walt Disney

**W**ALT DISNEY'S STORY starts in Chicago and is forged in places like Missouri's Marceline and Kansas City. Yet as influential as those places might have been, they miss the full story of the one place on earth that influenced Walt's life more than any other. It was a place of reinvention filled with heroic, almost mythological characters: cowboys, Indians, gold miners, gunslingers, and movie moguls. It was romanticized in the art of Frederic Remington, the photographs of Ansel Adams, and the books of Mark Twain. It was a place of possibility far away from the rules of the old world—California.

When California joined the Union in 1850, there were fewer than two thousand residents in the city of Los Angeles. The Santa Fe railroad came to town and set off a rate war with competitor Southern Pacific Railroad, and fares dropped to as low as a dollar for a trip from the Midwest to L.A. Things started to change. More than 120,000 people came to Los Angeles by train in 1887 alone.

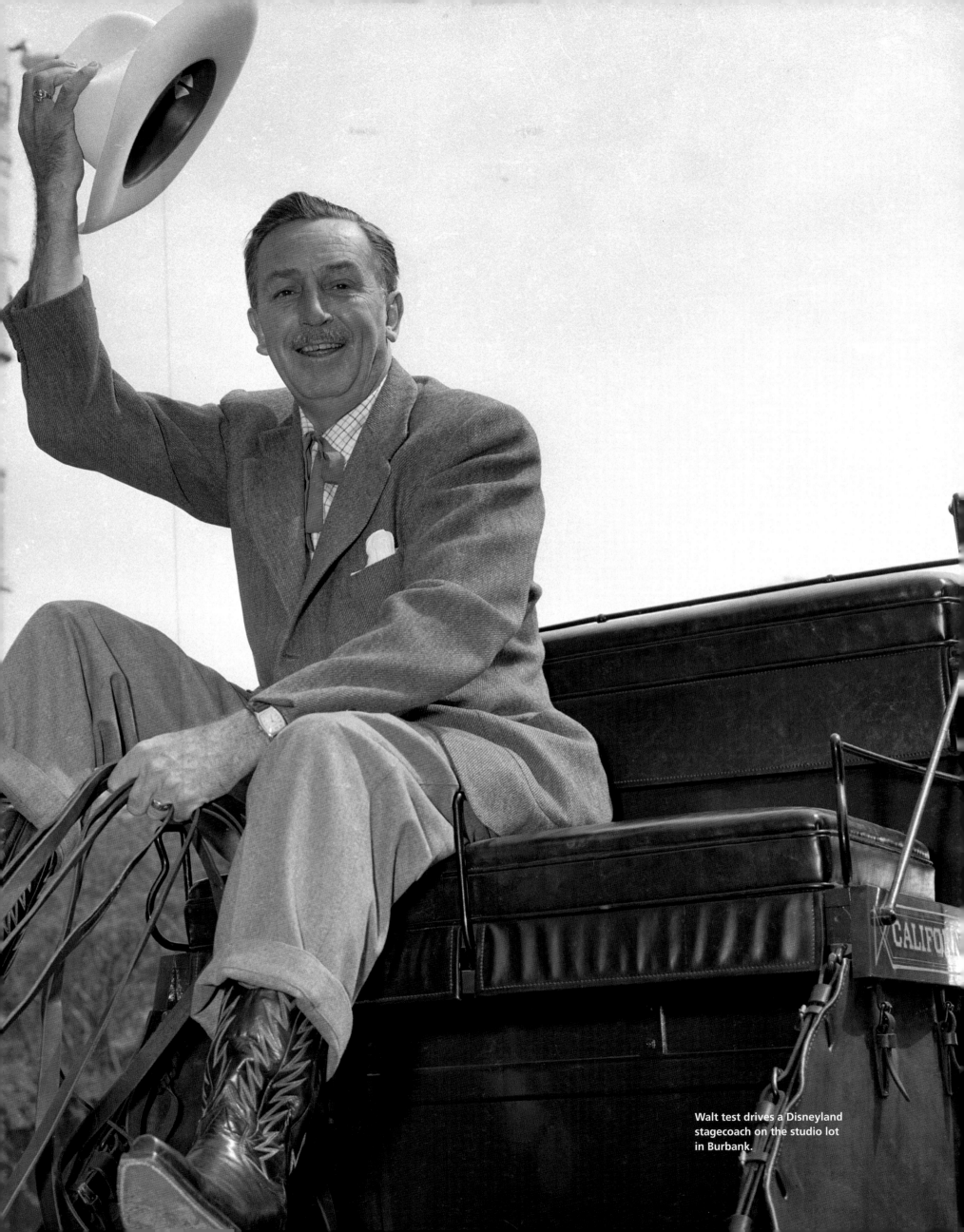

Walt test drives a Disneyland stagecoach on the studio lot in Burbank.

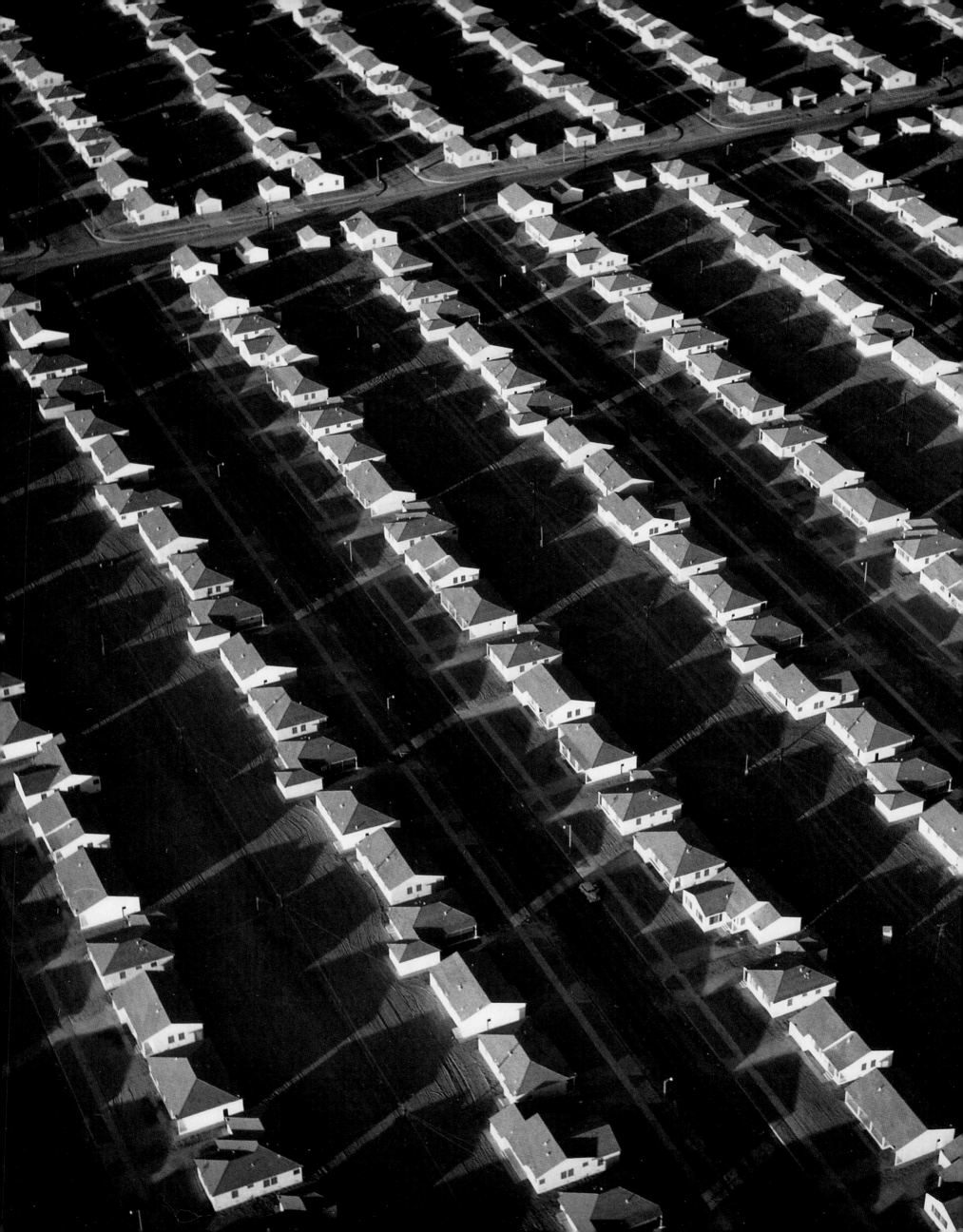

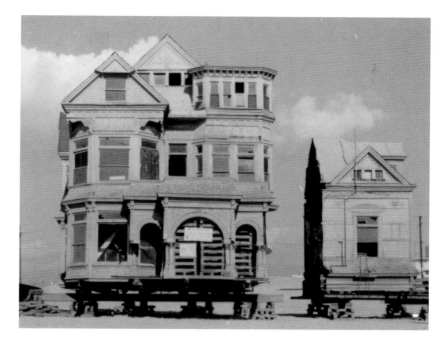

Left: Newly finished houses in Lakewood, California, a suburb of Los Angeles, 1950. Above: The last remaining Victorian residence is moved out of downtown L.A. to make room for the city's Music Center, 1969.

Promoters and land developers sold Los Angeles's healthy climate as a cure for ailments of any variety, and the land was soon covered with orange groves and hotels for the wealthy who opted to spend the winter season in the sunshine and fresh air.

After the First World War, many returning veterans headed to or stayed in Los Angeles, turning the town into a boomtown. It was a place of new beginnings, where new technical industries like motion pictures and aerospace were gaining a foothold. By the time Walt Disney arrived in 1923, the population topped one million. Within a few years, the spectacular worldwide successes of Mickey Mouse made Walt something of an American folk hero, and his studio on Hyperion Avenue was exploding with young talent that had come west to work with him. By 1941 his feature films—*Snow White, Pinocchio, Dumbo,* and *Fantasia*—had dazzled Depression-era audiences and established Disney as a master filmmaker.

Then it all changed as a disabling labor strike and the onset of World War II virtually emptied Walt's studio of talent and he turned his attention to helping the Allies' war effort with government training films and a few package pictures like *So Dear to My Heart* and *Saludos Amigos.* It had been a great ride for Walt and his brother Roy, but it seemed that the magic was over.

When World War II ended, the streets of L.A., and its suburbs, were flooded again by returning veterans (many with their young families) who were eager to put years of Depression and war

11

behind them. Developers obliged by building complete model cities like Lakewood—called "America's Fastest Growing Community"—which transformed an area of lima bean fields in 1950 into a complete "suburban paradise" by 1960.

"No theorist or urban planner had the experience then to gauge how thirty thousand former GIs and their wives would take to frame and stucco houses on small, rectangular lots next to hog farms and dairies," wrote author D. J. Waldie about the phenomenon.[1] Other suburbs fed the dream of young families with shopping malls and rows of picture-perfect suburban homes that instantly were filled with what *Life* magazine called "400 New Angels Every Day."[2] It was an era of social optimism, when a middle-class family could live the American dream in a new world of sunshine and prosperity.

Walt Disney was in a unique place to respond to this boom time and contribute to the colorful optimistic tone of the era, first with films like *Cinderella, Alice in Wonderland,* and *Peter Pan*. Then his first full live-action film, *Treasure Island*, was a hit; and at the same time tens of thousands of American families were buying televisions, which would bring entertainment right into their homes—with a good portion of it being Walt Disney entertainment.

Television was in many ways the dawn of modernism at Disney. The urgent need for programming gave Disney the opportunity to launch *Disneyland*, the ABC anthology series that brought Walt

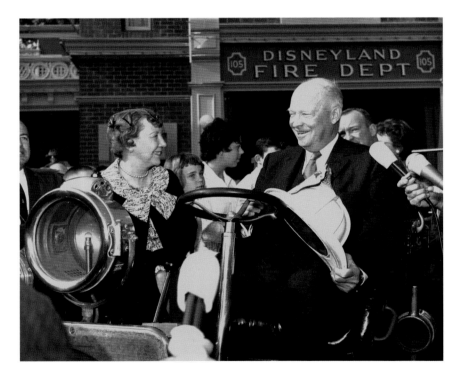

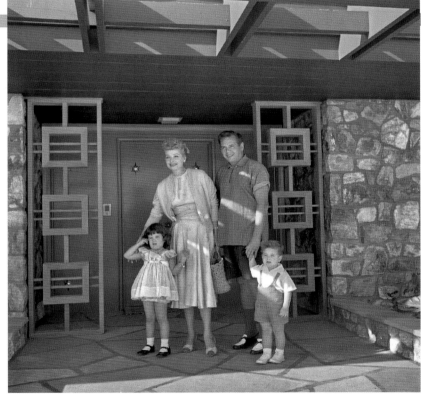

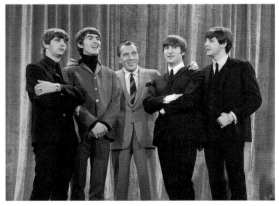

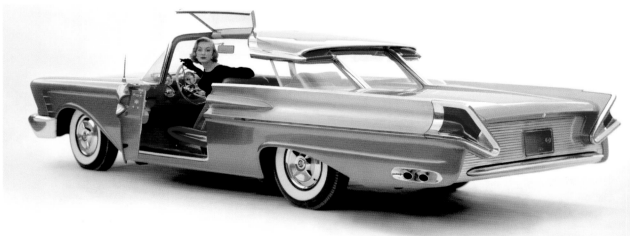

into the living rooms of America on Sunday evenings. In addition, the ABC deal also funded Disneyland and provided a brilliant way for audiences to walk into and enjoy the lands of tomorrow, fantasy, adventure, and frontiers through their televisions.

Then in his midfifties, Walt Disney had become an innovator in film, animation, nature films, publications, television, and theme parks, all of which were staffed by artists who pushed the studio's artistic style into a modern world and a look that in many ways became the look of Disney for years to come.

The Disney Studios had to change to reflect all that was taking place at a rapid clip. The new modernism was pervasive in the arts and lifestyle of Southern California. The studio itself was surrounded by the future. The space race was under way, and the nearby California Institute of Technology and NASA's Jet Propulsion Laboratory in Pasadena, California, were leading the charge. Modern ranch-style architecture with backyard swimming pools and barbecues sprouted from the former orange groves of the San Fernando Valley, and the first freeway in America (which ran between Los Angeles and Pasadena), were all making an indelible mark within a few miles from Walt's home—and studio.

It was a unique time in history when social attitudes, wealth, sunshine, and the culture of possibility could make dreams come true. Walt Disney and his artists were about to become primary players in it all.

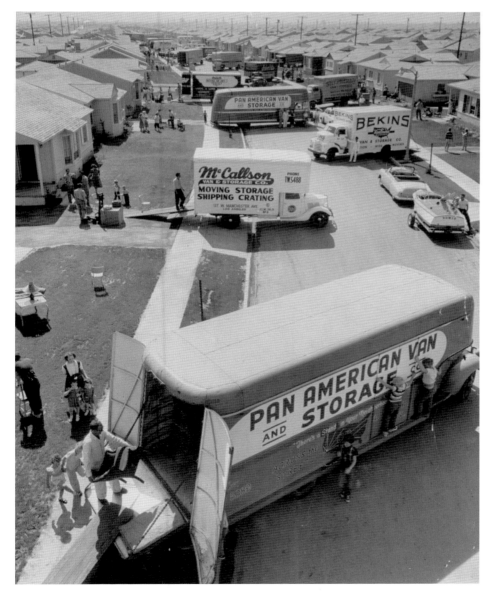

Opposite top: President and Mrs. Eisenhower take a spin on Main Street, U.S.A. Actress Lucille Ball and husband, Desi Arnaz—and family—at their Palm Springs, California, home, 1954. Opposite bottom: The Beatles appear on the *Ed Sullivan Show*, 1964. The Mercury Turnpike Cruiser concept car, 1956. Left: Moving day at a new housing development in Los Angeles, 1952. Above: Walt relaxes at his residence in the Holmby Hills section of Los Angeles.

# 2
# CINEMA

I N THE FIRST HALF of the twentieth century, Walt Disney's reputation as a filmmaker was secure. Animated motion pictures and well-constructed storytelling were always his strong suits, but the genius of Disney during this post–World War II era was how he reinvented himself and took all the tools of cinema—lighting composition, sets, props, actors, costumes, sound, music—and repurposed them to use off the screen, in unconventional ways and to dazzling effect. There would be no Disneyland without the language of film and the process of storytelling that Walt loved and had mastered in the first half of the century.

In the latter half of the 1940s, Walt would grind his gears trying to jump-start his studio. *Make Mine Music, Fun and Fancy Free,* and *Melody Time* were the studio's feature offerings. They were considered "package pictures": a series of short subjects strung together with a narrative to create a feature-length film. There is some wonderful work in these films, but none of them garnered strong box office sales or critical acclaim.

One Disney film that attracted attention at this time was *Song of the South*, a polarizing film because of what some critics said was an unrealistic depiction of life in the South after the Civil War. It was an ambitious project, combining both live action and animation, and when it premiered on November 12, 1946, at the Fox Theater in Atlanta, it drew protests from the NAACP.[3] It didn't help

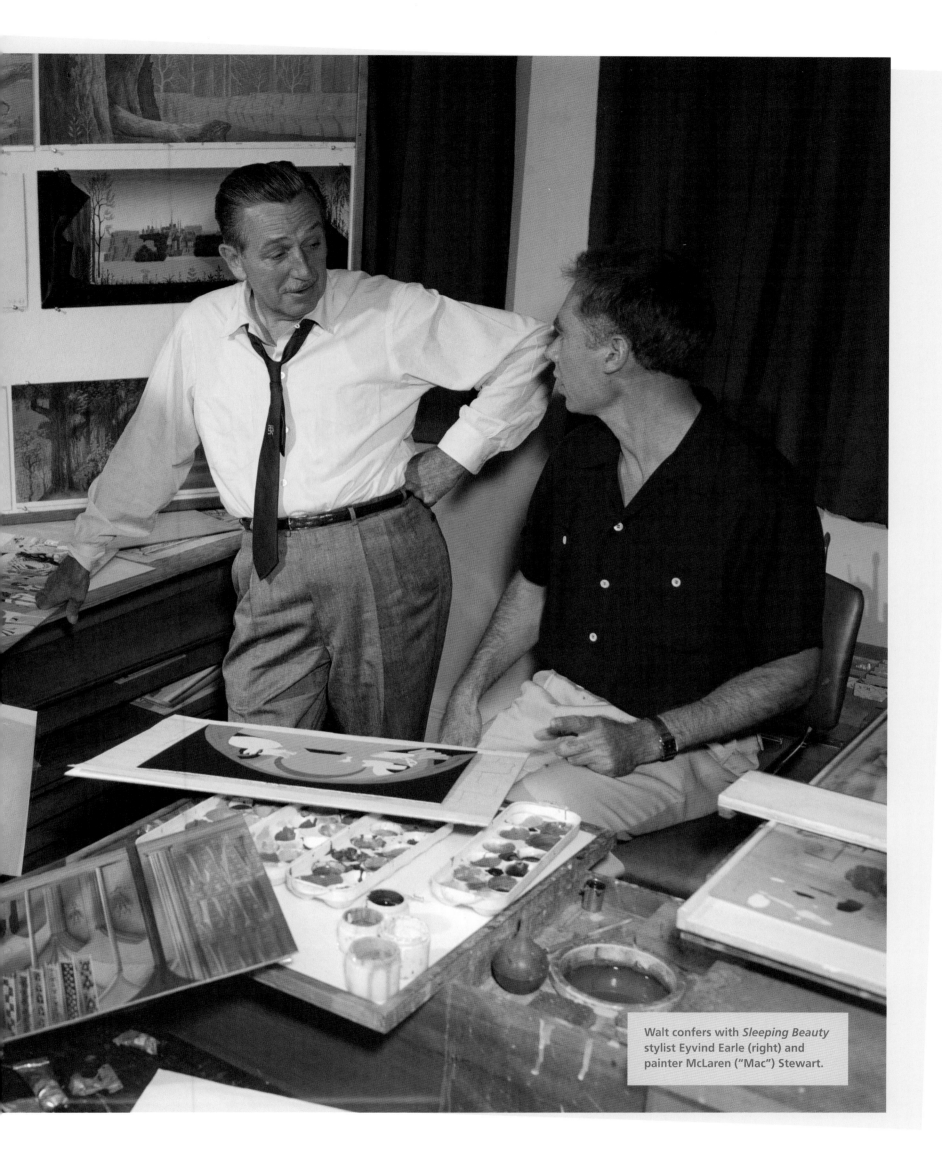

Walt confers with *Sleeping Beauty* stylist Eyvind Earle (right) and painter McLaren ("Mac") Stewart.

Clockwise (from right): Actor James Baskett with the young stars of *Song of the South* (Luana Patten and Bobby Driscoll); Polish movie poster for *The Living Desert*, 1953; and Mary Blair's concept art for *Cinderella*, *Alice in Wonderland*, and *Johnny Appleseed*, respectively.

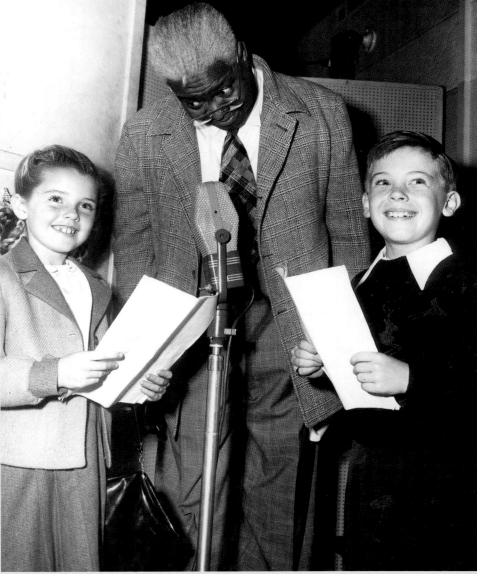

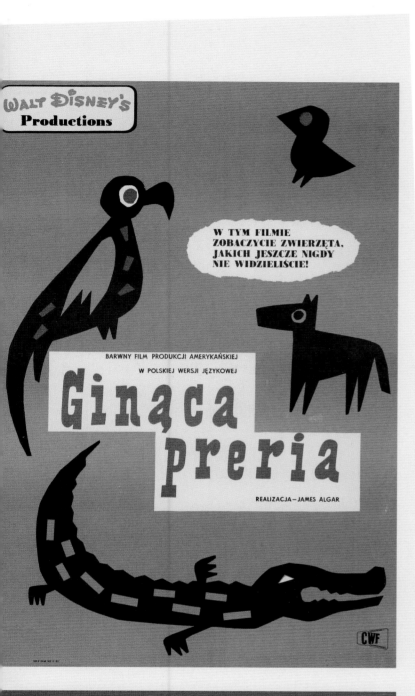

that Atlanta was a racially segregated city and Uncle Remus himself, actor James Baskett, and his costar Hattie McDaniel couldn't participate in any of the premiere activities. The experience left Walt deeply frustrated, and after delivering his opening remarks, he walked to his hotel, where he stayed during the screening.

Still, Baskett's performance was universally praised by critics, and the Academy of Motion Picture Arts and Sciences gave him a special Oscar for his performance, the first of its kind for an African American actor. [4]

At the end of a difficult decade, Walt needed a change. He took his knowledge of cinema to the animal kingdom with anthropomorphized plots shot on location with real animals. Animal films were not unusual in the early part of the century, but Disney's innovation was to take hours of footage shot in nature and construct compelling stories using the tools they had used in animation. These were not documentaries. The True-Life Adventure projects featured narrative storytelling with music, charm, humor, and pathos, not unlike what the team had done with *Bambi*.

The first film, *Seal Island* (1949), was dismissed by Disney distributor RKO, which didn't believe audiences would sit through a film with only animals in it. Walt took the film to nearby Pasadena, where he screened it in the Crown Theatre for one week to qualify it for the Academy Awards. The result: *Seal Island* won in the Best Documentary Short Category. Again in 1953 RKO decided not to distribute the first feature-length nature film in the series, *The Living Desert*. It was the last straw for the Disney brothers, and they not only cut their ties with their longtime distributor, RKO, but cleverly started their own company, Buena Vista Distribution, to market and distribute all Disney films from then on. *The Living Desert* won the Oscar for Best Documentary Feature that year.

Ever cash-strapped, the studio needed hits. Walt started work on three animated feature films that he felt had great audience appeal but that could be made for a reasonable price.

The first of the three films, *Cinderella* (1950), was a box office triumph for Disney Studios—the first since *Snow White* thirteen years earlier—and it allowed the studio to reduce its debt load. Next up was *Alice in Wonderland*, a box office disappointment that was thin on plot and didn't connect with the audience. It lost money. The third film, *Peter Pan*, was critically well received and a win at the box office for the still struggling studio. Most important, it solidified a new look forged in part by the brilliance of art director Mary Blair, whose graphic styling for all three pictures was explosively colorful and decidedly modern.

Mary Blair's stunning concept art for *Peter Pan*. Cover for the *Peter Pan* Golden Book (right) illustrated by John Hench and Al Dempster.

Concept art for the 1953 Oscar-winning short *Toot, Whistle, Plunk and Boom.*

When *Alice in Wonderland* premiered, Walt agreed to produce his first television special, *One Hour in Wonderland*, a holiday show that would also be a soft promotion for *Alice*. It was the first television program produced by a major studio, and it starred ventriloquist Edgar Bergen[5] and actors Bobby Driscoll and Kathryn Beaumont. But the lasting star turned out to be Walt Disney himself, who lit up the small screen with his charisma and Midwestern authenticity. It was a watershed moment—not only airing on Christmas Day 1950 to an astounding ninety million viewers, but paving the way for Disney's entrance into television; it also marked the first step toward the creation of Disneyland.[6]

The dawn of television signaled the end of the theatrical market for shorts as audiences fled movie palaces during the 1950s to stay home and watch television. Among the final shorts produced at Disney was an educational project called *Toot, Whistle, Plunk and Boom*, one of the last Disney films RKO released. Production started with director Ward Kimball while Walt was traveling in Europe with his family. Kimball began working with a New York artist, Eyvind Earle, a very quiet, private man who was originally hired to paint backgrounds for *Peter Pan*. On Kimball's project, Earle's masterful use of color and highly graphic approach to design "got a lot of flack from old-timers at Disney when they saw some of the drawing techniques we were using in the picture," said Kimball of the iconoclastic style.[7]

Most thought Kimball was pulling too much from the extremely modern style of rival UPA studios, and others were sure the show would get shelved once Walt saw it. The opposite happened: Walt screened it when he returned from his trip and loved it. It began the inevitable turn toward a stylistic modernism. For decades Disney artists watched the art world embrace Picasso, then Matisse, and later the abstract expressionism of people like Jackson Pollock and Willem de Kooning.

Disney drew heavily from traditional storybooks and the European illustrators of the nineteenth century. There was a growing faction of artists at Disney who couldn't resist the concept of bringing modernism into their own work. After *Toot, Whistle* director Jack Kinney followed up with the short *Pigs Is Pigs* in 1954, styled once again by Earle and studio veteran Al Dempster, and the result was an even stronger commitment to a modernist style.

The next year, the venerable feature animation crew neared completion on *Lady and the Tramp,* but there was a hitch. Televisions were everywhere. Studio owners saw their box office numbers dwindling, and theaters started closing. To make matters worse,

Clockwise (from top): Vic Haboush, Tony Rizzo, Walt Peregoy, and Tom Oreb (left to right) led a new wave of modernism at the studio. Train station from *Pigs Is Pigs, Donald's Diary, Donald in Mathmagic Land*, and a background from *Pigs Is Pigs.*

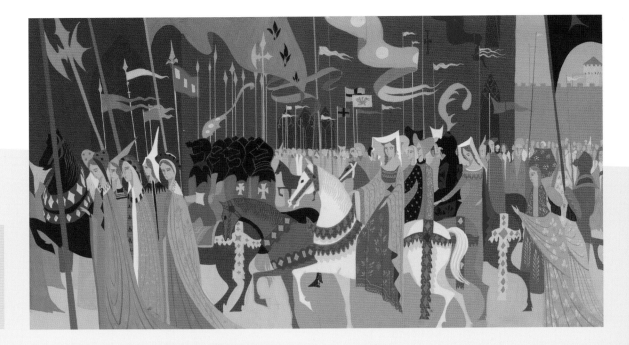

color televisions hit the market. The industry's answer was a wide-screen format that Fox had developed called CinemaScope that made the theatrical experience, in a word, epic. Walt was the first to license the technology and had the crew on *Lady* shoot the film twice: once in a standard format (the common 1.33:1 screen ratio) and then a second time in CinemaScope (a ratio of 2.35:1). In wide-screen the film looks a little empty at the edges of the frame, but the overall effect was stunning, and *Lady* marked the first animated film ever to appear in that format.

Disney himself wasn't shy about artistic progress. Film critics were skeptical of his motivations, though. "*Toot, Whistle* resembles closely the work of Stephen Bosustow and his United Productions Associates," said the *New York Herald Tribune* of the film. "You would swear that it was a UPA Cartoon." Finally, when *Time* magazine put rival Bosustow of UPA on their cover with the title "The New Walt Disney," Walt snapped. "We have got to get some new blood in here," recounted animator Victor Haboush of Walt's tirade. "We can't allow these people to come in and try to take us out of the business."[7] *Toot, Whistle* brought the studio an Oscar for Animated Short, the first award for the studio after a ten-year drought.

Walt doubled down on his "new blood" threat by bringing Eyvind Earle front and center to be production designer in full control of the aesthetics of *Sleeping Beauty*. The old guard felt passed over. The palette he chose for the film was inspired by

the jewel tones of medieval tapestries and design elements from Persian miniature painting. His choices, along with stunning character animation, made the film a high point of modern graphic design and created a look that was, in effect, a moving illustration, all at a personal cost to Earle.

"Walt 'married him' when he came in and put him ahead of everybody," said Haboush of Earle's position. "All the old guys that been there for years—boy you don't screw with them guys—they sort of owned the place. When Walt turned over all the background stuff to Eyvind, they were out to try and get him." Years after the release of the film, animator Frank Thomas was still burning and used a celebration of animation at New York City's Lincoln Center

as occasion to attack Earle's work publicly. "That was a big battle, because we, and some of the other animators, wanted the personality to be dominant," said Thomas of the tensions on the film, "and Earle didn't think anything was as important as his backgrounds."[8]

Production on *Sleeping Beauty* was ugly, expensive, and troubled, due in part to Walt's inattention to animation and in part to the difficulty the artists had executing Earle's style. The production ended with a mass layoff. Earle left the studio, unwilling to push back against the established artists who disdained him. Walt himself confided in producer Bill Anderson that *he* personally didn't want to spend time in animation. Not only had his interests turned to Disneyland and television, but he wondered if animation

YESTERDAY'S TOMORROW: DISNEY'S MAGICAL MID-CENTURY

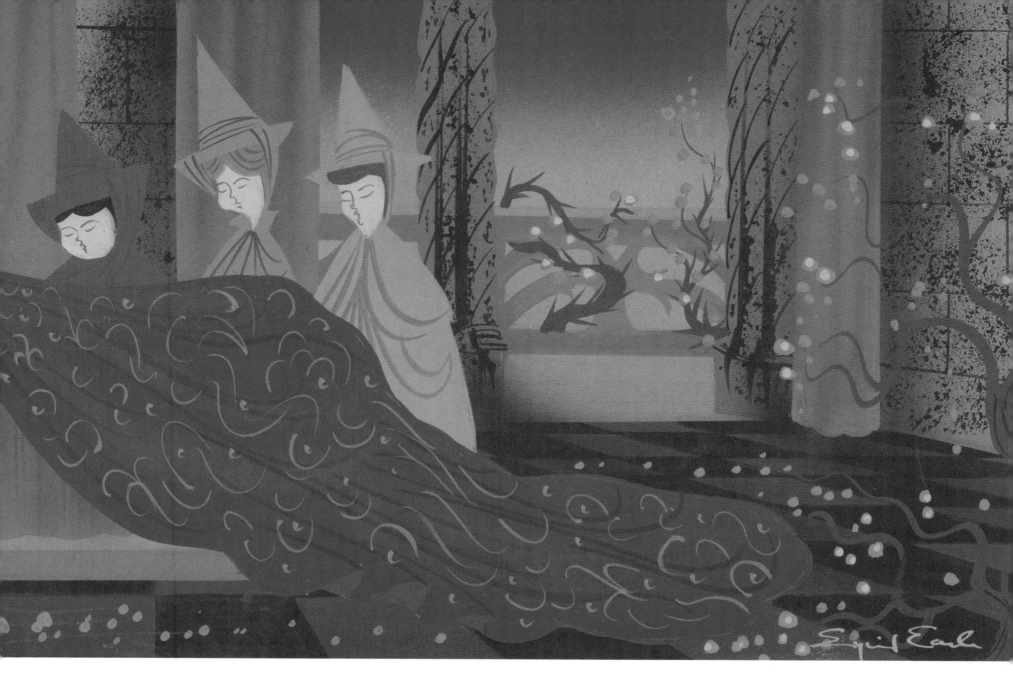

BARWNY FILM RYSUNKOWY

PRODUKCJA
AMERYKAŃSKA

DUMBO

REALIZACJA I
PRODUKCJA:

WALT DISNEY

NAGRODA FESTIWALU W CANNES
1947 ROK

Clockwise (from top left): Shere Kahn animation drawing by Milt Kahl; *Sleeping Beauty* concept art by Eyvind Earle; art from *Toot, Whistle, Plunk and Boom*; and Polish-designed posters for Disney animated films, which are masterworks of mid-century poster design.

**Color stylist Walt Peregoy's color concepts for *One Hundred and One Dalmatians*.**

Production designer Ken Anderson's sketch of Roger's flat on Primrose Hill.

was something Disney did out of a sense of tradition and no longer for profit. The next feature, *One Hundred and One Dalmatians*, would need to be far less expensive for the art form to continue.[9]

*Dalmatians* moved ahead with a smaller staff, and the introduction of xerography made the hand inking of drawings onto clear celluloid an obsolete process, which further helped lower the cost of films. Skeptics of the Xerox process felt that copying the animator's drawings onto cels looked rough and unfinished. But to the animators, it didn't cheapen the look of the film, but rather it emboldened them. Art director Ken Anderson introduced style elements that were fresh and firmly grounded in mid-century style. Disney animator and legend Andreas Deja would later call it "Picasso meets Disney."

With Eyvind Earle gone, Anderson turned to a young painter who was as blunt and outspoken as Earle was introspective and private. That person, Walt Peregoy, painted and color-styled the film. He worked with layout artist Ernie Nordli, who styled the line drawing overlays that sat over the painted background and not only contributed to the graphic style but also bonded the animation with the background.

The animators loved the process because for the first time, xerography literally reproduced their drawings on the screen as opposed to the hand inking and tracing of drawings that had been used up until *Sleeping Beauty*. That style, along with a brilliant story adapted from Dodie Smith's 1956 novel, would make *One Hundred and One Dalmatians* a contemporary family hit when it was released in January of 1961. The film pulled Disney out of the financial setback caused by *Sleeping Beauty*, and with

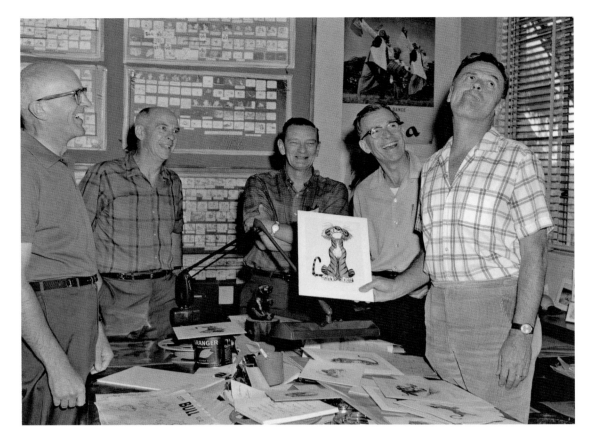

Producer Director Woolie Reitherman (far right) clowns with *Jungle Book* animators Milt Kahl, Ollie Johnston, John Lounsberry, and Frank Thomas (left to right).

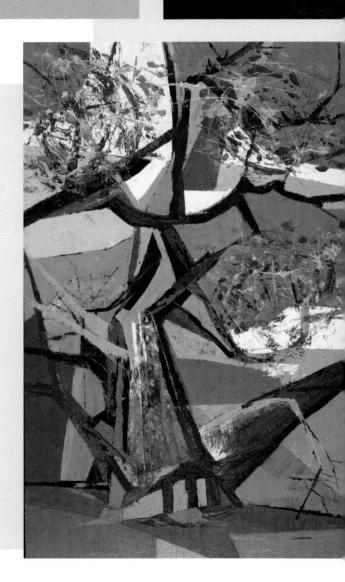

Left to right: Josh Meador, Marc Davis, Eyvind Earle, and Walt Peregoy, and their final paintings (below) from *4 Artists Paint 1 Tree*, 1958.

multiple rereleases, it remains one of the top-grossing animated films of all time. The modern style further reenergized the animators. Peregoy and Nordli would style *The Sword in the Stone* and a short, *The Saga of Windwagon Smith*, with the same technique.

There's a little-known 1958 television show that illustrates the stylistic struggle going on within the studio as artists sought to justify the Disney house style with what was going on in the real world. Special effects wizard and plein air painter Josh Meador came up with the idea for a program called *4 Artists Paint 1 Tree*. In it Marc Davis, Eyvind Earle, Walt Peregoy, and Meador set up outdoors at the Golden Oak Ranch facility to paint a California live oak tree using their very different personal painting styles.

Walt Disney is the on-camera host, explaining what it means to be an individual with a personal style and approach to painting. It's an ironic exercise since animation relies not on individuality but artists willing to sublimate their own style and collaborate on the style of a movie. Davis was a studio veteran and masterful draftsman, and his tree was the most representational in style but still extremely angular and modern in design. Meador paints boldly with a palette knife in a manner typical of a plein air painting. Disney loved Meador's style and even collected his work and hung it in his Los Angeles home and at his vacation house in Palm Springs, California.

In contrast, Earle was deep in production on *Sleeping Beauty*

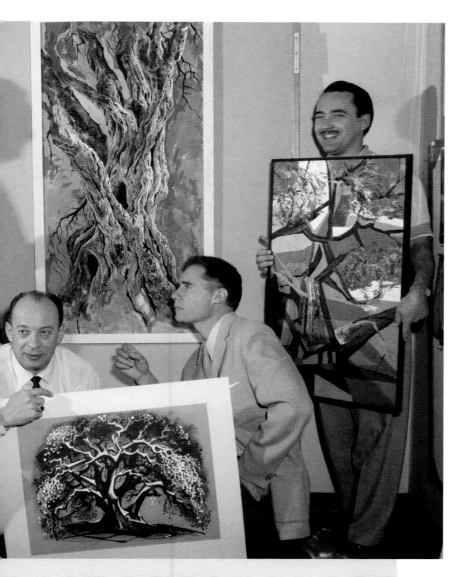

when this was filmed, and he painted in his own highly graphic and controversial style. Peregoy was beginning work on *One Hundred and One Dalmatians,* and being the enfant terrible of the group, painted something wildly abstract and wonderful.

The episode is inspiring but shows a subtext of artistic tension in a studio that only twenty years earlier had rallied around the cozy style of European illustrators to make *Snow White*. Now with iconoclasts like Earle and Peregoy, and old pros like the open-minded Meador and Davis, the era of the individual was surfacing in a way that would not have been tolerated in the 1930s.

The same year *4 Artists Paint 1 Tree* aired, Golden Press published a richly illustrated book to celebrate the release of *Sleeping Beauty*. The book, *The Art of Animation* by Bob Thomas, showed and named the Disney artists for the first time, further proof of the rise of the individual in a studio that had only ever been associated with a singular personality: Walt Disney.

The costs and conflicts of *Sleeping Beauty* were in Walt's rearview mirror as he green-lit Rudyard Kipling's *The Jungle Book* for development. He had long ago entrusted animation production to Woolie Reitherman and a group of experienced animators and story men. But when artist Bill Peet began drawing storyboards with a darker tone and a true-to-Kipling version of the story, Disney stopped production and grabbed the steering wheel.

Writer Larry Clemmons and songwriter Richard Sherman both recall a story meeting where Walt asked the crew if anyone had read *The Jungle Book* by Kipling. No one had, so Walt blurted out, "Good! We're going to do Walt Disney's *Jungle Book*, not Kipling's."[10]

As he had done with virtually all of his animated features, Walt freely adapted the source material and rallied the team around a simple set of appealing characters and a deeply entertaining story about a boy in the jungle looking for his identity.

The lavishly illustrated pages from the opening storybook prologue of *Sleeping Beauty*, 1959.

A daughter was born. They called her AURORA

Aurora sweet AURORA. Yes they named her after the dawn for she filled their lives with sunshine.

Then a great holiday was proclaimed throughout the kingdom so that all of high or low estate might pay homage to the infant Princess

And our story begins on that Most Joyful day

Many sad and lonely years passed by for KING STEFAN and his people

Everyone knew that as long as Maleficent's domain the forbidden mountains thundered with her wrath and frustration her evil prophecy had not yet been fullfilled

And they lived happily ever after

# 3
# LIVE ACTION

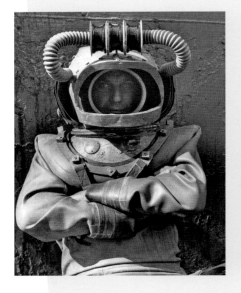

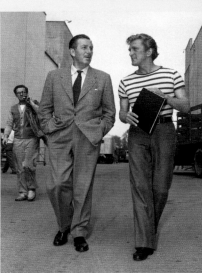

I T WAS DURING this postwar era that Walt also turned to live action to diversify the studio output and to establish Disney as more than a cartoon studio in the eyes of the industry. But there was another reason. The Second World War had cut off nearly all foreign markets, particularly in Europe, where Mickey Mouse and *Snow White* had built a reliable audience for the studio. At war's end, Disney's European profits were frozen, and Walt felt he could make either animated or live-action films in the United Kingdom to recoup some of the money that remained locked up there.

The amount of time and training it would take to set up an animation studio in London would be prohibitive, and Walt had been developing *Treasure Island* as a potential live-action film. It turned out to be a good fit for production in England and the final results were so strong that he put three more productions into work in the United Kingdom.[11] As a process, Walt could hire freelance directors and work with them on the script and storyboards as a blueprint for his vision of the film. It's not that the directors were weak: writer and film critic Leonard Maltin interviewed several of the directors of that era and "they said unanimously that they felt great freedom. . . . I think that's because they had that blueprint. It helped them. It gave them confidence, and Walt stayed out of their way."[12]

"In live action, you can take a mediocre story and put in

Top and right: Production designs and concepts for *20,000 Leagues Under the Sea* by Harper Goff, 1954. Above left: Director Richard Fleischer tries out a diving suit. Above right: Walt and Kirk Douglas talk during filming on the Disney lot in Burbank.

interesting characters and personalities and have a good show," said Walt when asked about the process of producing a live film. "We can't do that in cartoons. We can't hire actors; we have to create them ourselves. We have to make them interesting, or we're sunk."

Walt loved the speed and variety of genres he could muster and produced a slate of memorable films. Some, like the wide-screen epic *20,000 Leagues Under the Sea* (1954), used an all-star cast and elaborate stage effects. Live-action director Richard Fleischer shot *20,000 Leagues Under the Sea* with the same CinemaScope technology Walt had licensed from Fox for the upcoming *Lady and the Tramp* (1955). With good reviews and a stellar cast led by Kirk Douglas, *20,000 Leagues* was the second-highest-grossing film of 1954 (behind Bing Crosby's *White Christmas*), and won Oscars for Art Direction and Special Effects.

Other Disney films, such as *Old Yeller* (1957) and *Pollyanna* (1960), were simple stories from the heart. Walt ran a modified studio system using some actors as regulars of Disney fare; none was more widely cast than Fred MacMurray, who starred in *The Shaggy Dog* in 1959. That movie was followed by others, such as *The Absent-Minded Professor*; *Bon Voyage*; *Son of Flubber*; *Follow Me, Boys!*; and *The Happiest Millionaire*.

The stories that the studio developed played right into the ideal of a strong home and family, a story that was coveted by audiences during what became known as the Cold War era. *Lady and the Tramp* and *One Hundred and One Dalmatians* certainly carried that theme in animation. The live-action films did that as

Right: *Darby O'Gill* stars Janet Munro and Sean Connery try out the Autopia cars at Disneyland, 1959.

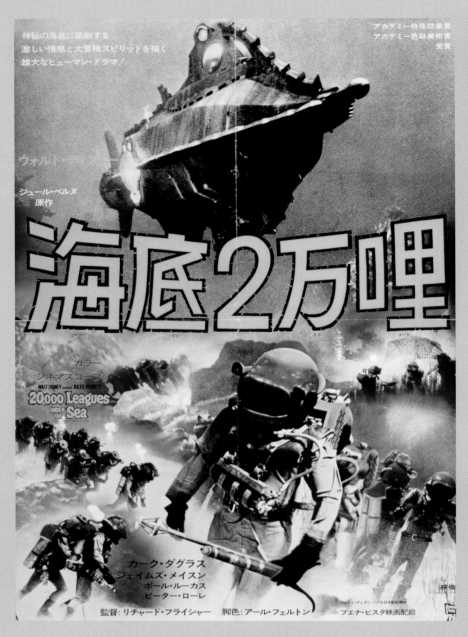

HAYLEY and a ROMANTIC STRANGER
*bound together by an ancient secret...
too dangerous to share!*

Walt Disney presents
**The Moon-Spinners**
*a surprise in suspense!*

starring
Hayley MILLS
Eli WALLACH
Peter McENERY
Joan GREENWOOD
Irene PAPAS
Pola NEGRI

TECHNICOLOR

Walt Disney zeigt
**DER PAUKER KANN'S NICHT LASSEN**

FRED MACMURRAY · NANCY OLSON · KEENAN WYNN

A MAN OF TWO FACES.

*who rode
in defiance
of a king's
tyranny!*

Walt Disney presents
**Dr. Syn**
*alias The Scarecrow*

Starring PATRICK McGOOHAN · GEORGE COLE · TONY BRITTON · SEAN SCULLY
**TECHNICOLOR**

Co-Producer BILL ANDERSON · Associate Producer HUGH ATTWOOLL · Directed by JAMES NEILSON · Screenplay by ROBERT WESTERBY
Based on "Christopher Syn" by RUSSELL THORNDIKE and WILLIAM BUCHANAN

International one-sheet posters from
Disney live-action films of the era.

THEY TURNED A LOST ISLAND INTO AN EXOTIC PARADISE!

WALT DISNEY presents
**SWISS FAMILY ROBINSON**

JOHN MILLS · DOROTHY McGUIRE · JAMES MacARTHUR · JANET MUNRO
TECHNICOLOR FILMED IN PANAVISION

All the heart, all the excitement
of a great frontier adventure!

**WALT DISNEY**
presents
DOROTHY McGUIRE and FESS PARKER
also starring in
**OLD YELLER**
TECHNICOLOR

with JEFF YORK · TOMMY KIRK · KEVIN CORCORAN · BEVERLY WASHBURN · CHUCK CONNORS
Screenplay by FRED GIPSON and WILLIAM TUNBERG · Based on the book by FRED GIPSON · Associate Producer BILL ANDERSON · Directed by ROBERT STEVENSON

The funniest discovery since laughter!!

Walt Disney's
**The Absent-minded Professor**

All about a
scrambled egghead
...a flying flivver
and FLUBBER
(the GOO that Flew)!

FRED MacMURRAY · NANCY OLSON · KEENAN WYNN · TOMMY KIRK
LEON AMES · ELLIOTT REID · EDWARD ANDREWS

well, but also reveled in the romanticized stories of America's great past. The film titles sound like chapters of an American history book: *Westward Ho the Wagons!*; *Davy Crockett*; *The Great Locomotive Chase.*

At the same time Walt found a story by German author, poet, and screenwriter Erich Kästner. Kästner had built a career writing mostly children's books, including *Emil and the Detectives* (1929) and was a pacifist during the war opposing the Nazi regime. In return the Nazis burned his books and banned him from the Nazi-controlled National Writers Guild.

After the war Kästner wrote prolifically, including a story about identical twins, separated at birth, who meet at a summer camp. The story, *Das doppelte Lottchen* (The double Lottie), was later reissued in English as *The Parent Trap*. The story is about the contemporary problem of divorce, an unconventional topic for a family film but an issue that Walt and director David Swift handle without stigma and with a good deal of humor and romance. The couple, played by Brian Keith and Maureen O'Hara, live in a California ranch house, which was designed by Oscar-winning art director Emile Kuri to represent the affluent dream house in the idyllic California west. Kuri, who was born in Mexico to Lebanese parents, had worked with Alfred Hitchcock on *Spellbound* and Frank Capra on *It's a Wonderful Life*, and had won an Oscar for William Wyler's, *The Heiress.*

The exterior of the house was built at the edge of the lake at the Golden Oak Ranch, the rural film studio set north of Los Angeles that Walt had bought as a location for his growing television and live-action business. The film is masterfully designed as a study in visual contrast between two worlds, the structured and formal old world of Boston in the East versus the relaxed and sprawling life of the Western ranch house. It made *Parent Trap* the ultimate wish-fulfillment movie, not only for kids hoping their separated parents would get back together, but for young couples who read *Sunset* magazine and dreamt of a ranch house in the new world: California.

As the Cold War continued, audiences' hunger for stability and family shed light on a new story based on a series of books by British author P. L. Travers. What emerged, *Mary Poppins*, became a project that used every aspect of Disney's expertise, from animation, live action, and music to on-screen Audio-Animatronics and technological advances like the sodium screen, which made for seamless integration of live-action and animation elements. It was in many ways the culmination of Walt's film career and a validation at long last by an industry that had never truly embraced him.

In the same year *Mary Poppins* garnered thirteen Academy Award nominations, President Lyndon Johnson awarded Walt the Presidential Medal of Freedom, and the New York World's Fair opened with four attractions designed and built by Walt's boutique and privately held company, WED Enterprises.

Mid-century ranch house interiors and stop-motion puppets used in the title animation for *The Parent Trap*, 1961.

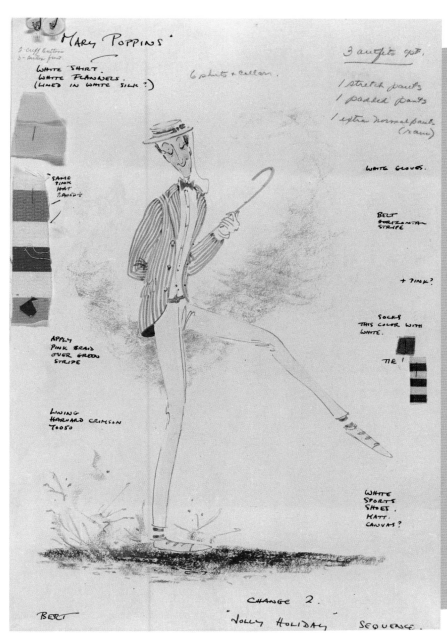

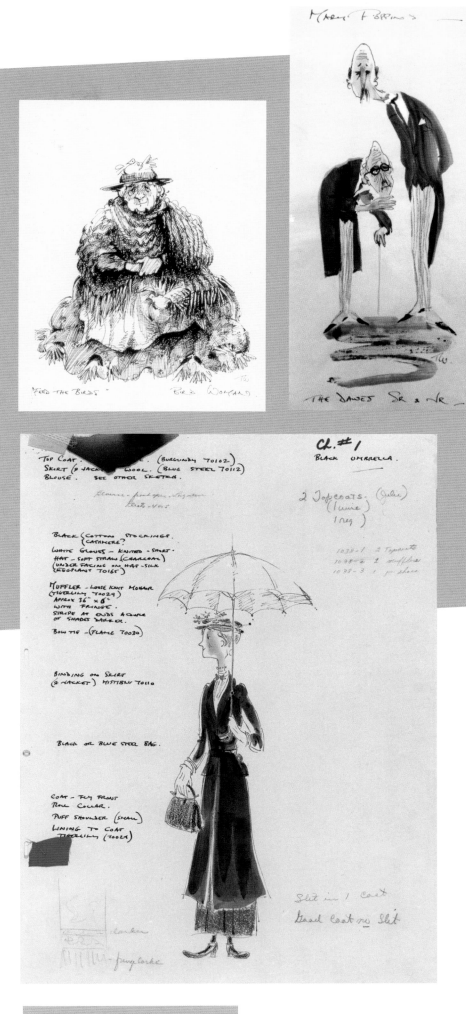

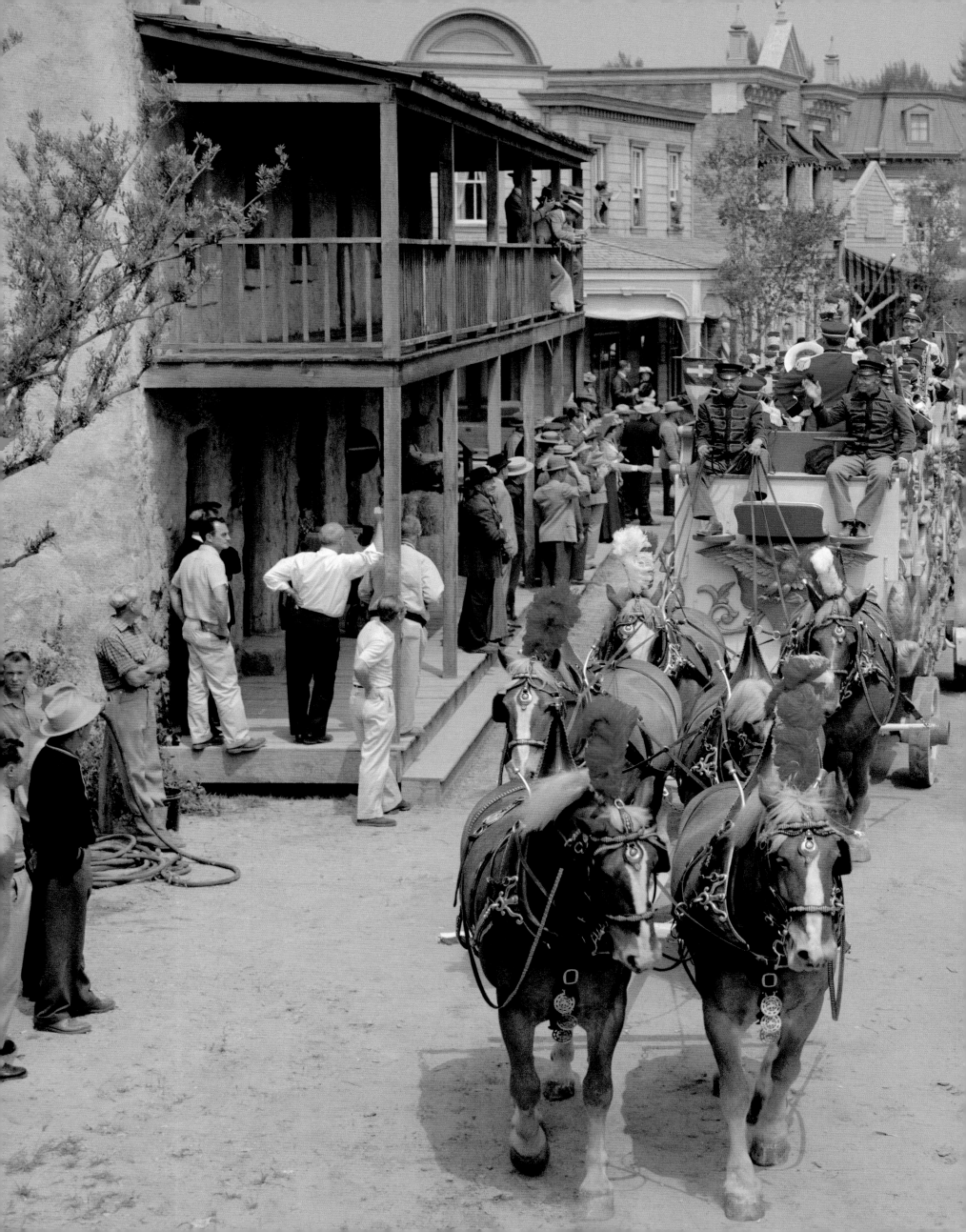

A film crew captures the circus parade in the 1960 film *Toby Tyler* on the back lot at Disney's Burbank studio.

# 4

# INVENTING DISNEYLAND

*Make no little plans; they have no magic to stir men's blood and probably themselves will not be realized. Make big plans; aim high in hope and work, remembering that a noble, logical diagram once recorded will never die, but long after we are gone be a living thing, asserting itself with ever-growing insistency.*

—Daniel Burnham, architect of the
1893 World's Columbian Exposition in Chicago

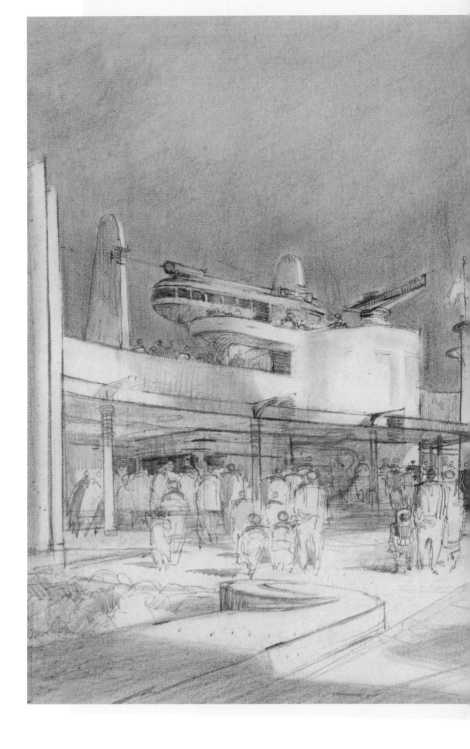

**S**NOW WHITE *and the Seven Dwarfs* was a phenomenon when it was released in 1937. It was the highest-grossing film of all time until *Gone with the Wind* broke that record two years later. Walt used the windfall from the record box office to build a creative campus in Burbank, California. It was self-contained, with its own water, power, restaurants, gym, softball field, and every amenity needed to make films.

A few miles up Riverside Drive from the new campus was Universal Studios, which for years had opened its back lot to visitors. It's not unlikely that Walt imagined the same thing for his studio. But unlike the glamour of a Hollywood studio filled with

handsome actors and fascinating sets, touring an animation studio was like watching paint dry. Walt thought people might get bored with the technical tedium of observing animators draw. So he thought a small park with picnic tables, a statue of Mickey, and a steam train visitors could ride through the Disney campus would fit the culture of his place.

At first, Walt brought in Harper Goff, a set designer who came from Warner Bros., to play with ideas for the small park on the acres wedged between the Los Angeles River and the Disney Studio. His early drawings featured ideas that would someday make it to the final design of Disneyland: a Native American village, stagecoaches, a lake with an island, and even a circus in one corner of the property.

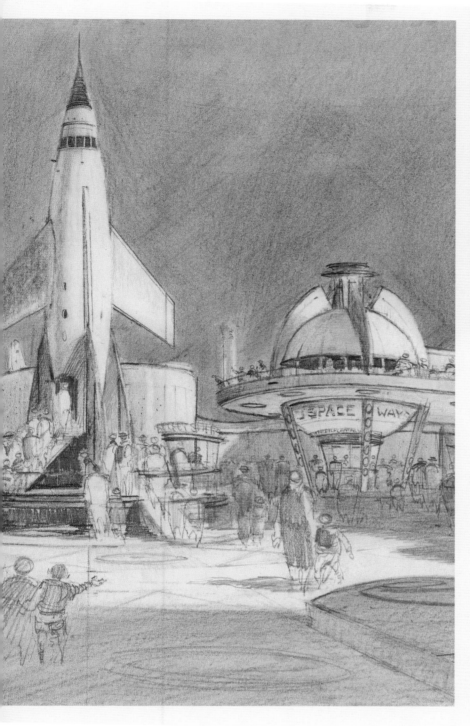

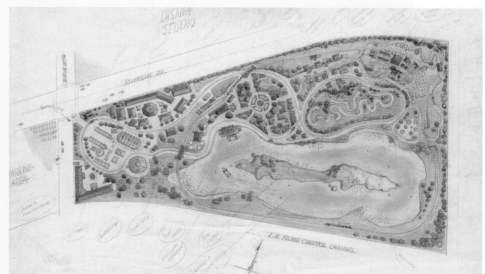

Left: Dale Hennesy's conceptual artwork for Disneyland's Tomorrowland. Top: Walt pitches ABC president Robert Kintner on the park. Above: An early drawing by Harper Goff for a small pleasure park opposite the studio in Burbank, 1951.

The initial plans were reported in the Burbank press in March 1952, and despite Walt's charm and his knack for selling anything to anyone, the last thing that Burbank wanted in their backyard was a "carnival" in the worst sense of the word. Walt soon shelved the Burbank plan and searched for a larger parcel of land that could hold more of his ideas. For a brief time, he explored the idea of working with miniatures (one of his many hobbies) and called in art director Ken Anderson to design a touring show called Disneylandia. The show would feature dazzling miniatures displayed in train cars that would tour the country. It was a cute idea, but in the end, the thought of looking at tiny dioramas on a train didn't inspire anyone. Walt continued to shop for ideas.

At age fifty, Walt found himself at a crossroads. He had many ideas and missed working with a nimble team of loyalists that could execute his ideas quickly and navigate this new world of television and themed entertainment with him. His frustration came to a head when in 1951 he told Roy and the board of directors that he wanted to create a new firm, Walt Disney, Inc., as an incubator for new concepts. Walt would be chief executive officer and sole shareholder, of the company. This was complete insanity to shareholders, who worried that Walt Disney was leaving his own company. After a few unsuccessful suits from shareholders, the name of his new company was changed to WED, which stood for Walter Elias Disney. It remained wholly owned by Walt and was

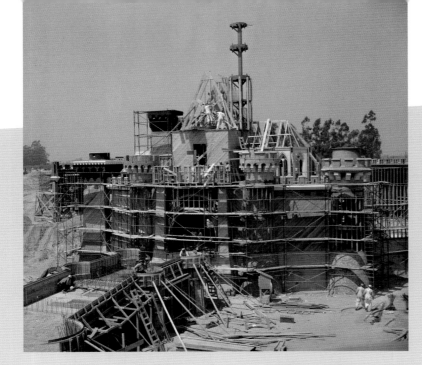

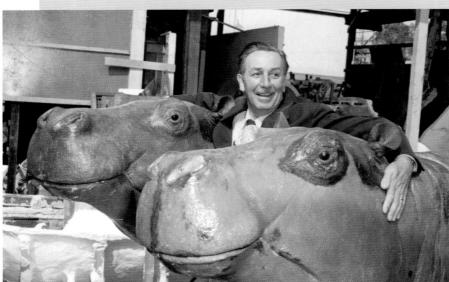

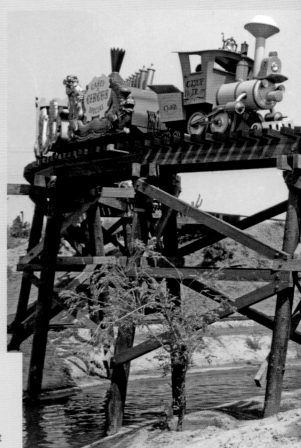

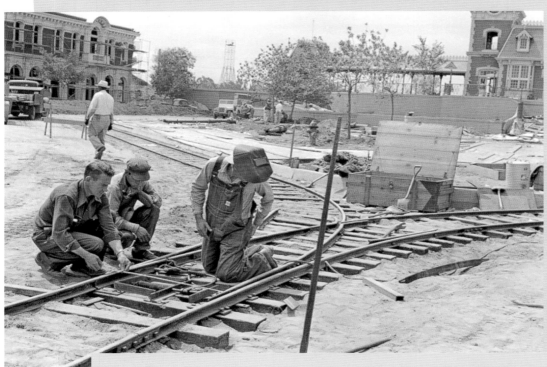

Top left to right: Sleeping Beauty Castle under construction; a 1958 *Vacationland* magazine promoting vacations at Disneyland; and Main Street, U.S.A. construction. Middle (left to right): Walt visits the hippo fabrication shop, then surveys the construction from the top of the berm surrounding the park. Bottom (left to right): Welders install trolley tracks on Main Street, U.S.A.; Casey Jr. Circus Train takes a test lap; and the Matterhorn and submarine attractions take shape during a 1959 expansion of the park. Far right: Attraction coupons, including the coveted E-ticket.

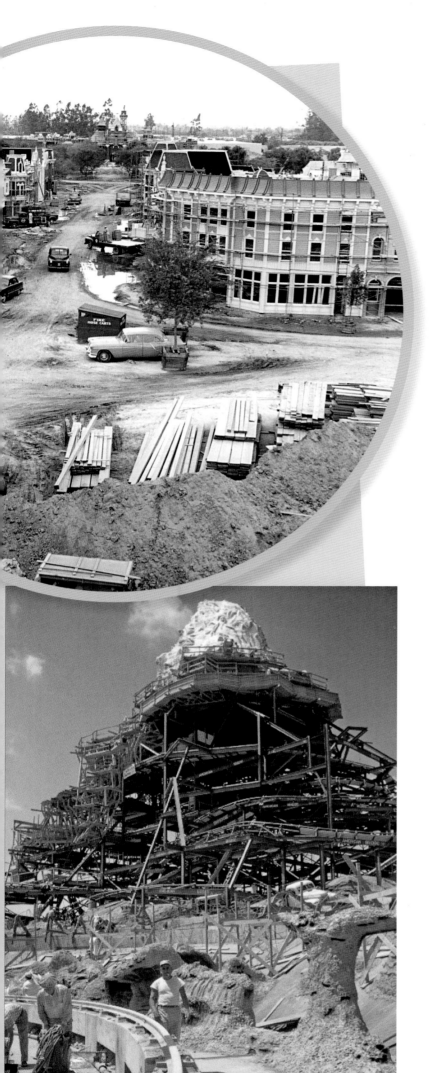

described as his "production company." It soon became clear that the production he contemplated creating was not a film—it was a theme park, Disneyland.

By March of 1953, the Disney board considered Walt's proposal: he would offer services for both the studio and for his privately owned company, WED Enterprises, which would design and build attractions for Disneyland, billing the studio at cost plus overhead. In addition, Walt kept ownership of the steam trains, the Monorail, and his apartment at Disneyland, and would license the use of his name back to Walt Disney Productions for use on ancillary products.[13] The board was powerless to stop Walt's drive to reinvent himself and they reluctantly approved the arrangement. Three board members resigned after the vote.

In July of the same year, Roy went to New York to visit financiers and television networks. CBS and NBC, which had both hosted Disney's hugely successful television premieres, would have loved to have programming from Disney but had no interest in Disneyland, so they passed. Roy called back to California and requested concept drawings to show how a park and a television show would work together to draw an audience. Both would be called *Disneyland* and both would be themed around the lands of Fantasy, Adventure, Frontier, and Tomorrow.

In August, Marvin Davis drew the first plans for a triangular park surrounded by a railroad. Then in September Walt spent two days and nights huddled with Herb Ryman, an art director who had worked on the Emerald City sequence of *The Wizard of Oz*. Together they drafted a master plan that was both practical as a planning tool and spectacular as a sales tool. It was designed like the back lot of a movie studio—a mix of Tivoli garden (in Copenhagen, Denmark), Colonial Williamsburg (in Virginia), and Henry Ford's Greenfield Village (in Michigan). With their drawing in hand, Roy got ABC chief Leonard Goldenson to agree to the largest television deal in history, with Disney supplying programming for the ABC network and ABC agreeing to a $500,000 investment and a $4.5 million line of credit in return for an interest in the park and the profits from concessions.

Walt hired Buzz Price and the Stanford Research Institute to study the best locations for Disneyland, taking into account the

explosive growth trends throughout the Los Angeles area, access to transportation, and even broadcast television capabilities. Walt refused to give them any direction, wanting the decision to be based on their research data alone.

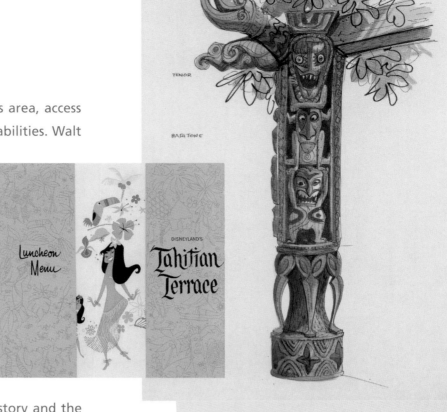

The layout for Disneyland evolved in a way that reflected the urban planning ideas of the era. The sections of the park were delineated with names and identities, and all emanated from a central hub. Each land was devoted to a different style of architecture, some primitive, some futuristic, and the park became a lab for transportation ideas and the management of everything from crowds to food preparation to waste disposal and recycling. Disneyland, however, was very reliant on story and the vocabulary of cinema, as was every aspect of Disney's work. Story would give the guest an emotional attachment to each land in a way that had been foreign to amusement parks up to this point.

Stanford's findings centered on 160 acres of orange trees in the Ball Road subdivision of Anaheim, California, directly on the route of a newly proposed Santa Ana Freeway.

In October 1954, the first *Disneyland* television show aired on ABC for an audience of 30.8 million American viewers. The show was called "The Disneyland Story." Only nine months were left until the opening day of the park.

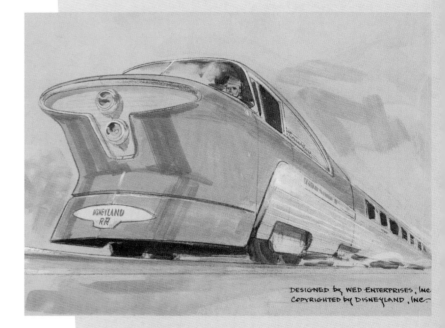

The plan was both outrageous and brilliant because it fit so perfectly into the zeitgeist of the times. The park was squarely in the path of burgeoning suburbs, and people would soon be moving there by the millions. It was counter to anything that had happened before, when typically people had moved to frontier for farmland or to the centers of manufacturing or industry for jobs. "The move to the suburb, as it occurs in contemporary America, is emotionally, if not geographically, something almost unprecedented historically," is how sociologist David Riesman described the phenomenon, portraying it as a return to frontier living.

But Riesman added a warning that "those who move to any new frontier are likely to pay a price, in loneliness and discomfort."[14] Disney, his park, his movies, and his television shows would be uniquely positioned as the antidote to all of that.

Construction continued at a feverish pace right up until—and actually after—opening day in July. The project had burned through the ABC money, Disney's money, and another investment by Western Publishing and Lithograph Company, which had licensed Disney publications since the 1930s. Roy bolstered the construction fund

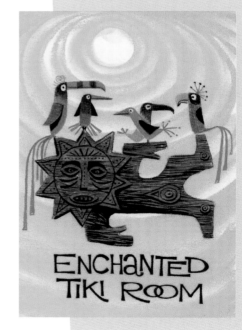

From top, down: Marc Davis brings personality to a Tiki Room totem. Lunch menu at the Tahitian Terrace. The Viewliner ran for just one year and was replaced by the Disneyland-Alweg Monorail in 1959. An attraction poster by Rolly Crump features the Sun God for the Enchanted Tiki Room.

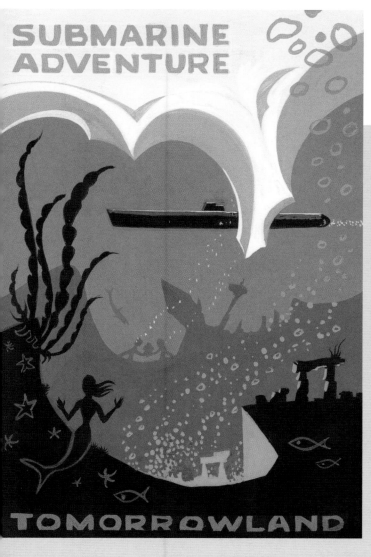

SUBMARINE
ADVENTURE

TOMORROWLAND

TOMORROW LAND

CANDY PALACE

MAIN STREET

STAGE COACH RIDE

MINE TRAIN RIDE

MULE PACK RIDE

FRONTIERLAND

From top left: Concept for the Submarine Adventure attraction poster. Mountaineers scale the new Matterhorn in 1959. The entrance to Tomorrowland. Attraction poster concept for the Candy Palace on Main Street and attraction poster for Frontierland.

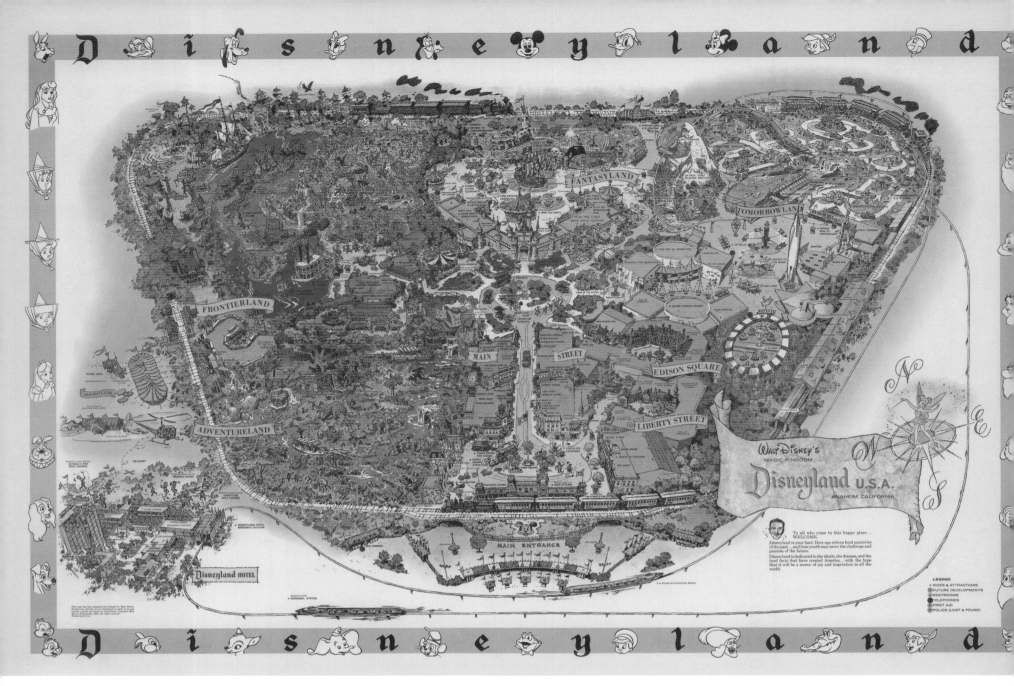

Sam McKim's iconic 1962 map of Disneyland with the new Matterhorn, Submarine Voyage, and the new heliport at the Disneyland Hotel.

by recruiting corporate sponsors. There were thirty-three in all, from Bank of America, Maxwell House Coffee, and Wurlitzer Music to Carnation Ice Cream, Chicken of the Sea, and Kodak. Santa Fe Railroad signed up to have its name and company logo on all the Disneyland trains, while the Intimate Apparel shop on Main Street, sponsored by the Hollywood-Maxwell Brassiere Co., featured (and I am not making this up) "The Wizard of Bras," who delighted guests with his history of underwear.

Opening day was both a disaster and a triumph. Thousands reacted to the siren call of Disneyland as promoted heavily on the *Disneyland* television show, and they swamped the gates early in the morning of the opening. Inside, Walt's friend and neighbor Art Linkletter prepared for a live television broadcast with Ronald Reagan, Bob Cummings, and a host of other celebrities to millions of viewers who had been smitten by the sights of

the park even when it was under construction.

Disney's initial dream of a small park with a studio tour was alive at a scale that no one had ever seen before. The very idea that visitors could wander through the old West, have an ice cream on a turn-of-the-century main street, or even meet Mickey Mouse was irresistible. To a nation of people who had endured decades of the Depression, patched clothes, world war, and now a Cold War, it was the epitome of wish fulfillment.

The *New York Times* later wrote that Disney achieved "the same suspension of disbelief which has been the secret of theatrical success down the corridors of time." They too saw the brilliant use of cinema in the real world. "In the theater the vital ingredient is not realism, but a blending of the real with the imaginary. The entertainer invites the audience to meet him halfway. This is what has been successfully achieved at Disneyland."[15]

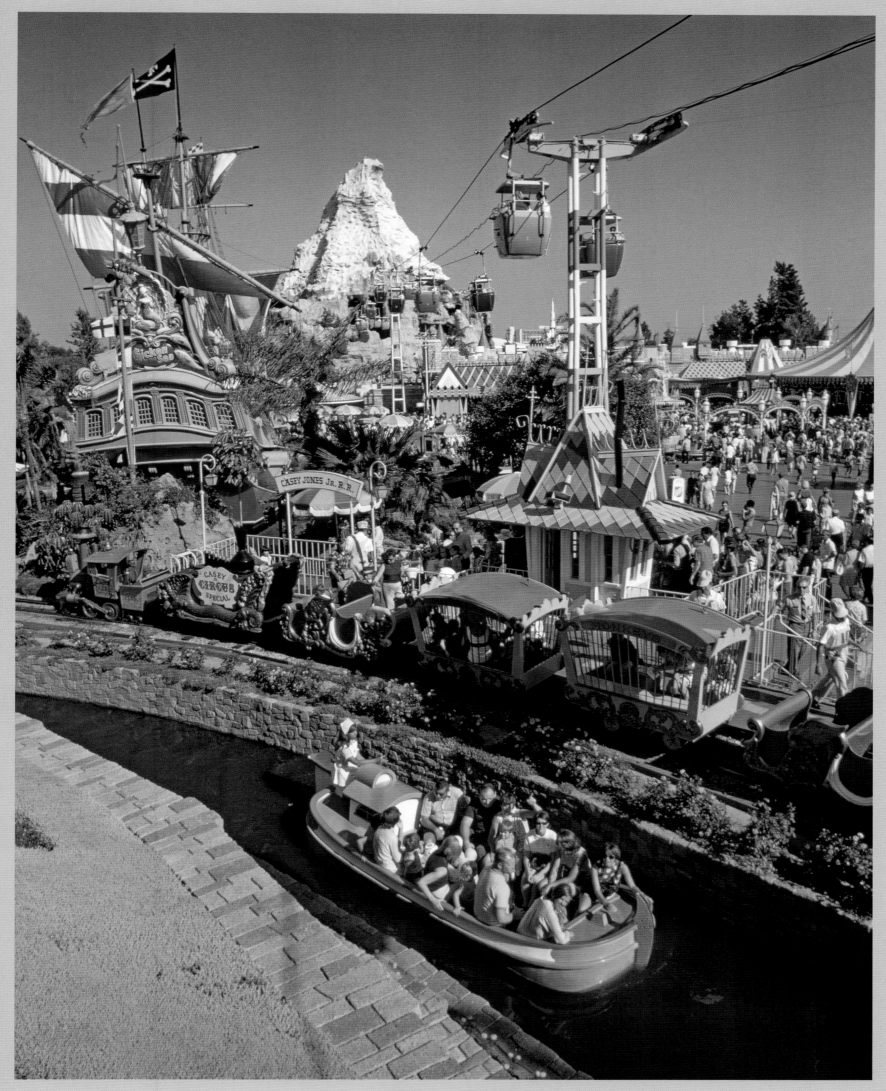

Guests tour Fantasyland by boat, train, and skyway, 1970.

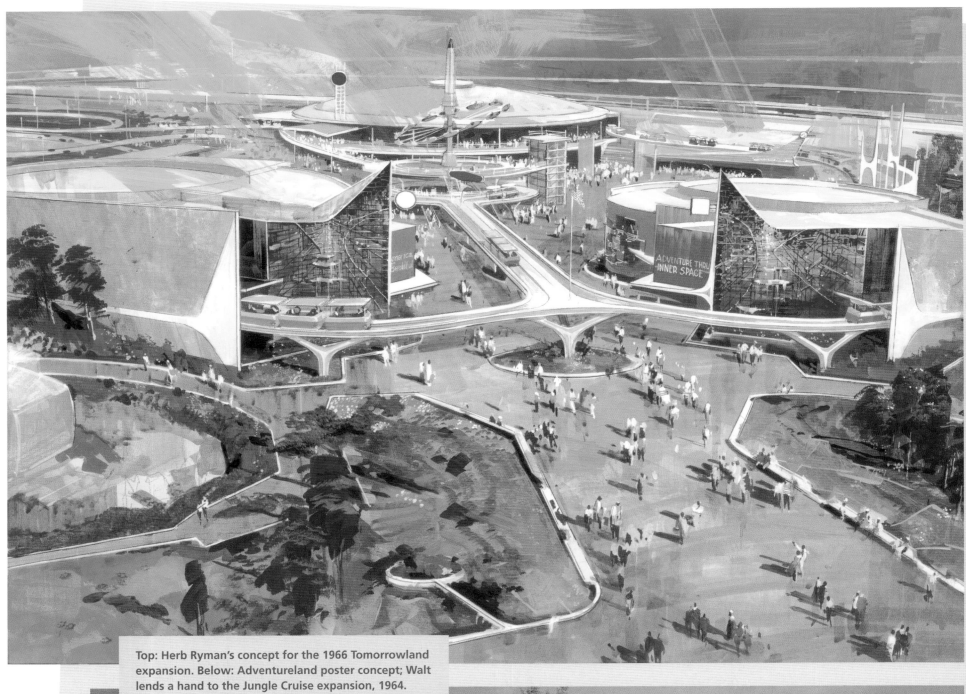

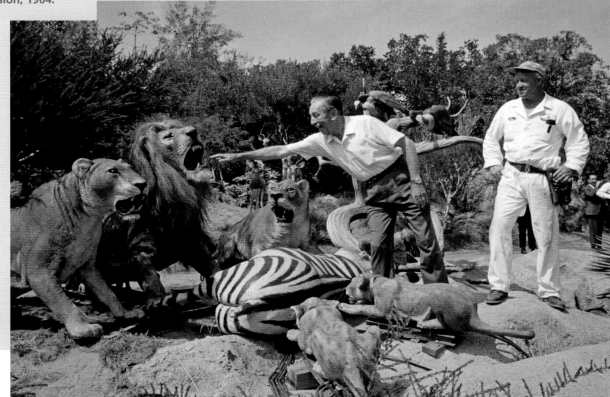

Top: Herb Ryman's concept for the 1966 Tomorrowland expansion. Below: Adventureland poster concept; Walt lends a hand to the Jungle Cruise expansion, 1964.

FOR AN EXCITING ADVENTURE IN EATING

PAVILION

ADVENTURELAND

Clockwise (from top left): An astronaut band plays on the Flying Saucers attraction; attraction poster by Rolly Crump; geysers spout on the Mine Train Through Nature's Wonderland; promotional illustration of the Tahitian Terrace by Paul Hartley, 1962.

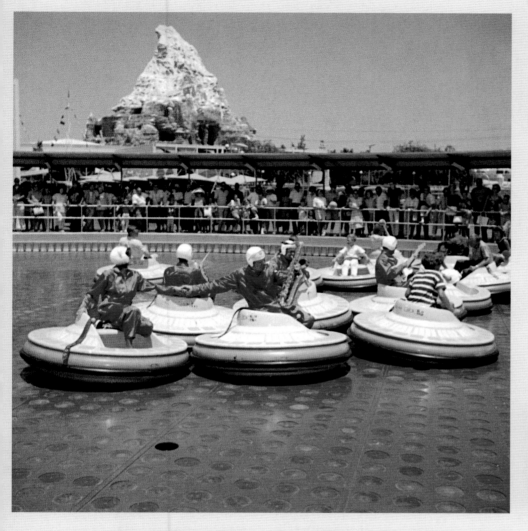

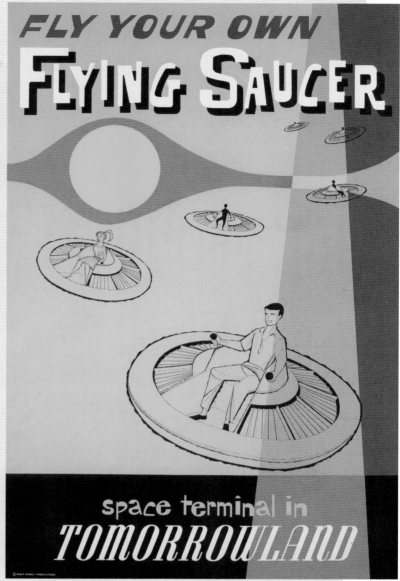

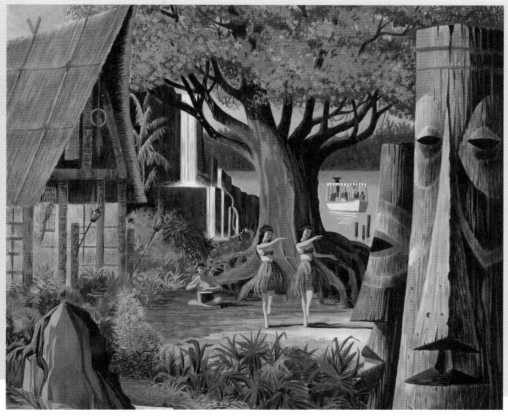

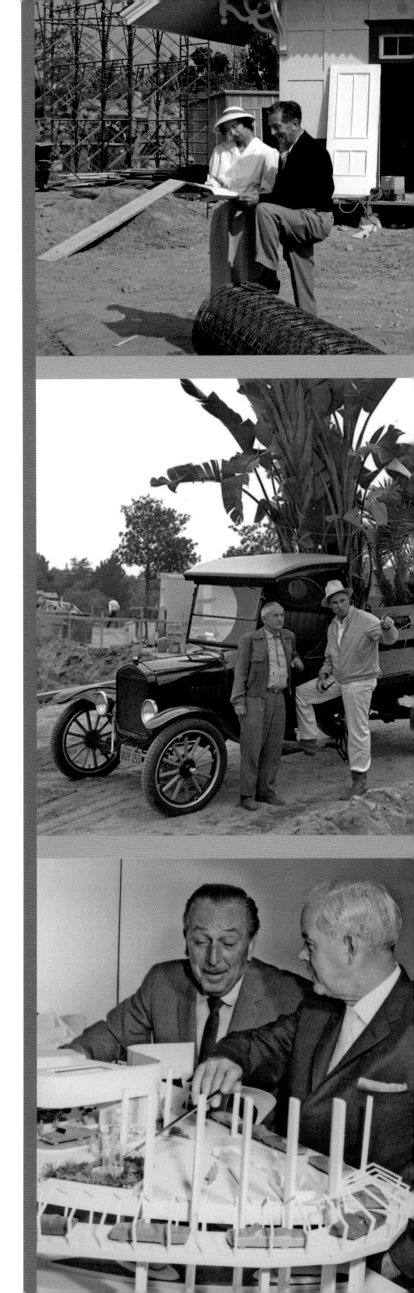

# 5

# WALT AND WELTON

**W**ELTON BECKET, whose House of Tomorrow inspired a generation of postwar dreamers, was Walt Disney's neighbor in the tony Holmby Hills section of Los Angeles. He and Walt had become friends and confidants, even vacationing together with their wives. Becket was an architect from the Pacific Northwest who had relocated to L.A., where he built his practice into the largest architectural firm in the United States. Like the cities of the future, his buildings became icons that defined the architectural fabric of the area: Century City, the Capitol Records Building, the Cinerama Dome, the Music Center in downtown Los Angeles, and the new jetport, Los Angeles International Airport.

He had Walt's ear, and his influence on Disneyland was profound, not only because of the themed designs he had done for tourist towns like Canyon Village in Yellowstone and Hawaiian Village in Honolulu, but for having just built the first suburban department store in America, Bullock's Pasadena. His plans for the Los Angeles Music Center gave the city what architecture critic Alan Hess called "a latter-day Acropolis for the arts." He was designing and building the cities of tomorrow, and Walt Disney was paying attention. When you look at his work, "you have a comprehensive catalog of the era's confidence, innovation, and progress," Hess concluded.[16]

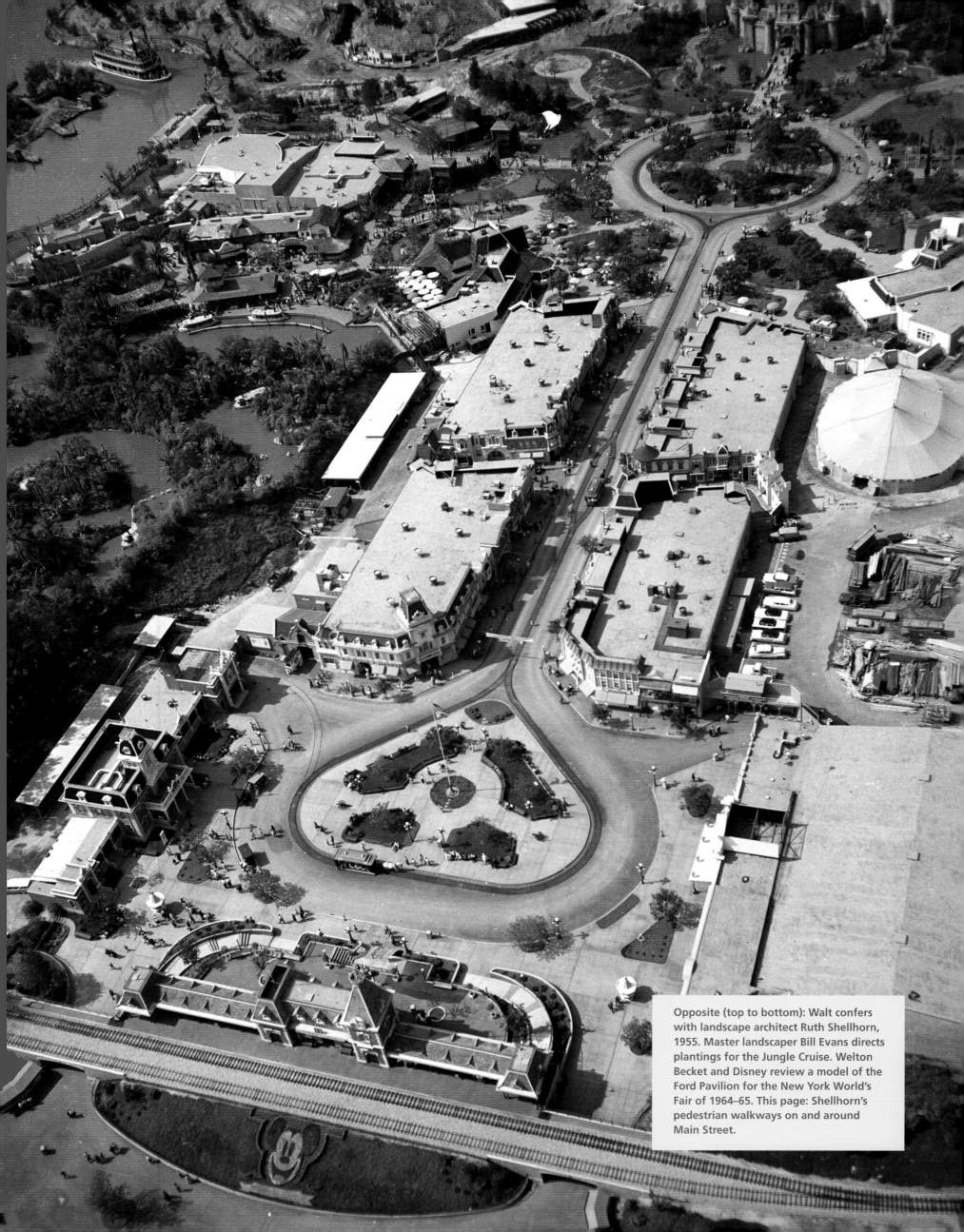

Opposite (top to bottom): Walt confers with landscape architect Ruth Shellhorn, 1955. Master landscaper Bill Evans directs plantings for the Jungle Cruise. Welton Becket and Disney review a model of the Ford Pavilion for the New York World's Fair of 1964–65. This page: Shellhorn's pedestrian walkways on and around Main Street.

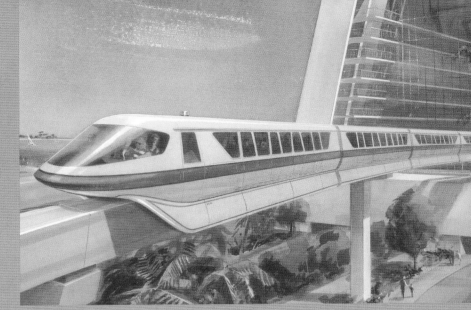
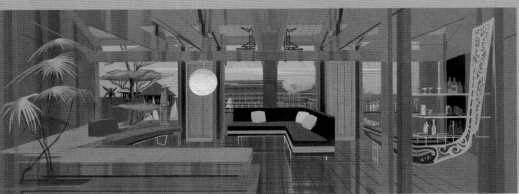
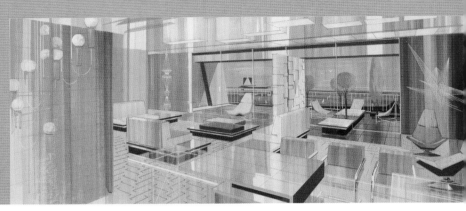

Clockwise (from top left): Marty Sklar, Welton Becket, and Dick Irvine mark the location of Cinderella Castle in Florida; George McGinnis concept of a Mark IV monorail exiting the Contemporary Hotel; The Contemporary Parlor concept art and a lobby design for the Polynesian Resort hotel, both by John DeCuir Jr..

But it was Becket's behind-the-scenes influence with Walt that was perhaps most significant, not just to Walt himself but to the future of urban planning. As the design and construction of Disneyland got under way, he told Disney to abandon the formal architecture firms Walt had hired to design the park and instead replace them with production designers and set designers from the movie business. They would give Walt a familiar crew that could speak in the same vernacular as a filmmaker, and be able to work quickly and nimbly, allowing for the flexibility and constant change that was inherent in Walt's creative process as the park was coming to life.

As construction neared completion, Walt became concerned about pedestrian flow and traffic patterns for guests within the park. Bill and Jack Evans were qualified nurserymen who had recently landscaped Walt's house in Holmby Hills. They found specimen plants and fully mature trees wherever they could to fill in the landscape at Disneyland, but as nurs-

Shellhorn's concepts for pedestrian flow were crucial to the design of Disneyland.

erymen, they didn't have the perspective of a landscape architect. Becket suggested meeting with Ruth Shellhorn, whom he had worked with on the Bullock's Pasadena store.

With just three months until opening day, Walt brought Shellhorn in to work as liaison with both the WED designers and the Evans brothers on a pedestrian circulation plan that would create a natural flow for the guests from Town Square, down Main Street, to the hub, and finally to the individual lands. Each land was designed by a different art director, and construction on most everything at the site was well under way, all without a comprehensive site plan.[17]

There soon was mounting conflict between Shellhorn and the Evans brothers. Both thought they were in charge of landscape for the park. Shellhorn had an exquisite attention to detail in her plans, the selection of materials, and the installation of the landscape. That discipline didn't fit the freewheeling culture being permitted on the work site, especially since she was the only woman on the architecture team.

On May 25, Shellhorn wrote in her diary,

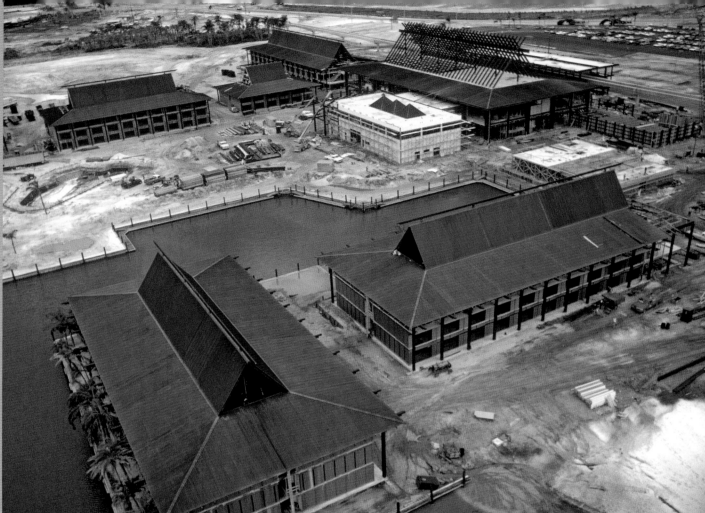

Above: A fully finished room is hoisted into place in the Contemporary Hotel (left). The same method was used at the Polynesian Resort construction site (right).
Below: Becket's design for the Polynesian Resort restaurant lounge.

"So to heck with it, I can see how Jack [Evans] has gotten to his dirty work with the men for their attitude now that I'm a little 'filly' who doesn't know how to handle a big job."[18]

The tensions came to a head when *Landscape Architecture Quarterly Magazine* wrote Shelhorn asking her to write about her work on the park. She passed the idea by Dick Irvine, who was running design and planning for Disneyland. He said he had to pass it by the Evans brothers. He called her back to say, "Jack said the article was okay as long as Ruth was billed as his assistant."

"I feel I was being used," she wrote. "[Jack] gets the publicity, and I do the planning."

The tense relationship held together out of necessity, but when the park opened, Shellhorn was let go. "In terms of creative power, Shellhorn enjoyed great control over the landscape designs of Disneyland," said Disney historian Todd James Pierce. "Her designs were implemented with very few changes throughout the park. But in terms of social power, she found herself ostracized."

For years, Welton Becket stayed Walt's confidant, advising on the early plans for the Florida Project. His most visible contribution to Disney would be the epic pavilions he designed for the 1964 New York World's Fair. At Walt Disney World, his Contemporary and Polynesian Resort hotels were built with an innovative modular construction method that shipped prefabricated and finished rooms to the site, where they were craned into place in a steel superstructure.

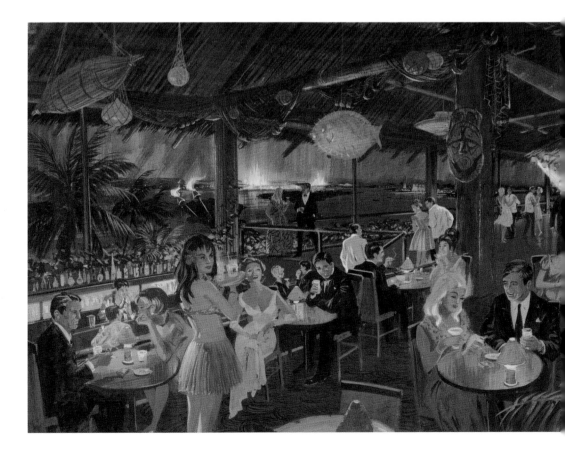

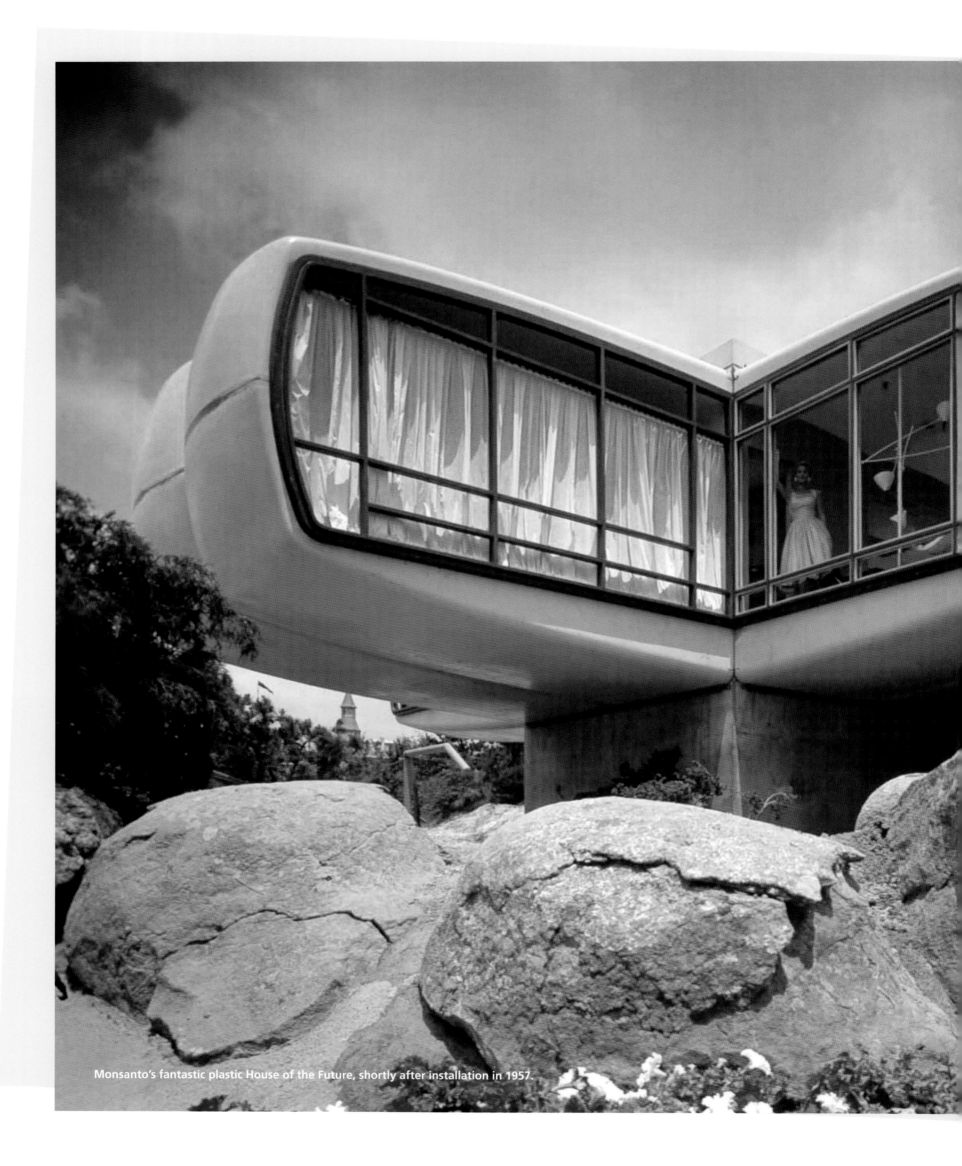

Monsanto's fantastic plastic House of the Future, shortly after installation in 1957.

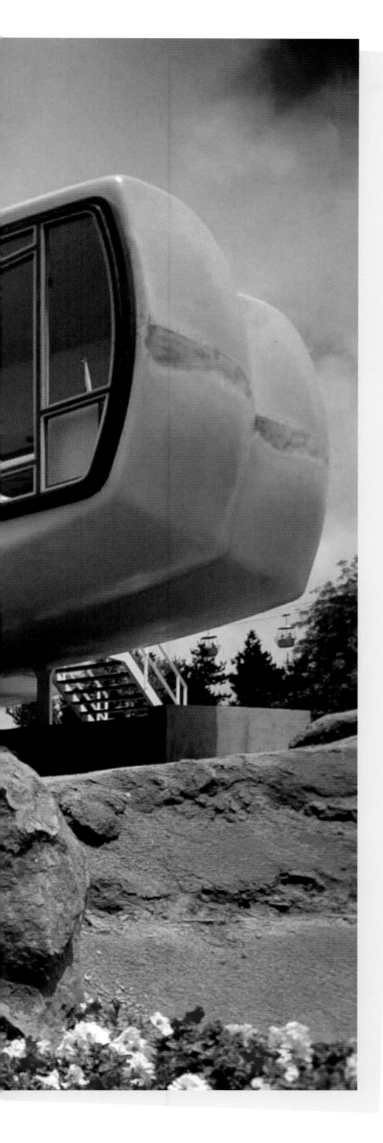

# 6

# THE HOUSE OF THE FUTURE

**M**ONSANTO hosted four attractions over time. One, called Fashions and Fabrics Through the Ages, was part of the Hall of Chemistry. It displayed historic gowns of famous women and explained to guests how natural fibers of the past like cotton and wool could be duplicated with modern man-made fibers like Acrilan and nylon. Visitors marveled at the antebellum dress worn by Mary Todd Lincoln, a gown worn by President John Tyler's wife when she attended President James Garfield's inauguration, an opera gown worn by actress Sarah Bernhardt, and an evening gown owned by actress Jean Harlow.

"In startling contrast to the elaborate fashions of history, are a group of five contemporary gowns by Anthony Muto," touted the exhibition's brochure. "These gowns were created entirely of Acrilan and nylon fibers made by Monsanto's Chemstrand Company Division."

Fashion was just a small part of the Hall of Chemistry, where you could also find the "Chematron" and learn about "the romance of chemistry, how chemically-made products . . . can make a new and startling world tomorrow." To further emphasize its vital impact, it was noted that "your food, clothing, housing, health, and transportation all depend upon chemistry."

Ten years earlier, Welton Becket had designed and constructed a "house of tomorrow" in Los Angeles, which became the envy of

returning World War II GIs and their families. It was featured in the pages of *House Beautiful* and visited by a million people who paid a dollar each to tour the house and see every modern and labor-saving device known to man—including a helipad. "Designed to enchant, astound[,] and inspire the home-loving public, this exhibition house displays a multitude of novel ideas, innovations, and devices," boasted developer Fitz B. Burns in *Architectural Record* magazine in April 1946.

The house Becket built was the showcase for electric garbage disposals, intercoms, and built-in barbecues. "No expense has been spared in providing the utmost in glamour and gadgets."[19]

The popularity of Becket's house inspired Monsanto to sign a ten-year lease and build its own House of the Future on a site in Disneyland.

The house was designed by Marvin Goody and Richard Hamil-ton, both on the MIT architecture faculty and hired by Monsanto to find new markets for their plastic products. It showcased all-new materials, including a fiberglass shell manufactured by Winner Manufacturing of Trenton, New Jersey, which was trucked to Disneyland and assembled on-site. Everything in the House of the Future—the interior walls, the ceilings, the floors, the chairs, the tables, the plates—was made of plastic except for the exterior walls of the structure (which were floor-to-ceiling glass). The floor plan inside the 1,280-square-foot home consisted of a master suite, two bedrooms, a living room, and kitchen in four wings that were built out over a central base.

The kitchen, set in the futuristic year 1986, featured a "revolutionary microwave oven," a technology that had been around since the 1940s; but here it was shown in compact form, along with moving cabinets that shuttled dishes up and out of the way and a

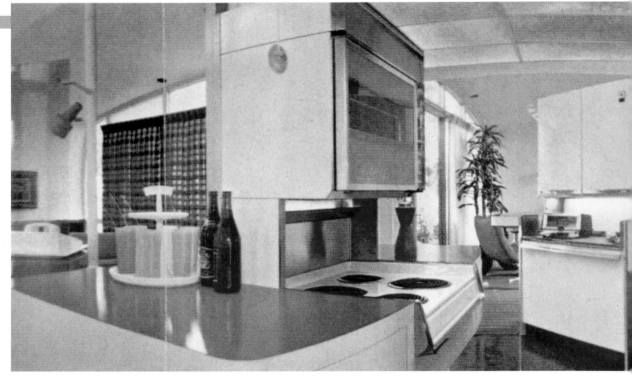

dishwasher that hid beneath the counter and washed with ultrasonic waves. Overhead lights were controlled by preset dimmers. The refrigerator-freezer had "cold zones" for cold, frozen, and irradiated foods. Storage shelves were lowered from overhead cabinets.

Another innovation was contributed by the Crane Plumbing Company, which displayed a climate control device that handled heat and air-conditioning needs with the scent of sea air and roses.

In the master bedroom, the nightstand held a Bell Telephone Company push-button speakerphone. If that wasn't futuristic enough, the phone was connected to a closed-circuit television that showed the outside of the front door. The living room had built-in high-fidelity stereo equipment and a large flat-screen television. Remember, at the time, 90 percent of Americans owned one small black-and-white television. The bathroom had a height-adjustable toilet designed so users could avoid stretching or bending. In addi-

tion, there was a built-in electric razor and toothbrush.

As many as ten thousand people toured the free exhibit every day, and a total of more than twenty million would view it by the time the house was closed in 1967 at the end of Monsanto's ten-year lease. When it was dismantled, the planned one-day demolition ended up taking two weeks since the wrecking ball just bounced off the exterior. Workers ended up cutting the house into pieces with hacksaws.

After it was removed, the landscaping, waterfalls, and walkways were preserved. Today the foundation of the house is Ariel's Grotto.

But Monsanto was not out of Disneyland by any means. It next sponsored a new attraction that opened in 1967 with the remodeling of Tomorrowland. The attraction, Adventure Thru Inner Space, took guests on a ride through the "mighty microscope" via Imagineer Bob Gurr's revolutionary ride system on a voyage deep into the inner space of a snowflake. The ride vehicles had individual sound systems so that the narration traveled with each guest as they explored the vastness of inner space. At journey's end, there was a display touting Monsanto's many advances in science and technology.

Clockwise (from top left): MIT architects (left to right) Marvin Goody and Richard Hamilton; the kitchen, which envisioned a future from the then-distant 1986 with ultrasonic dishwashers, a microwave oven, and "cold zones" to replace refrigerators; Walt visits with an ideal mid-century family; parents enjoy views through the plastic safety glass in the living room; and an early concept sketch of the house by Herb Ryman.

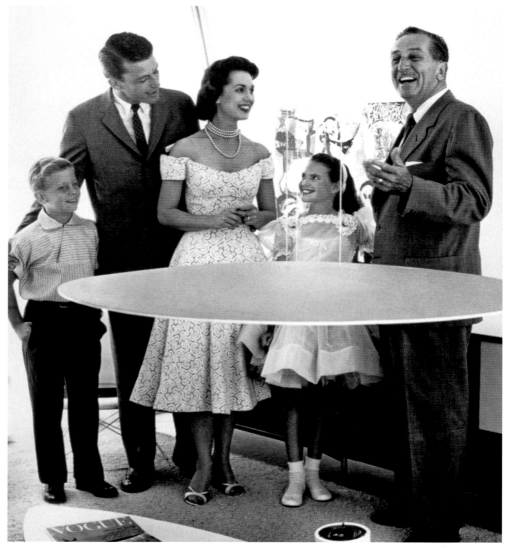

# 7

# CARS OF
# THE FUTURE

**I**N 1949, seventeen-year-old Robert Henry Gurr started at the Art Center College of Design in Pasadena, California. The school was world renowned as a center for automotive design, and Gurr studied with the best, including Strother MacMinn. MacMinn not only had taught car design at the school for fifty years, but also designed cars for Opel and General Motors, and its Oldsmobile unit. By late 1952, Gurr, who was still completing his design education, finished writing and illustrating a book called *How to Draw Cars of Tomorrow*. The book was locally published with only a few hundred copies, but it would establish Gurr as a visionary of car design in the mid-century.

At graduation, he was recruited by both GM and Ford to work in their design plants, but after a year in Detroit, he missed the freedom of designing his own ideas. He had heard of Disney's plans to build a place that could be a potential home for his innovative designs in Anaheim.

Gurr joined WED in January 1955 to consult on a car attraction at the park. He was typical of the Imagineers[20] being hired during that era: young, curious, incredibly gifted as a designer, and fearless in his ability to try things that Walt wanted. Autopia was an attraction where kids could actually drive their own cars. Children's auto rides were not new to amusement parks, but it was Gurr who brought to it his design sensibility and built a car that could be driven by a child or an adult and that had the style of a high-end

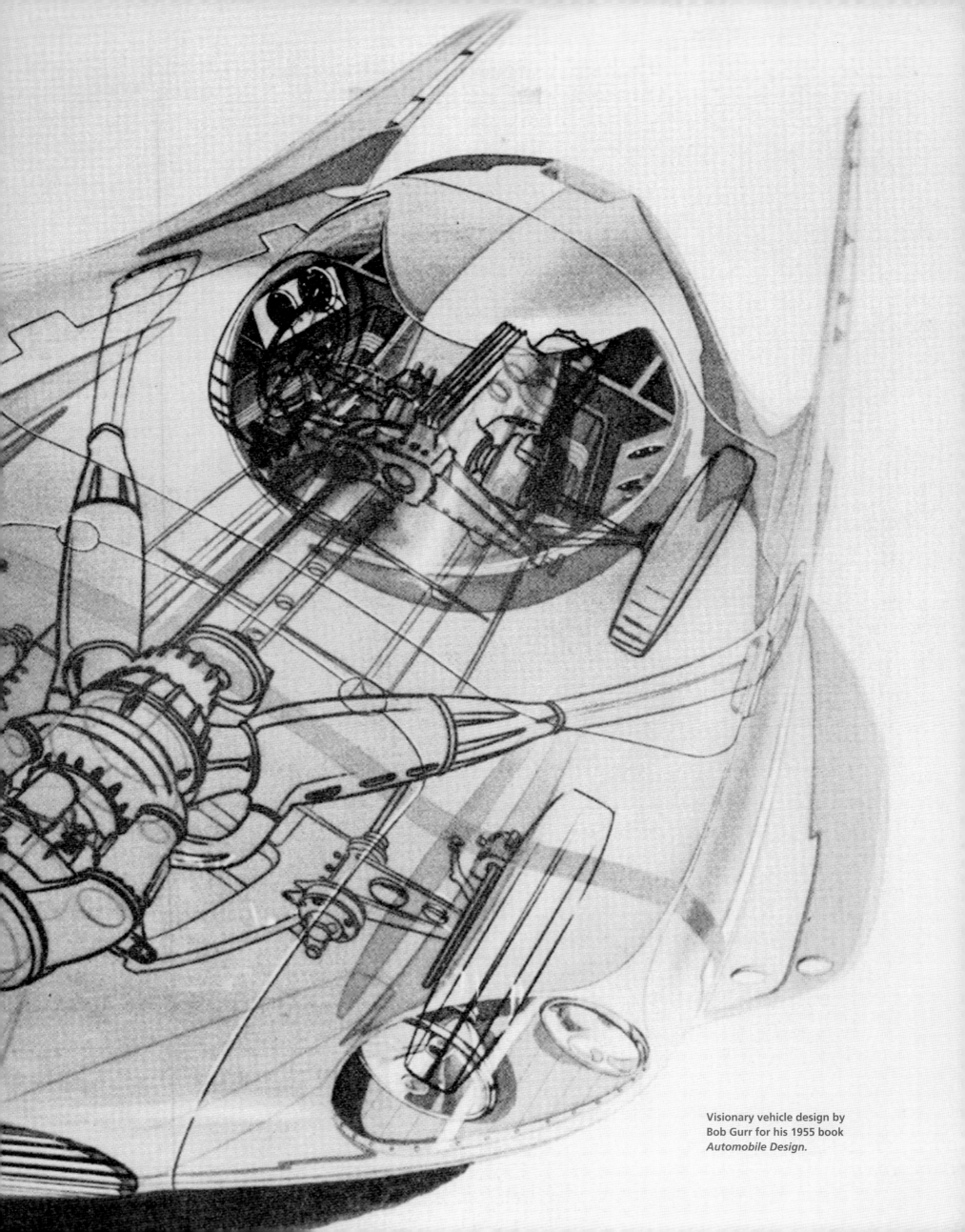

Visionary vehicle design by
Bob Gurr for his 1955 book
*Automobile Design.*

European vehicle. Walt Disney was so impressed with Gurr's knowledge and skill that he asked him to join WED permanently.

His design aesthetic extended to the amazing yet short-lived Flying Saucers attraction and the futuristic shape of the Disneyland-Alweg Monorail. His design for the Matterhorn ride system was both technically advanced and stylistically simple. He also designed the less modern but still stylish antique cars and double-decker bus on Main Street. Walt went to him again and again—on more than one hundred designs for attractions in the parks and at the 1964–65 New York World's Fair. The Magic Skyway featured late-model Ford cars that circled the Ford Pavilion and would soon be introduced in a new form as Disneyland's PeopleMover.

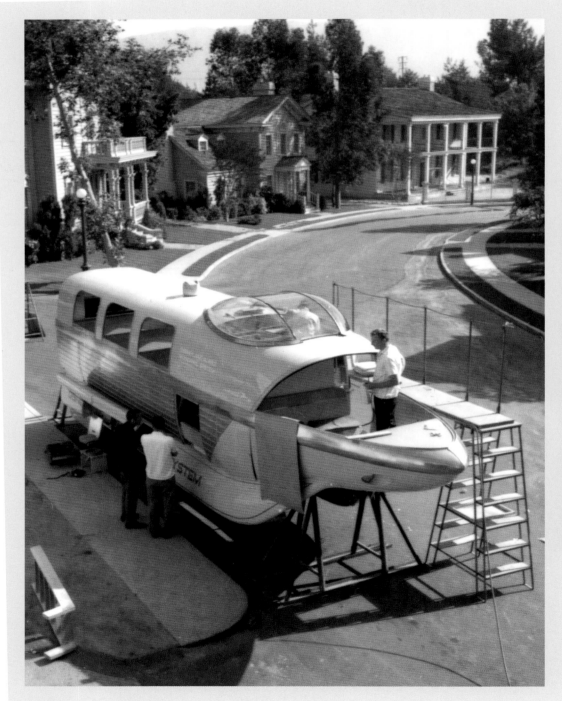

Clockwise (from top): Bob Gurr at the Art Center in Pasadena, California; Walt takes his daughter Diane and grandson Christopher for a spin on the Autopia; Gurr test-drives a prototype for the Autopia vehicle, 1955; and the Mill at the Disney studio in Burbank during construction of Disneyland vehicles. The Burbank back lot was used to assemble monorails.

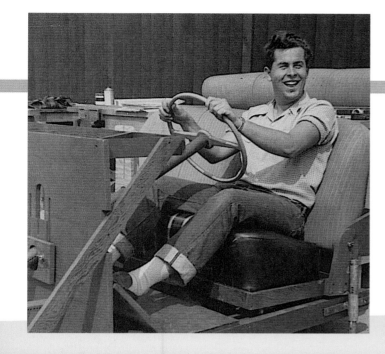

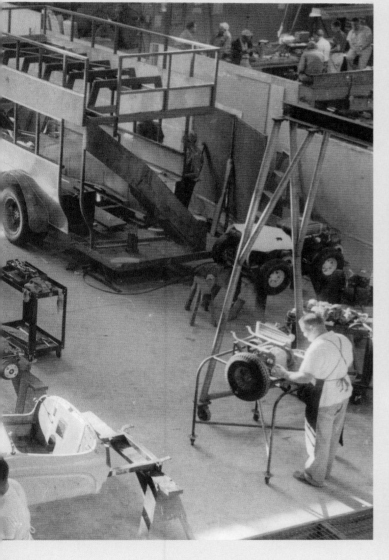

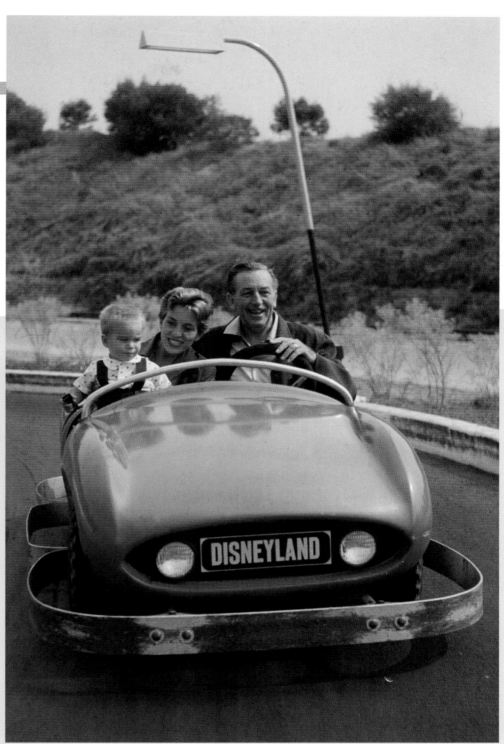

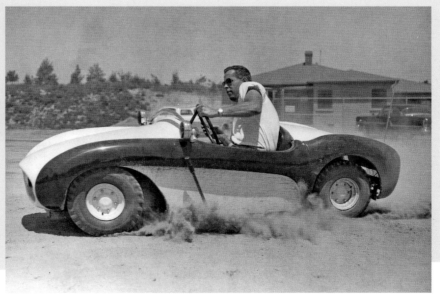

# 8

# ARROW: THE MEN BEHIND THE CURTAIN

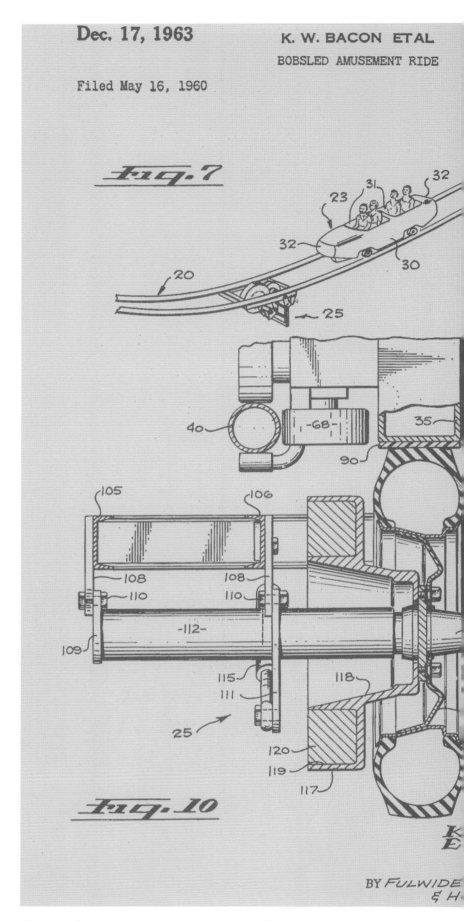

**Fig. 7**

**Fig. 10**

BY *FULWIDE*

**Above: Karl Bacon and Edgar Morgan's patent for a "Bobsled Amusement Ride."**

**D**URING WORLD WAR II, Ed Morgan, Karl Bacon, Bill Hardiman, and Angus "Andy" Anderson worked for Hendy Iron Works in Sunnyvale, California, south of San Francisco in what would later become known as Silicon Valley. Hendy built torpedo launchers and marine steam engines for the US Navy.

In the fall of 1945, with the war having ended, this gifted quartet and their wives celebrated with a dinner at San Francisco's Forbidden City Restaurant. They had worked together for years, and always talked of having their own shop, so they decided there and then to leave Hendy and go out on their own. At first, their new company, Arrow Development, repaired and sold used machine tools and made replacement parts for trucks. But they also did custom machining and assembly work for the Luscombe Hewlett Packard Accelerator Center and the NASA Ames Research Center. Anderson was a master electrician, Morgan an auto mechanic, and Bacon and Hardiman were both machinists (with Hardiman doubling as an accountant). They were fearless when it came to building whatever design came in.

Morgan had read about Disneyland in the newspaper and contacted Disney regarding a small stern-wheeler paddleboat Arrow had built in 1952. They had designed it as a boat that would be ideal for an amusement park. Disney wasn't interested, but Bruce Bushman, the Imagineer assigned to design Fantasyland,

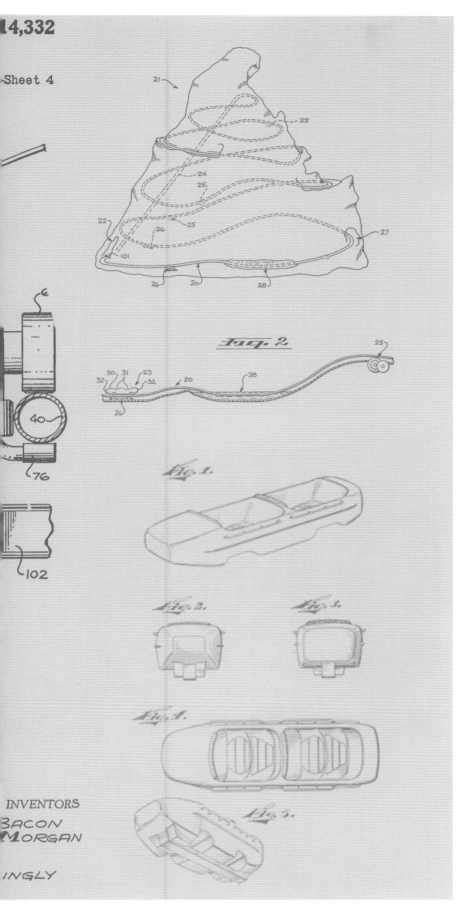

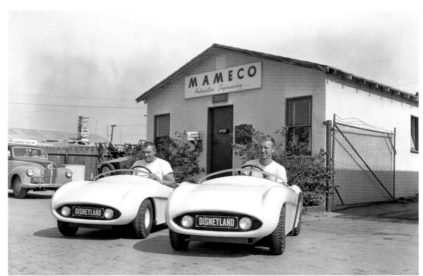

Top right: Paul Hartley's concept for the Matterhorn poster, 1959. Above: Ed Martindale and Ted Mangels test Autopia cars at Mameco in Newport Beach, 1955.

was impressed with their work and contacted Arrow asking if they could build a prototype of the Mr. Toad ride vehicle.[21]

Arrow jumped in. Bob Gurr recalled Morgan laying paper templates out on the floor of the shop, then cutting and welding to match his templates. There were no engineering drawings, just

Bushman's rough sketches. The prototype was a success and WED ordered twelve cars. A long and productive relationship was born.

Arrow worked in an unconventional way. Their shop drafters made large assembly drawings for every part and clipped them to a clothesline. "Ed [Morgan] and Karl [Bacon] were practical realists,

very aware of efficient manufacture," said Gurr. Their process was more efficient and, as Gurr pointed out, way more fun than the more formal engineering protocols common in large companies.[21] They were the perfect fit for the improvisational, creative process that Walt Disney and his crew were used to.

The process between WED and Arrow was simple: when Walt wanted something, the art director would draw it; Roger Broggie Sr., the brilliant mechanical engineer who ran Walt's machine shop, would look at the technical requirements and then send it up to Arrow, whose people would figure out how to build it. Their assignments quickly expanded to include the Mad Tea Party, Dumbo the Flying Elephant, and Peter Pan's Flight ride vehicles. The Casey Jr. Circus Train needed special attention to climb steep hills and operate at high speeds—an inexact science that they were refining up to and after opening day. They were brilliant craftsmen, and delivered to Disneyland on time for opening day.

But Arrow had done the Disneyland jobs on fixed bids and lost money on them all. When the park opened, Walt doubled back with them and covered their losses. He knew he couldn't have built the place without their spirited shop in Sunnyvale.[22]

Arrow's most important contribution would come a few years later with the game-changing ride system they built for the Matterhorn Bobsleds. Originally, Walt wanted a toboggan run with real snow in the park, but Disneyland general manager Joe Fowler thought it was impossible to maintain real snow for a year-round toboggan run in Anaheim. The idea changed when Walt visited the location where director Ken Annakin was filming *Third Man on the Mountain*. Walt dashed off a postcard with a photo of the Matterhorn to art director Vic Greene with the message, "Vic, build this, Walt."[23] What had started as a small hill for sledding became a thrilling bobsled run set on the slopes of the Matterhorn.

To navigate the narrow passages and fast turns of the ride, Arrow developed a brilliant system using steel tube as the track and electronic dispatch of each vehicle to control speed and safety. It was the first tubular steel roller coaster in the world and a forerunner of modern roller coasters still being designed today.

The Matterhorn ride system and attraction, along with the new Disney-Alweg Monorail and the Submarine Voyage, opened in June of 1959. Arrow was now family, and central to the design and build of WED's ambitious attractions, so Disney bought a third of the company, allowing them to move to a larger shop at 1555 Plymouth Street in Mountain View, California. The new facility gave Disney elbow room for the development of ride systems for the next challenge, the 1964–65 New York World's Fair.

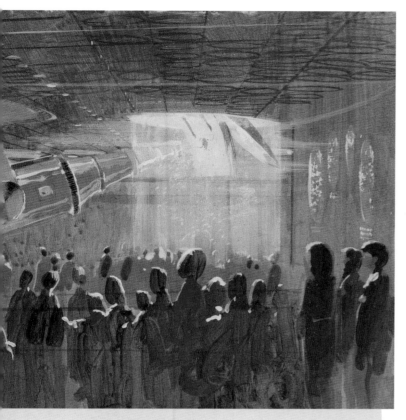

First up was what Walt called "a little boat ride" for Pepsi's "it's a small world" attraction. He wanted to create a silent propulsion system using water jets to move the boats along. It was later adapted for the Pirates of the Caribbean ride vehicles, which also needed technology to carry fully loaded boats both up and down a raging waterfall. The Pirates ride system powered twenty thousand gallons of water flowing through the attraction each minute to propel the boats, which held as many as twenty-two passengers each.

By far the most complex ride system was developed for a Monsanto-sponsored attraction at Disneyland called Adventure Thru Inner Space. The show required a ride system that would allow for more control over the rider's point of view in a very cinematic way. The solution was a series of individual cars linked together and moving at a constant speed, but each vehicle could also move independently side to side so that each guest would have a very narrow and specific point of view. It was a brilliant advancement developed by Roger Broggie and Bert Brundage for WED Enterprises and soon adapted for the Haunted Mansion attraction.

"In the Haunted Mansion, as in many other attractions at the park, another kind of vehicle—a car that runs on rails—is substituted for the camera," wrote historian Christopher Finch. "In this sense, then, it is used exactly like a movie camera. The rider is traveling through a programmed show, which unfolds in time. The choice of where to look is not his to make—it has already been made by the designer, who determines what will be seen, just as a director determines what the movie patron will see."[24] Whatever the challenge, Arrow built it all.

In 1965, two of Arrow's founders, Angus Anderson and Bill Hardiman, sold their interest in the company to their CPA Walter Schulze and went to work for their non-Disney clients, establishing themselves as innovative builders of log-flume rides and the first runaway mine train for Six Flags. By 1971 WED decided to do all their ride-system manufacturing in-house at Central Shops in Orlando. Dick Nunis, then a top executive at the parks, informed Arrow of the decision. Schulze's business acumen kept Arrow afloat in the post Disney era until he retired and sold Arrow to Rio Grande Industries.

Clockwise (from top): Omnimover vehicles take guests on an Adventure Thru Inner Space by Herb Ryman; Walt takes a saucer for a test drive; Casey Jr. train is readied for paint at Arrow Development; Walt and the Imagineers plunge down the Pirates of the Caribbean test track; and Arrow founders and their wives celebrate their new company at the Forbidden City Chinese Restaurant in San Francisco, 1945.

# 9
# THE DISNEYLAND HOTEL

**E**VEN WITH the rapid residential development of the suburbs around Disneyland, it was still a long drive from many Southern California neighborhoods to Anaheim, and the need arose for a place for visitors to stay overnight. The line of credit from ABC and other investors was spent building the park itself, so Walt turned to his friends, first Art Linkletter and then producer Jack Wrather Jr., to invest in a hotel at the park that would provide resort accommodation for the guests. Linkletter passed, but Wrather was willing to gamble.

Wrather was a Texas oil wildcatter who produced movies after the war and later diversified by buying television stations and resort properties. His hit television shows were *The Lone Ranger, Sergeant Preston of the Yukon,* and *Lassie. The Lone Ranger* became an American institution, and its star was even known to make rare guest appearances in Frontierland.[25] Wrather was able to move quickly to finance the construction of the Disneyland Hotel and managed to have it ready only three months after the park's opening.

The original hotel was expanded to include multiple towers and a shopping hub, and in 1961 the Monorail connected it directly to the park. Walt and Roy offered to buy the hotel, trying to unify their resort, but Wrather refused any offers. He and his company operated the resort until 1987, when Disney executives Frank Wells and Michael Eisner realized the only way Disney could own the hotel would be to buy a controlling interest in the Wrather Corporation.

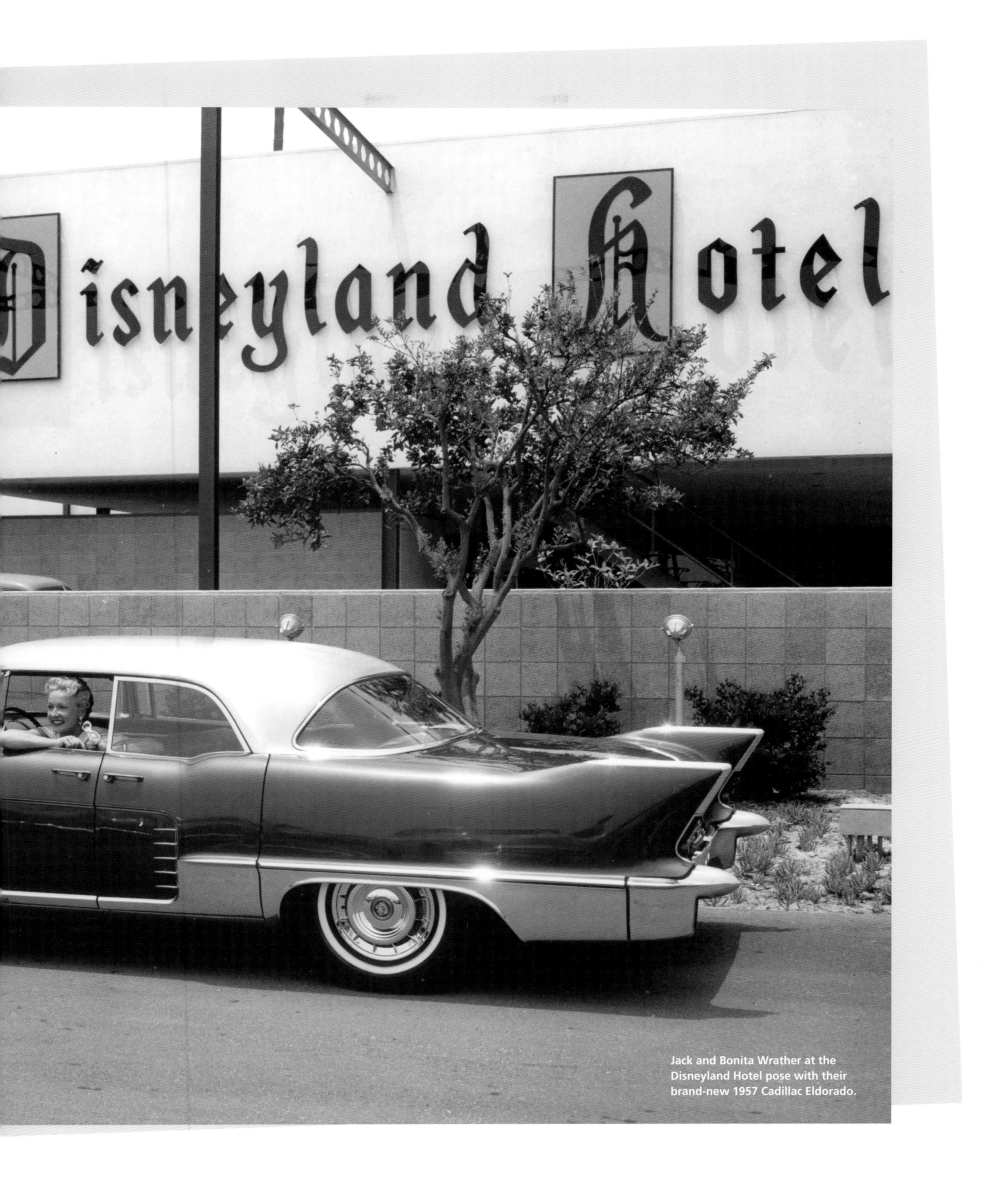

Jack and Bonita Wrather at the Disneyland Hotel pose with their brand-new 1957 Cadillac Eldorado.

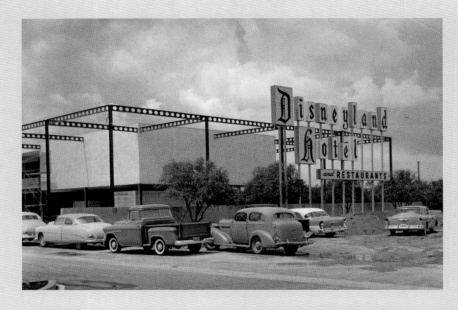

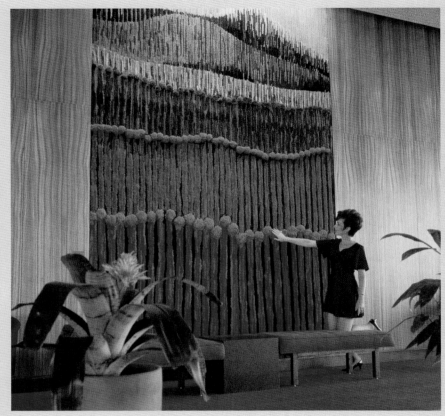

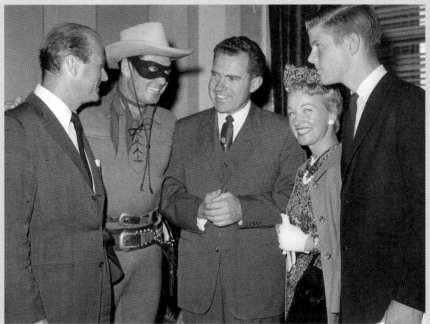

Clockwise (from top left): Construction nears completion, 1956; lobby textiles designed by John Gary Wallis in the new registration lobby, 1969; rooms featured studio couches for kids; models pose for a poolside fashion show, 1958; concept art for a hotel poster; then Vice President Richard M. Nixon visits with Jack, Bonita, and Christopher Wrather and the Lone Ranger, 1959.

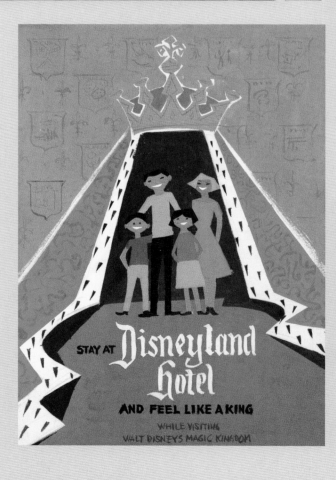

STAY AT Disneyland Hotel

AND FEEL LIKE A KING

WHILE VISITING
WALT DISNEY'S MAGIC KINGDOM

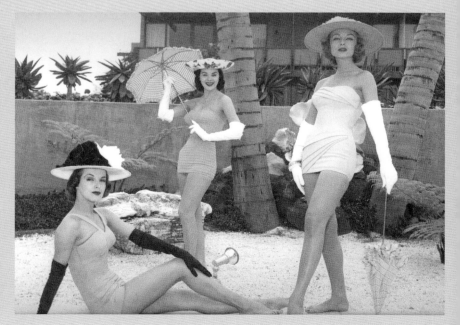

Clockwise (from top left): Hotel poster concept; L.A. Airways on approach to landing at the Disneyland Heliport; Disneyland Hotel attraction poster; guests at the end of a long day; and the hotel tram shuttling guests to the main gate.

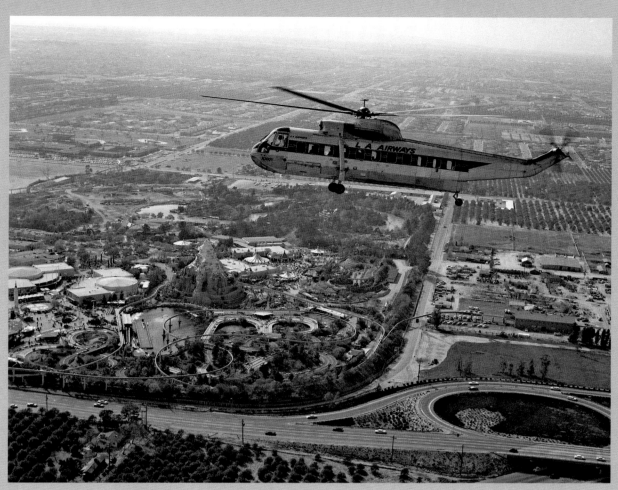

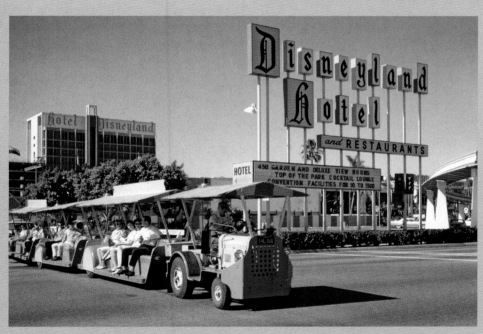

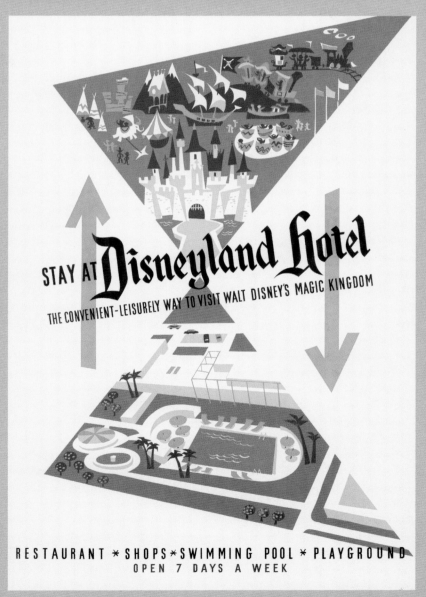

# 10
# THE TELEVISION PHENOMENON

**O**NCE THE INK was dry on the ABC deal, network president Robert Kintner led the way to grow and exploit the relationship with Disney. Kintner had started in journalism at ABC. His first major coup was landing full, live coverage of Senator Joseph McCarthy's anti-communism hearings.

"Walt Disney is undoubtedly the greatest creative force in the entertainment field today. His entrance into TV marks a major and historical step forward for the industry," Kintner said in his opening remarks about the deal. "ABC is very proud of the privilege of working with the Disney organization, which will bring a new conception to television."[26]

The deal for Disney's television shows was remarkable in that ABC not only agreed to bankroll and carry the new television show, called *Disneyland*, but it also invested in a brick-and-mortar Disneyland, too. In return, ABC would get ten years of profit from all the food concessions and a weekly television show from Walt Disney himself. The show was the first-ever ABC show to break into the top ten in the ratings.

As an encore, Walt followed up with a deal for two new Disney-produced series. First was the *Mickey Mouse Club*, a variety show for children with a regular cast of kids known as the Mouseketeers. It first aired on October 3, 1955 (more about that a little later). And then there was *Zorro*, a series based on the pulp-fiction tale about a swashbuckling, whip-cracking California

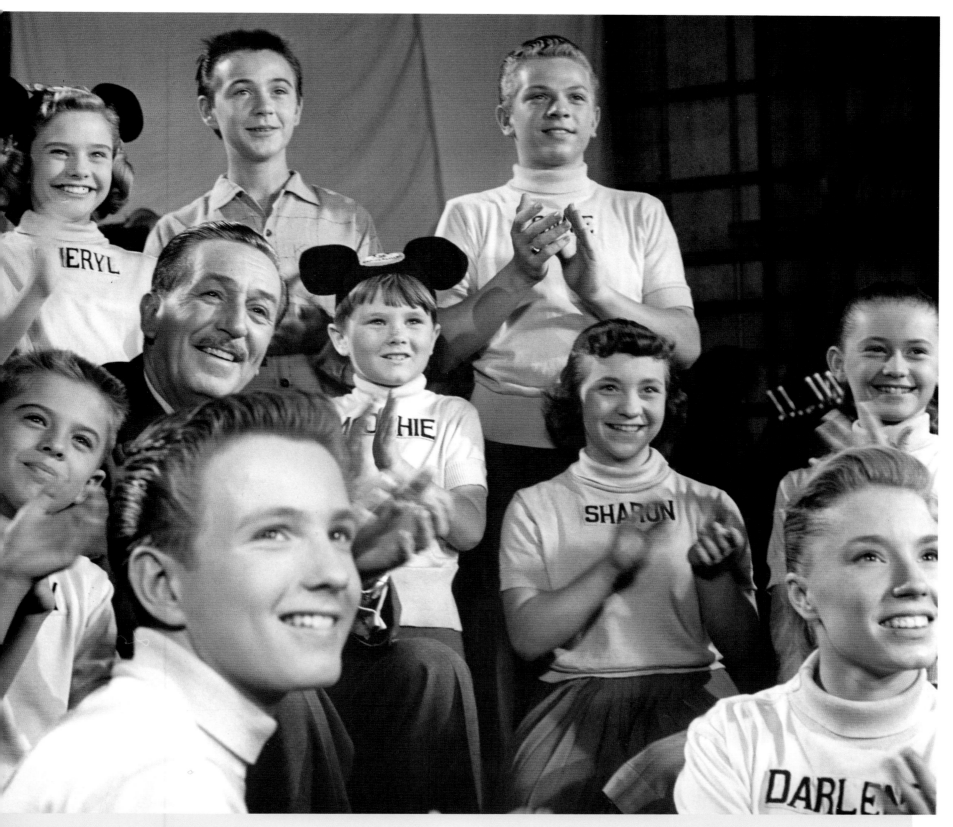

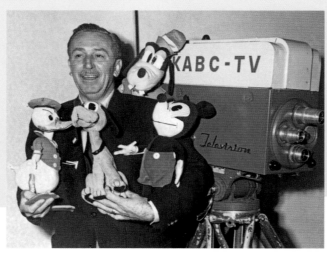

Clockwise (from top left): Walt and friends on the cover of *TV Guide*, 1954; Walt posing with the Mouseketeers; a publicity photo as ABC announces Walt's new weekly television show: *Disneyland*; Leslie Nielsen starring in *The Swamp Fox*, 1959; Walt filming the introduction to his Sunday-night show; Bruce Bushman's design for the *Mickey Mouse Club* logo.

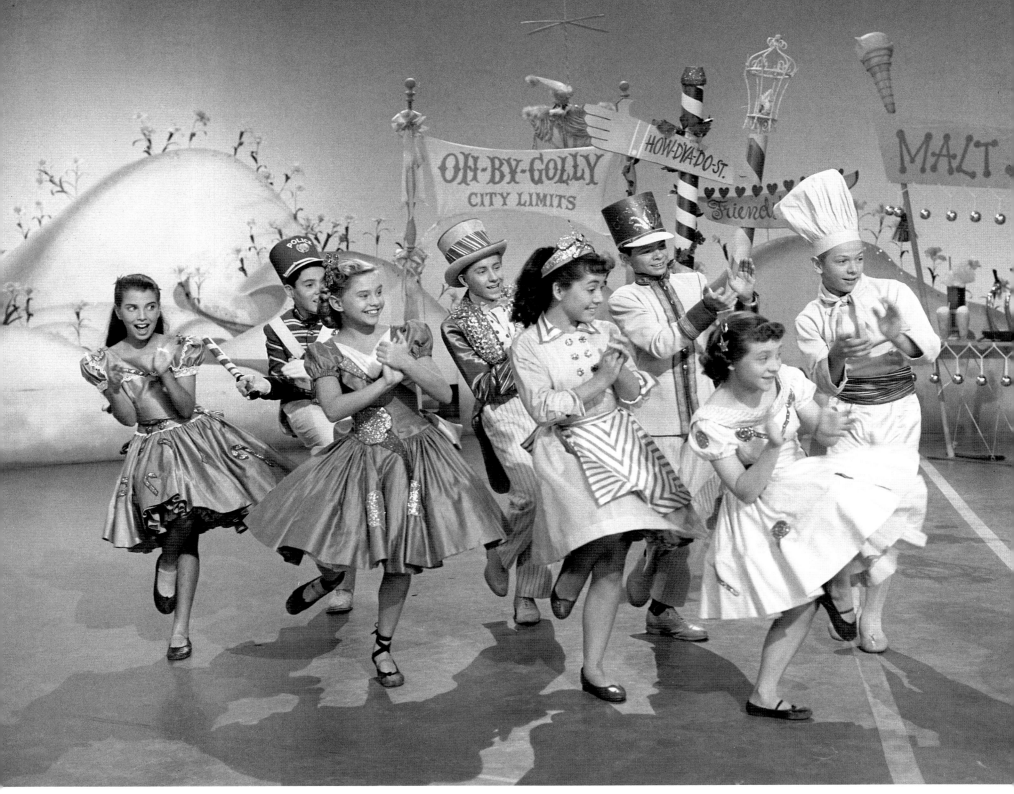

*Leave It to Beaver* star Pamela Baird dances with the Mouseketeers in *The Land of Me Oh My*, 1956.

nobleman, Don Diego de La Vega, who lived in Los Angeles when it was under Spanish rule. Part Robin Hood, part Lone Ranger, the show starring Guy Williams first aired in October of 1957 and was a huge hit, garnering as much as 40 percent of television viewers each week.

By far the most successful launch through the *Disneyland* show was the five-part serial *Davy Crockett*. No one could have imagined the phenomenon that was to come. Walt and producer Bill Walsh had developed the series based on nineteenth-century frontiersman and Tennessee congressman Davy Crockett, whose death in the Battle of the Alamo had made him an almost mythic American folk hero.

Actor James Arness (TV's *Gunsmoke*) was the first choice to play Crockett, but when Fess Parker came in to read for series writer Tom Blackburn, the actor got the nod from both Blackburn and Walsh. Dancer-actor Frank "Buddy" Ebsen was cast as Crockett's friend George Russell. During the first three months the show aired, Crockett merchandise flew off the shelves and was responsible for $100 million in retail sales. Compared to its competition—in this case Hopalong Cassidy with $1 million of products sold—Davy proved to be a massive success.

ABC was ecstatic with the show's popularity and it solidified their confidence in their investment in Walt. But no one was more surprised than Disney, Walsh, Blackburn, and Parker themselves.

Walt with his frequent costar Ludwig Von Drake in 1961, when his popular show moved to NBC as *The Wonderful World of Color*.

In hindsight, the quality of the show and the storytelling were the determining factor. Parker was not a star when he was cast, but *Davy Crockett* instilled in viewers patriotism and a love of American history; along with the Pledge of Allegiance, air-raid drills, and anticommunist sentiment, Crockett became the defining element in the popular culture of the times.

Parker recorded the theme song for *Davy Crockett* simply as a promotional song for the show. By February of 1955, the title song, by George Bruns and writer/lyricist Blackburn, had also been recorded by both Bill Hayes and Tennessee Ernie Ford. All three versions made the *Billboard* magazine charts in 1955. Hayes's version made it to number one on the weekly charts, and

both the Parker and Ford versions landed on the top twenty-five hit singles list of the year with more than ten million copies of various versions of the song sold.

The episodes were filmed in color and Walt capitalized on the phenomenon by editing the first three shows together and releasing them as a theatrical feature, *Davy Crockett: King of the Wild Frontier*. The feature film further fueled the success nationally and soon internationally. Coonskin hats and later Polly Crockett hats for girls were the must-have accessory for the boomer generation.

Parker was a tireless promoter and traveled to forty-two cities and thirteen foreign countries for the show. His original two-year deal was not with the studio but with Walt himself, and it didn't

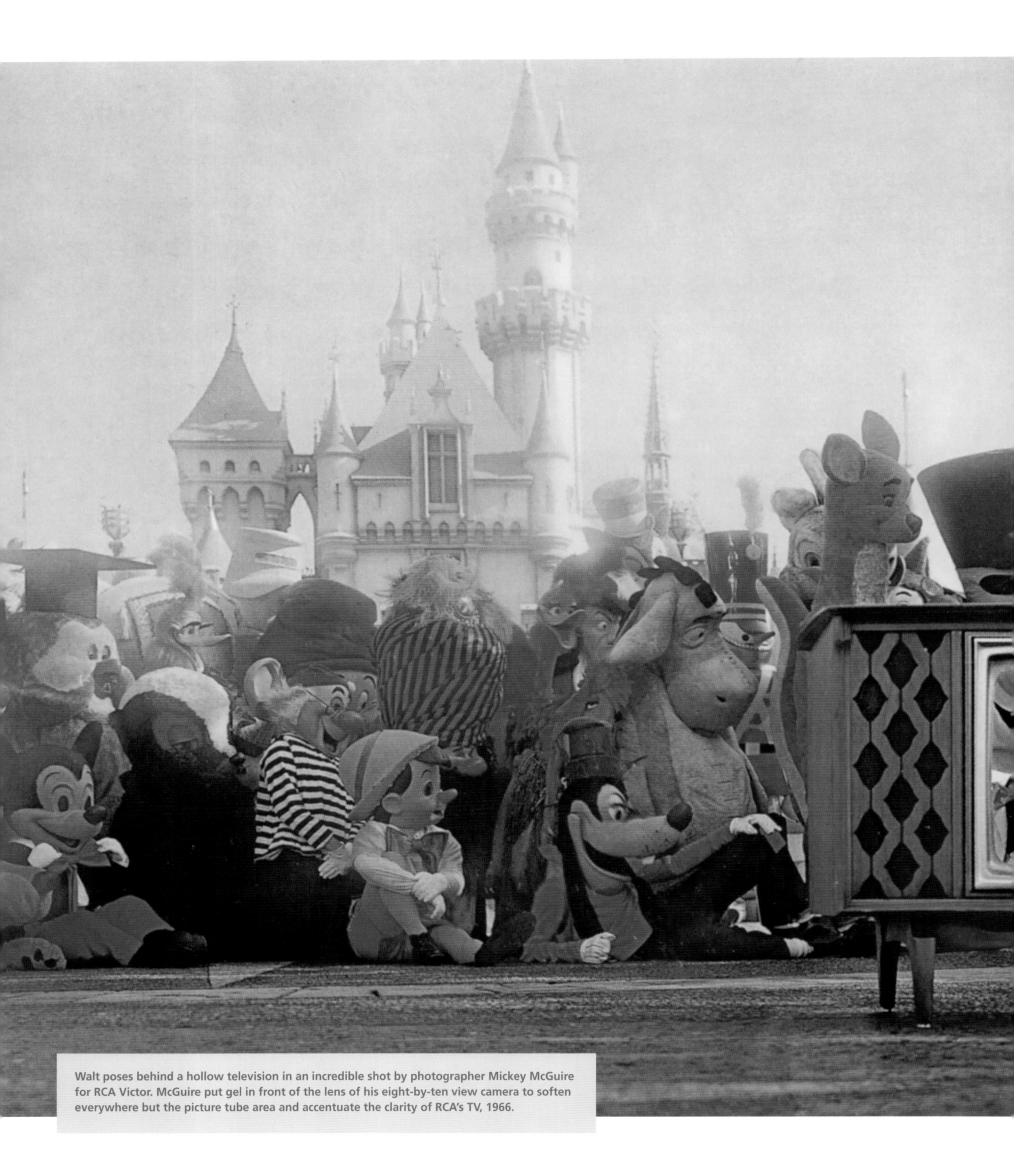

Walt poses behind a hollow television in an incredible shot by photographer Mickey McGuire for RCA Victor. McGuire put gel in front of the lens of his eight-by-ten view camera to soften everywhere but the picture tube area and accentuate the clarity of RCA's TV, 1966.

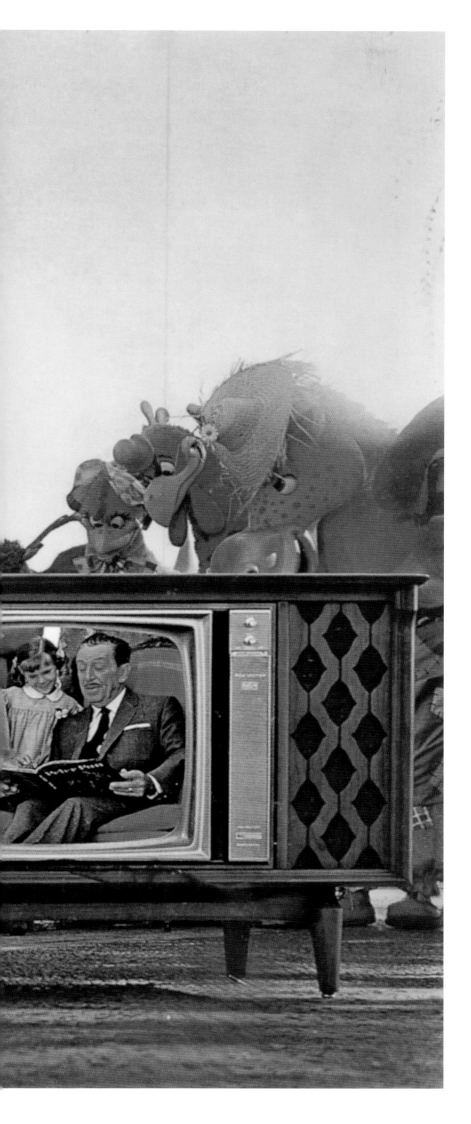

compensate him for the series' phenomenal success. In 1956, Parker hired as his agent producer Ray Stark, who renegotiated his contract into a new seven-year deal with Walt Disney Productions. Walt had no real experience with actors under contract, so Parker served as a utility player in Disney films like *The Great Locomotive Race*, *Westward Ho the Wagons!*, *Old Yeller*, and *The Light in the Forest*. Parker was loyal to Walt but felt no control over his own career, particularly when he was invited to act in the John Wayne film *The Searchers* only to have Walt refuse to loan him out. He was frustrated that he wasn't getting the parts he wanted and eventually left the studio and went to Paramount.

Parker said he held no long-term grudge toward Disney and later buried the hatchet with Walt and recalled his years at the studio were "like being in the sun. It was a warm place, and I felt very comfortable there."[27]

Long before the advent of television, there was a Mickey Mouse Fan Club. Started in January 1930, the club's aim was to keep kids coming to the theater to enjoy their favorite mouse. Within two years the club had a million members. By the 1950s those kids had all grown up and now were parents with kids of their own. The club was reborn as a variety show for children with a regular cast of talented young stars playing the Mouseketeers. Walt gave the show to producer Bill Walsh to create and develop the format, and Walsh hired actor-singer Jimmy Dodd as host and staff story artist Roy Williams as cohost.

The art direction and set design for the show was given to Bruce Bushman. Bushman was the son of silent-era actor Francis X. Bushman. He came to Disney in the early 1950s at the same time as Walt Peregoy and Eyvind Earle, the two artists who would later drive Disney toward modernism with *Sleeping Beauty* and *One Hundred and One Dalmatians*. Earle lived in the guesthouse behind Bushman's family home. Bushman painted backgrounds on animated features before he moved over to WED in 1953, where he substantively designed Fantasyland and elements of Tomorrowland.

Bushman's move back to the studio as the first art director of the *Mickey Mouse Club* would leave a big mark on American pop culture. He created the logo for the Mouseketeers costumes and the drawings that graced the stage curtains. He designed the sets, too, which had the same modern playfulness as his work in animation. Bushman's WED colleague Marvin Davis would later pick up the art direction duties on the serial show, but it was Bushman who set the look of it from the start. He finally left the studio in 1959 to art direct television shows like *Sea Hunt* and *Gentle*

*Ben* and to design at Hanna-Barbera Productions on their hit show *The Jetsons*.

*Mickey Mouse Club* ran for a full hour each weeknight, and after two years the length of the show was reduced to a half-hour format. After a fourth year of showing mostly reruns, Walt and Roy couldn't find sponsors to support what was considered educational programming for children.

ABC canceled the show and wouldn't let Disney air it in reruns on any other network. Disney filed suit and won, but still had to agree not to air it on a major television station.

With success came tension. Roy felt that the network was taking far too much of the profits and beginning to demand creative concessions from Walt on programming. The situation exploded when, after two years and seventy-eight episodes, the network canceled *Zorro* over a legal dispute that questioned Disney's ownership of the series, as well as the *Disneyland* show and the *Mickey Mouse Club*.

Roy filed suit against ABC in the summer of 1959 claiming anti-trust violation. His argument was that even though ABC had the right to cancel the shows, they had no right to claim ownership of the shows and prevent them from airing on other networks. Finally in 1961 the suit was settled out of court, and Disney moved its business to NBC. As part of the settlement, the Disney brothers acquired ABC's share in Disneyland for $7.5 million and merged Disneyland, Inc., into Walt Disney Productions.

"They had a third interest. They only had a half-million dollars invested in the park," said Walt Disney later. "But my brother figured, 'If we don't buy 'em out now, we're going to be payin' a lot more later.' And it was a smart move that he did it then."[28]

Disney had a friend at NBC. Robert Kintner had since moved to the ABC rival, where in 1957 he was named president. The network was pushing color television programs, because NBC's parent company, RCA, was trying to sell color television sets. The "peacock network" broadcast the first color program, the Rose Parade (from Pasadena), on New Year's Day 1954, when a color television set would have cost $1,295 (or $11,300 in 2016 dollars). Walt was already ahead of the trend and was shooting most of his early shows in color even under the ABC deal. On September 24, 1961, the long-running *Disneyland* show, now called *Walt Disney's Wonderful World of Color*, premiered on NBC with an all-new theme song by studio tunesmiths Richard and Robert Sherman. It was a ratings hit, and the Disney anthology program that started in 1954 has run in one form or another ever since.

*further adventures of SPIN and MARTY see page 18*

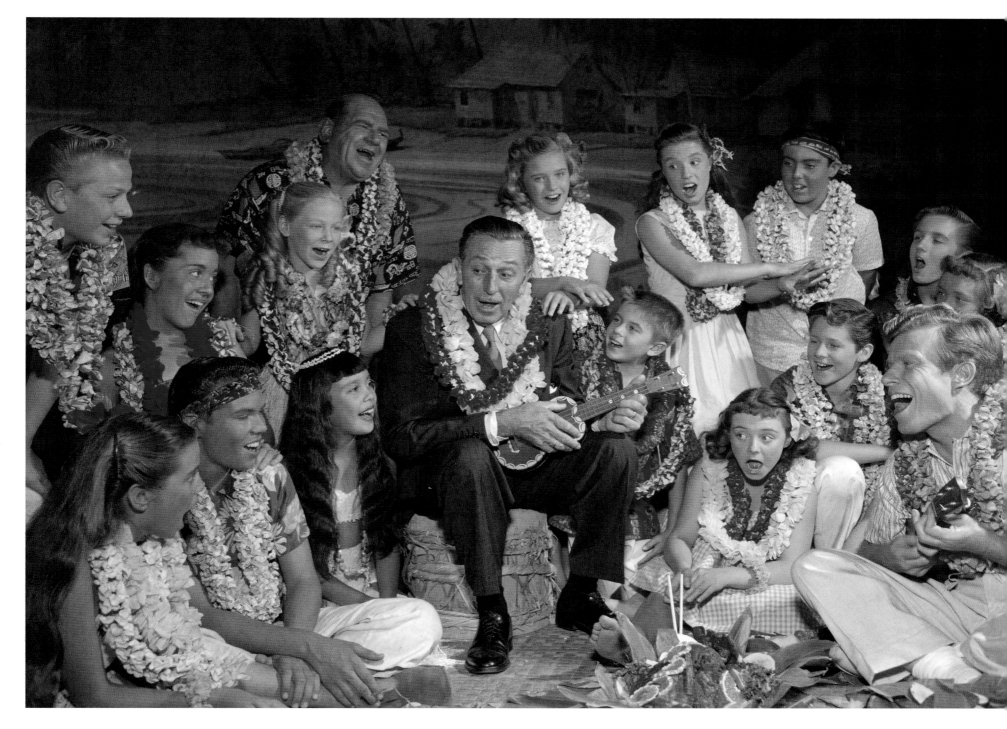

Opposite top: Mouseketeer Fans devoured the pages of *Walt Disney's Mickey Mouse Club Magazine*. This page: Walt shows up to film the "Holiday in Hawaii" segment for the *Mickey Mouse Club*, 1956. Opposite (bottom) and this page (above left): Bruce Bushman's design and finished set ready for filming. Above right: Bushman with his father, silent film actor Francis X. Bushman.

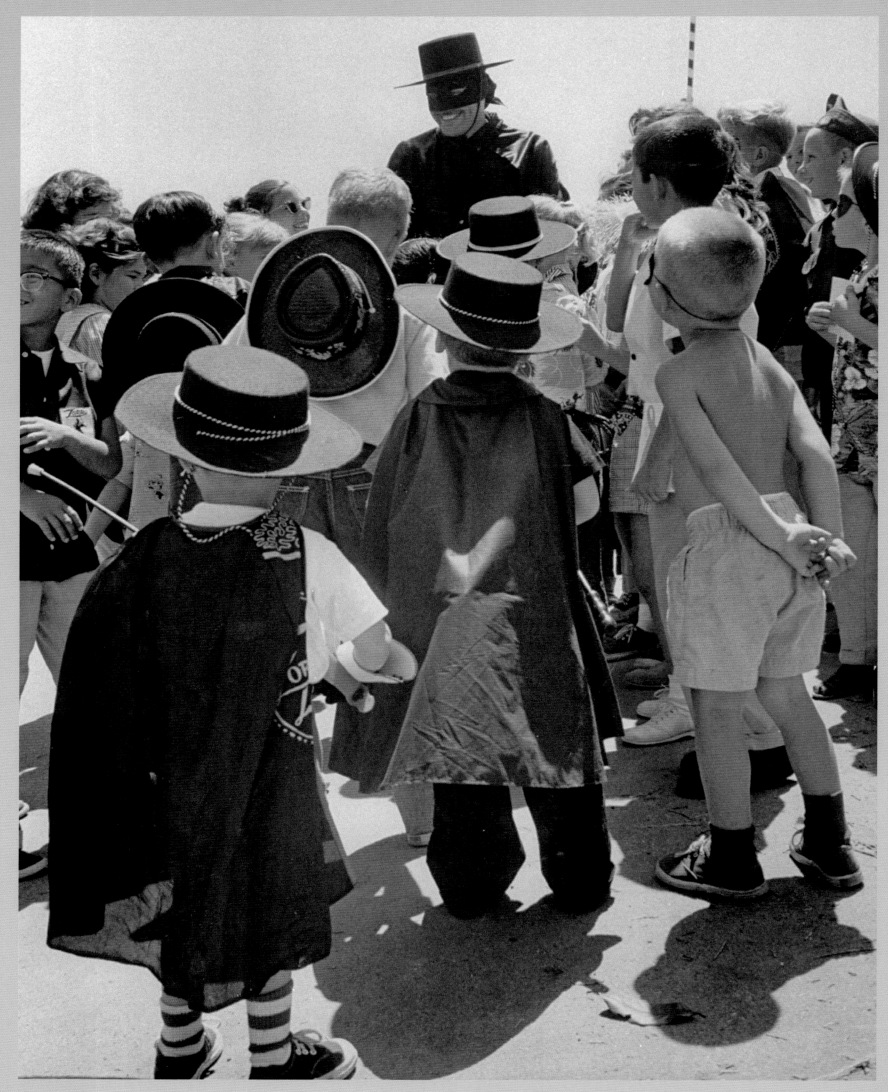

Guy Williams makes a surprise visit to Disneyland as Zorro, April 1958.

YESTERDAY'S TOMORROW: DISNEY'S MAGICAL MID-CENTURY

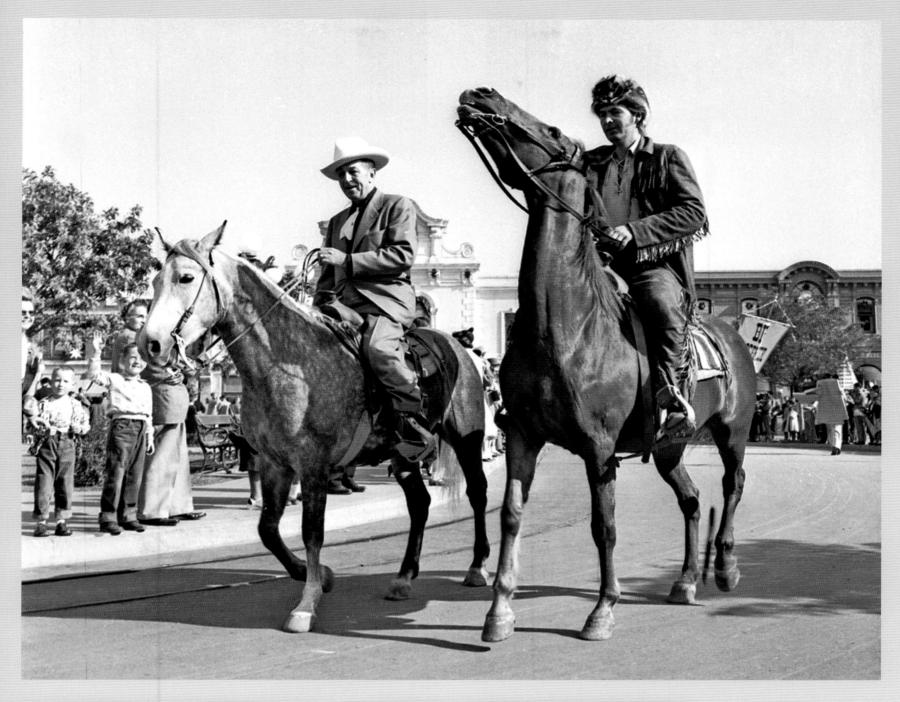

LOOK

New diet: Eat 6 times a day

The truth about Salk polio vaccine

15¢ JULY 26, 1955

Walt Disney, Davy Crockett and Disneyland

Walt and Fess Parker on Main Street, U.S.A. at Disneyland (top) and on the cover of the July 26, 1955, issue of *Look* magazine (bottom left). Bottom right: Walt and his grandson Christopher model their coonskin caps.

Simple Mickey Mouse designed for television ads by Tom Oreb.

# 11
# SELLING PEANUT BUTTER

**T**HE STUDIO TOOK on television advertising clients in the early 1950s as a way to raise money and keep their animators busy as the market for theatrical short films dried up. The work wasn't very demanding for animators who in the decades prior had worked on *Snow White, Pinocchio, Bambi*, and *Fantasia*. The film industry as a whole disdained the idea of doing work for television; the new medium was seen as a threat to the movie feature business.

Still it was a source of capital and diversification at a time when the studio was recovering from the impact of World War II. The commercials featured classic Disney characters in spots that were created primarily for the *Disneyland* television show. To the television audience, animated commercials were a novelty, and that translated into success.

How could you not love it when Brer Rabbit escapes Brer Bear in the comfort of "All Season" air-conditioning in American Motors' 1955 Rambler? Or when Tinker Bell rescues Captain Hook from his crocodile nemesis as a plug for Peter Pan Peanut Butter? Even Kathryn Beaumont as Alice convinced the audience that there is nothing like Jell-O.

The commercial work necessitated a simple but unique design that was inspired by the graphic style of a renegade animation studio, UPA. Tom Oreb, part of the *Sleeping Beauty* design team,

redesigned the Disney characters—even Mickey Mouse—so that they could be simply animated and feel appropriate for the small screen. Charles "Nick" Nichols, who had spent much of his time directing Pluto shorts, directed the spots using Oreb's designs and pulled in Cliff Edwards to do Jiminy Cricket's voice as pitchman for everything from Nash Rambler cars to Baker's Instant Chocolate Flavored Mix.

Disney artists also designed new characters that were directly inspired by products. "Fresh Up" Freddie was a self-assured rooster who always had plenty of 7-Up on

hand. In 1951 Walt signed a contract to produce eight animated commercials for Mohawk Carpets. Mohawk Tommy was an animated character carrying a tomahawk and sporting a Mohawk haircut to sell carpets with his demure Native American maiden friend, Minnehaha, and their squirrel sidekick, Chatter. Others would be added, including Bucky Beaver for Ipana toothpaste (voiced by the *Mickey Mouse Club*'s Jimmy Dodd) and the Trix Cereal Kids. All were Disney originals.

It may have seemed ridiculous that beloved characters like Geppetto and Pinocchio were pitching

Hudson Hornet cars, but as producer and Disney veteran Harry Tytle put it, "Commercial work answered our prayers, as it supplied badly needed capital. Advertising work clearly helped keep the studio intact. But while the studio made money with this type of product (and I mean big money), it was not a field either Walt or Roy were happy to be in." Paul Carlson, Nichols's assistant in the commercial unit, remembered that the unit did twenty-six commercials at $100,000 each, which was a huge financial windfall for the company.[29]

Inevitably, Walt and Roy realized that the commercials could devalue their feature characters. And since the original television commercial characters created by Disney for these sponsors were not owned by the studio, there was no residual value from the work in terms of long-range income potential.

Likely topping the list of negatives about commercial production was having to deal with the whims of clients, something Walt surely hated. By the late 1950s the animation department needed to focus on features, especially *Sleeping Beauty*, and with Disneyland providing a steady cash flow for the company, Walt decided to abandon the commercial business.

Clockwise (from top left): Television commercial designs for Welch's grape jelly, Trix cereal, Peter Pan peanut butter, Trix, Gold Seal, and Johnson's Wax. Center: An ad for Carnation.

# 12

# TUTTI HIRES THE SHERMANS

**I**N 1950, Roy asked Jimmy Johnson to head the studio's new music publishing division, as well as business affairs for the new Walt Disney Music Company. When the unit became profitable in 1954, Johnson started building toward a goal that would be a huge benefit to the company: he wanted Disney to have total ownership and control of its music and characters in publishing and music.

That same year, he and Bill Walsh brought in talent like Jimmy Dodd, who was initially hired as a songwriter and then host of the *Mickey Mouse Club*. Separately, *Davy Crockett* first aired on ABC around the same time, and "The Ballad of Davy Crockett" became a musical phenomenon. That single hit record, along with Johnson's desire to have the company control the studio's assets, emboldened Walt and Roy to enter the record business. In May of 1955, weekly music magazine *Billboard* reported that Disneyland would have its own retail record store on Main Street called the Wonderland Music Store. The article noted the store would carry current records as well as vintage 78s and possibly piano rolls.[30]

Charles Hansen was a New York music publisher who for years was the sole selling agent for Disney music. He and Johnson were looking for a producer who could run a new record label for Disney. Disneyland Records would of course release movie soundtrack albums, but he also wanted to produce new material for young Disney stars like Mouseketeer Annette Funicello. To achieve this, he hired Salvatore "Tutti" Camarata.

Clockwise (from top left): Salvatore "Tutti" Camarata records with Annette Funicello; Tutti, with Richard Sherman, Maurice Chevalier, and Hayley Mills, records for *In Search of the Castaways*; jazz greats Wayne King, Count Basie, Duke Ellington, and Bill Elliott perform at Disneyland's Big Band Festival, 1964; and Louis Armstrong and Fess Parker record with Tutti at Sunset Sound.

Tutti Camarata hosts the Sherman brothers, Annette Funicello, and the Beach Boys at Sunset Sound to record the theme song for *The Monkey's Uncle*. Clockwise (from top left): Brian Wilson, Tutti Camarata, Annette Funicello, Robert Sherman, Richard Sherman, Al Jardine, Mike Love, Dennis Wilson, and Carl Wilson. Right: Disneyland Records' incredible variety, from Dixieland to show tunes.

Camarata was a violinist and Juilliard alumnus who switched instruments in his teens to play the trumpet in big bands. It was Jimmy Dorsey who gave him the nickname Tutti. After a stint in the US Army Air Corps as a flight instructor, Tutti joined Decca Records, where he arranged and conducted for some of the biggest names of the time, including Bing Crosby, Ella Fitzgerald, Billie Holiday, and Louis Armstrong.

On Camarata's first visit to the Disney studio, Jimmy Johnson screened *Song of the South* for him. "He shocked the crew by 'watching' the film with his eyes closed. He wasn't really watching, he was listening," said Johnson. Camarata put together an LP of the *Song of the South* score and it became the first soundtrack in the Disneyland Record catalog.[31]

The new record label took off fast with hits by *Mickey Mouse Club* breakout star Annette Funicello, so Camarata hired a young songwriting team, brothers Richard and Robert Sherman, to write for her. It was the beginning of a historic collaboration between the brothers and Disney. Their first song for her was a top-ten hit, 1958's "Tall Paul." Walt had covertly been listening to their songs and asked the brothers to come to his office for a meeting. At that meeting he offered the Sherman brothers a life-changing job:

staff composers for the company. Their work for Disney became legendary, reaching new heights of worldwide renown with scores for films like *Mary Poppins* and tunes for attractions such as the Enchanted Tiki Room and "it's a small world."

Camarata also brought Sterling Holloway to Walt's attention and helped get Louis Prima and Phil Harris interested in voicing *The Jungle Book* characters King Louie and Baloo, respectively. With the sheer volume of records and licensed music growing, Tutti lobbied Walt and Roy to build a recording studio. But when they balked, he set up shop himself, buying a building on Sunset Boulevard in Hollywood and opening Sunset Sound. It was home to the most memorable recording sessions from then on for films like *One Hundred and One Dalmatians*, *Jungle Book*, and *Mary Poppins*.

The principal client for Sunset Sound was Disneyland Records, but Tutti opened the doors to others, and some of rock's biggest names, including the Rolling Stones, the Beach Boys, Prince, and Van Halen, became regular customers. More than fifty years later, Sunset Sound is still in business on Sunset Boulevard in Hollywood and home to bands and singers like Maroon 5, Rascal Flatts, Kelly Clarkson, and many more.

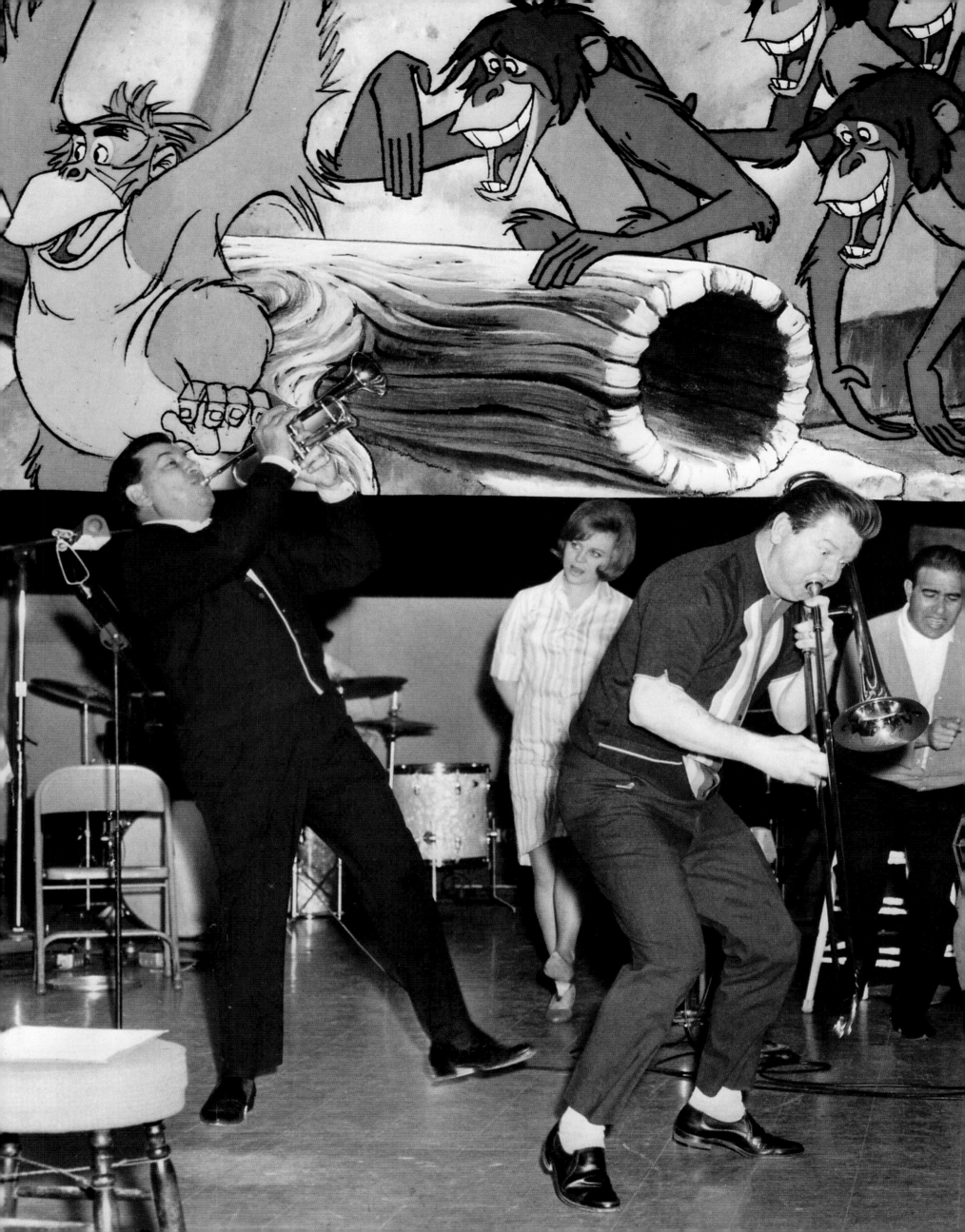

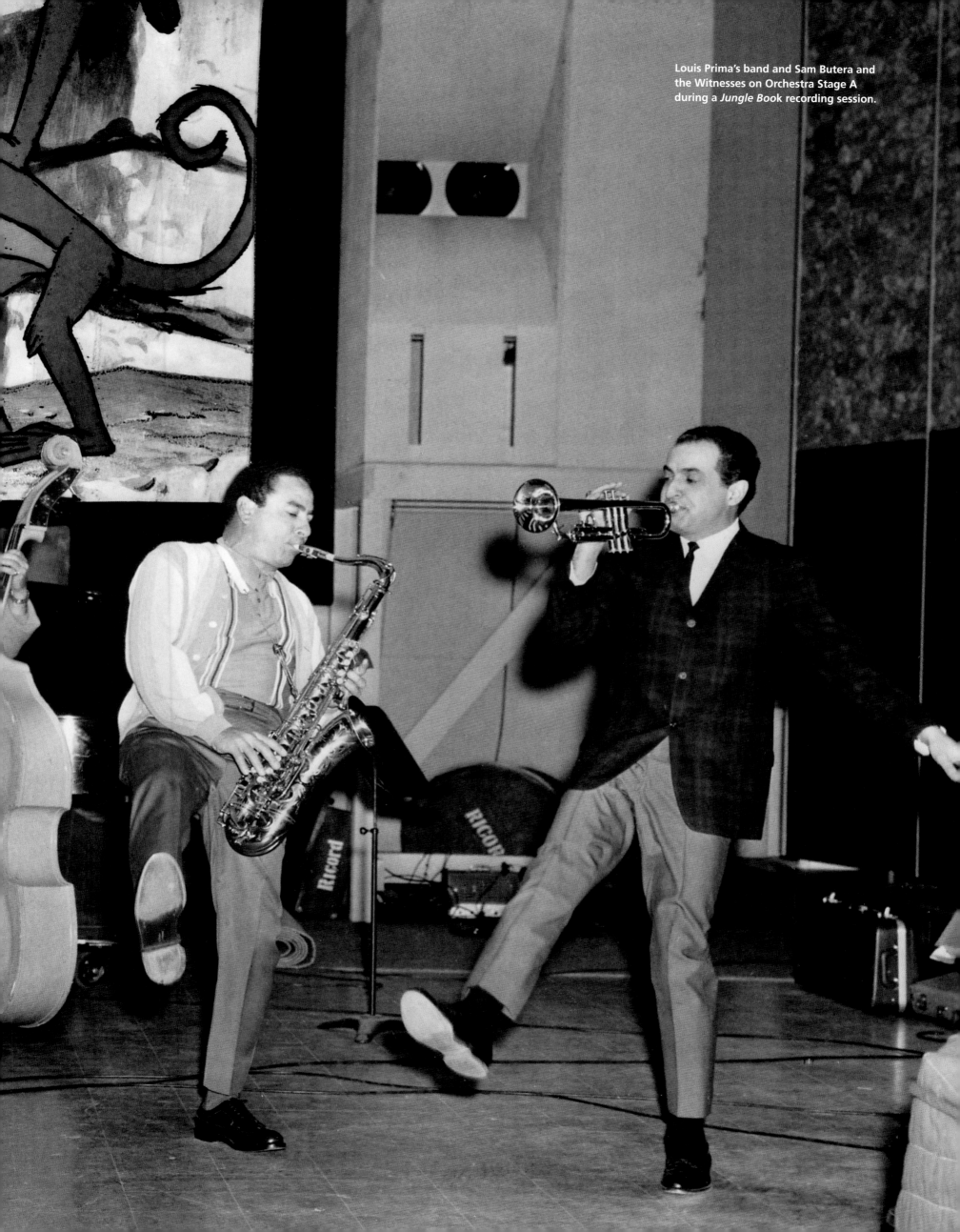

Louis Prima's band and Sam Butera and the Witnesses on Orchestra Stage A during a *Jungle Book* recording session.

# 13
# SPACE EXPLORATION

*A vista into a world of wondrous ideas, signifying man's achievements . . . a step into the future, with predictions of constructive things to come.*

—Walt Disney[28]

**A**S DISNEYLAND—both the park and the show—developed and grew, Walt had plenty of programming for Fantasyland, and with the *Davy Crockett* phenomenon, Frontierland was taken care of. True-Life Adventure films would supply Adventureland with stories for a long time. However, Tomorrowland was coming up short. It wasn't for lack of interest. The television audience was eager to consume an optimistic vision of the future, since now for the first time in decades a future with no wars or financial depression loomed (it appeared); the perception was there were no limits for Americans' tomorrow and the possibilities were endless.

Imagineer and Disney Legend Marty Sklar noted that Walt perceived a role for himself as the middleman between industry and the public to help communicate ideas for the future. He'd settle only for hiring the most accomplished authorities of the day to ensure that the portrayal of the future was plausible and not pure fiction.

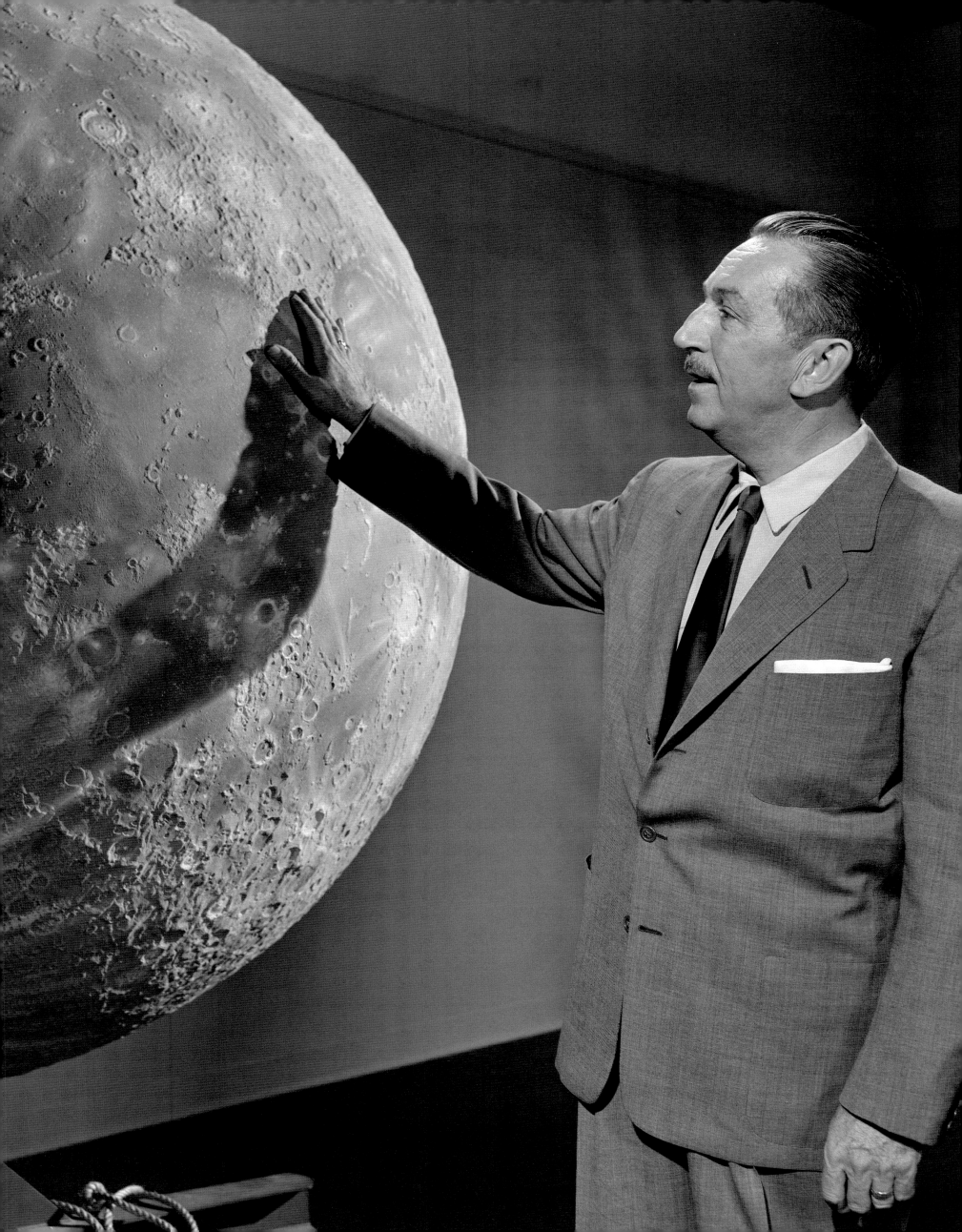

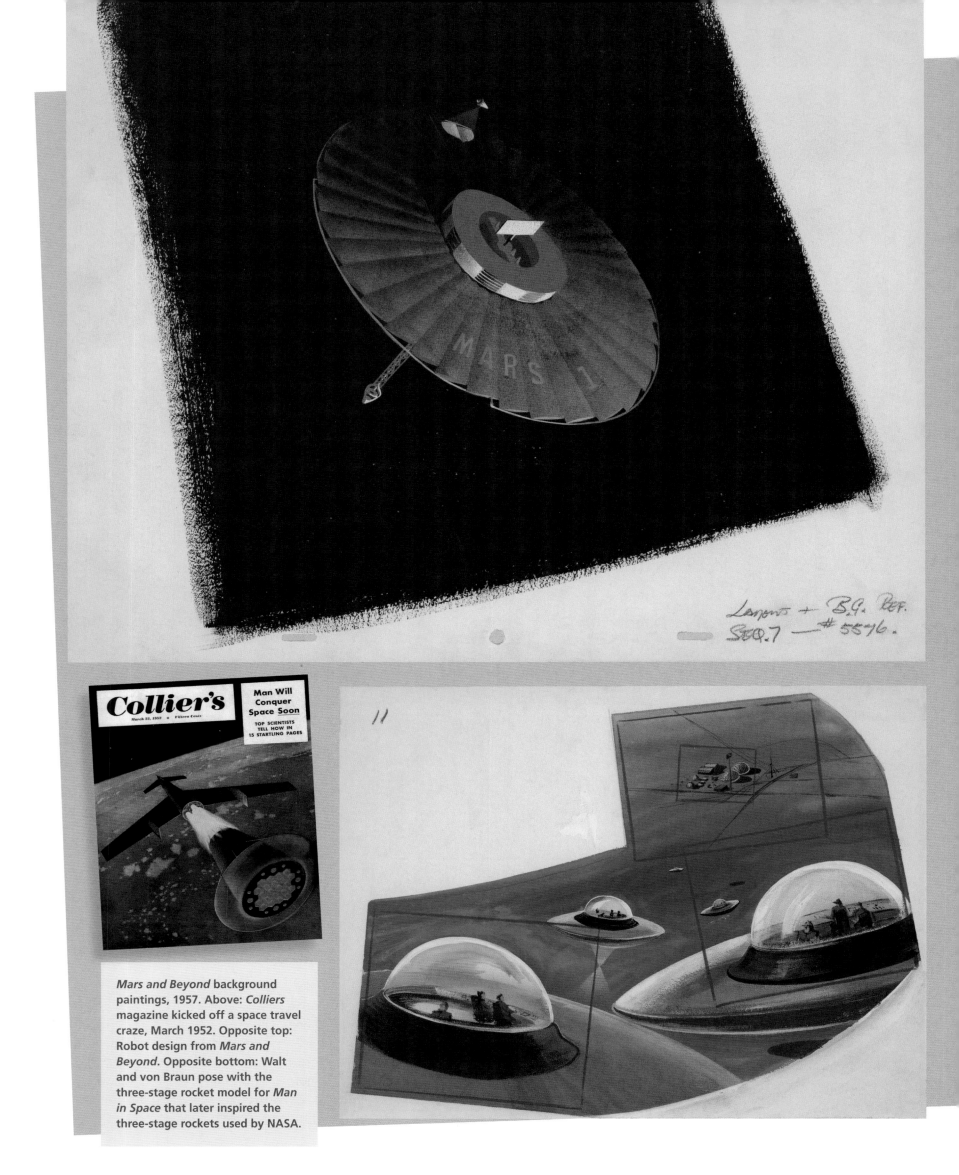

*Mars and Beyond* background paintings, 1957. Above: *Colliers* magazine kicked off a space travel craze, March 1952. Opposite top: Robot design from *Mars and Beyond*. Opposite bottom: Walt and von Braun pose with the three-stage rocket model for *Man in Space* that later inspired the three-stage rockets used by NASA.

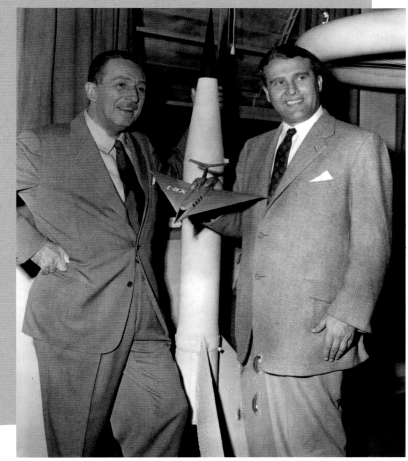

So for Tomorrowland, Walt turned to German scientist Wernher von Braun, who had helped design the V-2 rocket weapon for the German Wehrmacht during World War II. The Nazis' V-2 ravaged London and other Western European cities. At war's end, in an incredible chapter of history, von Braun and nearly a hundred German scientists surrendered to Allied forces and came to the United States to work for the army at Fort Bliss in Texas. The Central Intelligence Agency created new biographies for the scientists and expunged any affiliations with the Nazi Party from the public record. The scientists were given security clearance to work in the United States.

The American army had confiscated Nazi V-2 rocket hardware and blueprints and brought them back to the United States for the German scientists to use and continue their work—only now they were working for the US military, and eventually, unimaginably, they built NASA's space program.

Von Braun and his colleagues focused first on an army project called Redstone, which was developed to launch an Explorer satellite into orbit. But the government soon dropped funding for Redstone and chose instead to back a competing civilian endeavor called Project Vanguard. Vanguard was perceived as being more scientific than military in nature, and, because it put distance between von Braun and his Nazi past, it was less of a public relations risk.

*Collier's* magazine capitalized on the public's curiosity about space and exploration by inviting von Braun to publish an article on his vision for such endeavors. *Collier's* had a circulation of four million readers at the time, and von Braun was indisputably the world's leading rocket engineer. In *Collier's* he could finally distance himself from military work and talk to the general public about his visionary blueprint for realizing manned space travel.[32]

As popular as *Collier's* was, the fifteen million television sets in America provided a much bigger audience. As one writer put it, "Neither Walt Disney nor Dr. von Braun were ever backward in making maximum use of new media for advancing their ideas: Now was the age of television."[33] Ward Kimball, the animator/director who had won an Oscar for his short *Toot, Whistle, Plunk and Boom*, brought the *Collier's* article to Walt, suggesting that von Braun be contacted and consulted. Both Disney and von Braun leapt at the chance.[34]

Walt was happy to give Kimball full responsibility for developing material for the Tomorrowland segment of the *Disneyland* television show. Kimball's animation was stylized and fairly easy to animate for television, and he was a gifted storyteller able to

IN THE BEGINNING, MAN'S WORLD WAS HIS CAVE.

HIS ONLY CONCERN WAS FOR FOOD...

AND COMPANION-SHIP.

WITH THE SUN CAME THE DAY, BRINGING WARMTH AND LIGHT.

WITH THE STARS CAME THE NIGHT, BRINGING DARK-NESS AND FEAR.

ROAR!

LATER WHEN MAN BECAME A SHEPHERD, HE SPENT MORE TIME CONTEMPLATING THE MYSTERY OF THE STARS

Storyboard series for *Mars and Beyond*.

put across complex and often scientific ideas about transportation and space travel in an entertaining way. For the first show, Kimball worked with layout man Ken O'Connor and story sketch artist Jacques Rupp, and together they filled a room with drawings, which they then pitched to Walt as a show that they called "The Story of Space."

"By the time I got through telling the boards, it was obvious to me, and of course obvious to all," said Kimball of the sheer volume of material he had. "Walt said, 'Hell, we've got three shows here. We've got three or four shows here. Why don't you just break it up?'"[35]

They split the content into three shows: space, the moon, and Mars. For scientific accuracy, Kimball brought in scientists Willy Ley and Heinz Haber, along with von Braun, to do on-camera explanations of sophisticated concepts. All three had reached such a level of celebrity in popular culture that they even hired Jules Stein and MCA as their agents.

Kimball's team also worked with Dr. Ernst Stuhlinger, a von Braun associate, to ensure that the models of the rockets were accurate and the technical details, which included in-orbit refueling and solutions to the problems of cooking and eating in weightlessness, were accurately portrayed. Von Braun was hooked. His role with

Illustrations from *Mars and Beyond*, and the Disneyland Moonliner sold in England as Wernher von Braun's Moonliner.

the army would take him frequently to the West Coast; each time he would detour to Burbank for lengthy visits with Kimball, Stuhlinger, and the team, and frequently worked well into the night. [48]

As the story went into production, Kimball hired Paul Frees to do the narration, because, in Kimball's words, "He came the closest of all our announcers to sounding like the famous Orson Welles broadcast of the Martians landing."[36]

The first show, "Man in Space," aired on ABC on March 9, 1955, and Walt himself introduced it, saying that in this series he would use "the tools of our trade with the knowledge of the scientists to give a factual picture of the latest plans for man's newest adven-

ture." Walt later dubbed the show as "science factual."

For *Man and the Moon*, Walt continued to give Kimball tremendous leeway to produce the shows, even using him on camera as host and narrator. Willy Ley made an appearance as well to show an actual Nazi-designed V-2 rocket engine, speaking with an authoritative German accent. He gave a detailed description of the workings of the V-2 with a level of detail that today would be reserved for a doctoral thesis on physics.

Von Braun shared his visionary design for a multistage launch vehicle that would carry up to ten astronauts plus equipment into orbit. Kimball's animation illustrated how the four-stage rocket

Final frames from *Mars and Beyond*, 1957.

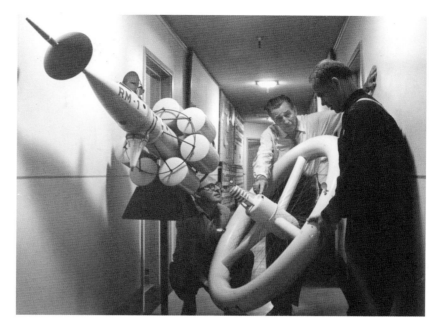

**Walt and Ward Kimball check out a model spacecraft featured in** *Man in Space.*

would be assembled in a vertical assembly building, then trucked to the launch site—all an amazingly accurate prediction of exactly what would happen a decade later as NASA's multistage Saturn V rocket launches became seemingly commonplace. The program's climactic scene showed the spacecraft returning to earth and making a runway landing that predicts the space shuttle program and the idea of reusable spacecraft—twenty-five years beforehand.

Von Braun's on-camera manner was clear but not academic. He was handsome but not an actor, and when he spoke, his German accent seemed to validate every word he said. "If we were to start today on an organized, well-supported space program, I believe a practical passenger rocket could be built and tested within ten years," he said.

Heinz Haber spoke as well, lending an authoritative voice to his specialty, space medicine. Haber had been a reconnaissance pilot for the Luftwaffe during the war, and immigrated to the United States to become part of the US Air Force School of Aviation Medicine. In this new era, he became Disney's chief scientific consultant.

It's no exaggeration to say that *Man in Space* is one of the most important television productions in the Disney canon. It predates by nearly six years President John Kennedy's call to put man on the moon, and aired fourteen years before Apollo 11 actually landed on the moon. Disney, Kimball, and von Braun provided an accurate visualization of the possibilities of space travel to the television audience, which simply marveled at the vision.

Mid-century America had an almost insatiable appetite for space-related science fiction. "After V-2s and atomic bombs, any fantasy seemed credible," said space historian Walter A. McDougall.

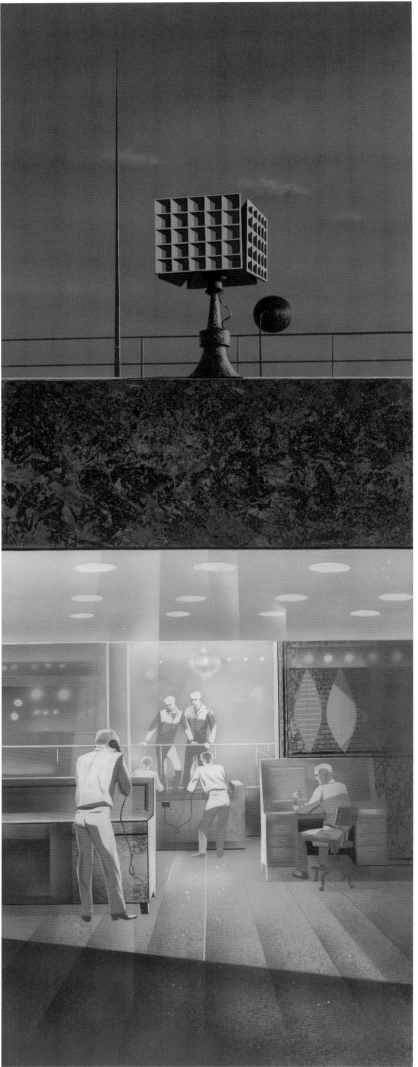

Top and right: *Man in Space*.
Above: *Man and the Moon*.

"It was in a way a cultural anticipation for the advances of science that the space age would bring."[37]

Kimball and his team began work on *Mars and Beyond* in 1954, hoping to air the show on the *Disneyland* show in 1956. But that got put on hold when the National Academy of Sciences and IBM came to Disney to commission a film about Project Vanguard.

With "Mars and Beyond" temporarily shelved, Kimball and crew began in earnest on the Project Vanguard story. But then on October 4, 1957, Russia launched the first satellite, Sputnik I, into orbit, and a month later, Sputnik II followed with a dog on board as a passenger. When Sputnik III was launched, it sent Cold War shivers down the spine of America. The space race was on and America was not even in the starting blocks. The government abandoned interest in Vanguard because it wouldn't be ready in time to launch a response to the Russian's accelerated and up to this point quite successful space program. Von Braun's original Redstone program was back on track, and he was happy to step forward to boldly announce that the United States would have a satellite in orbit by early 1958—only a few months away.

Meanwhile, Kimball jumped back onto "Mars and Beyond," which was in fair production shape already (from before the first Sputnik launch). Von Braun had spent extensive time with Kimball and had filmed the live-action elements for the show, which put "Mars and Beyond" back on the fast track.

The show aired on December 4, 1957, and was the last in the series that Kimball directed for the Tomorrowland segment of *Disneyland.* In it Walt Disney talks about mankind's fascination with space and Mars and the possibility of going there one day. Walt's guest star is Garco, a celebrity robot of the era. Garco was built in 1953 by Harvey Chapman as a garage project and a break from his work as an engineer at Garrett Supply in Los Angeles (hence the logo on Garco's chest). Garco's brain was made of six aircraft servos and three hundred feet of wire.

To animate the robot, Chapman used a five-jointed electro-mechanical control arm, which had a handgrip at the end. As Chapman moved his arm, the control unit in Garco's arm moved exactly the same way. It was the forerunner to a harness that Wathel Rogers used for the Audio-Animatronics figures in General Electric's Disney-designed 1964–65 New York World's Fair attraction, the Carousel of Progress.

"Mars and Beyond" opened with Kimball launching into speculation of life on Mars that's tempered with on-camera commentary by scientist Dr. Ernst Stuhlinger, who talks about atomic-powered

Above: Walt and Garco the celebrity robot introduce *Mars and Beyond*.
Left: Martian designs from the same show, 1957.

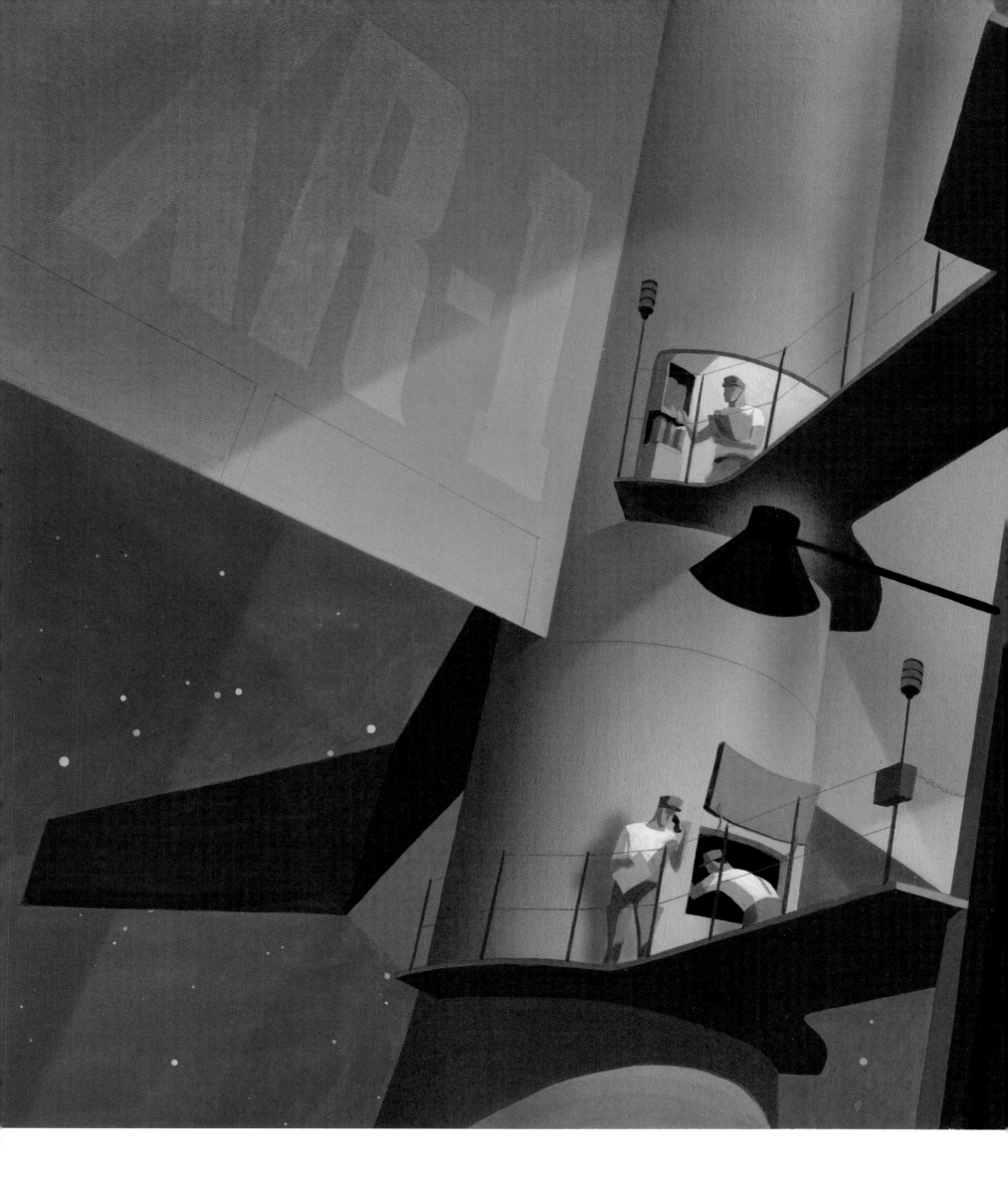

spaceflight vehicles that will be launched into orbit by von Braun's four-stage rocket. Von Braun appears on camera to show how the atomic-powered spacecraft would be used to travel to Mars using steam to drive a generator for power.

The narration is detailed as it describes a platinum grid that is electrically charged. Vaporized cesium atoms are blown through the white-hot grid, ionizing the atoms, which are then blasted into space, creating thrust. The science is laid out in detail and not watered down for general consumption. It assumes the intelligence of the audience and their willingness to embrace or at least understand this technology.

The Mars landing ship is shown slowing down via a drag chute before it touches down for exploration. The tail section is left behind and the top portion is used as a spacecraft in a design that we now would recognize as the lunar module.

Kimball wanted to take advantage of the UFO craze Americans were focusing on, so the show opened with flying saucers. But NASA technical consultants Willy Ley and Heinz Haber were adamant that they not even mention UFOs. There was no cover-up conspiracy, but Ley and Haber rightfully worried that UFO talk would distract from and discredit the real science being presented in the show.

Left: *Man in Space* production art. Above: Books and magazines supplied a curious audience with in-depth information on the Tomorrowland shows.

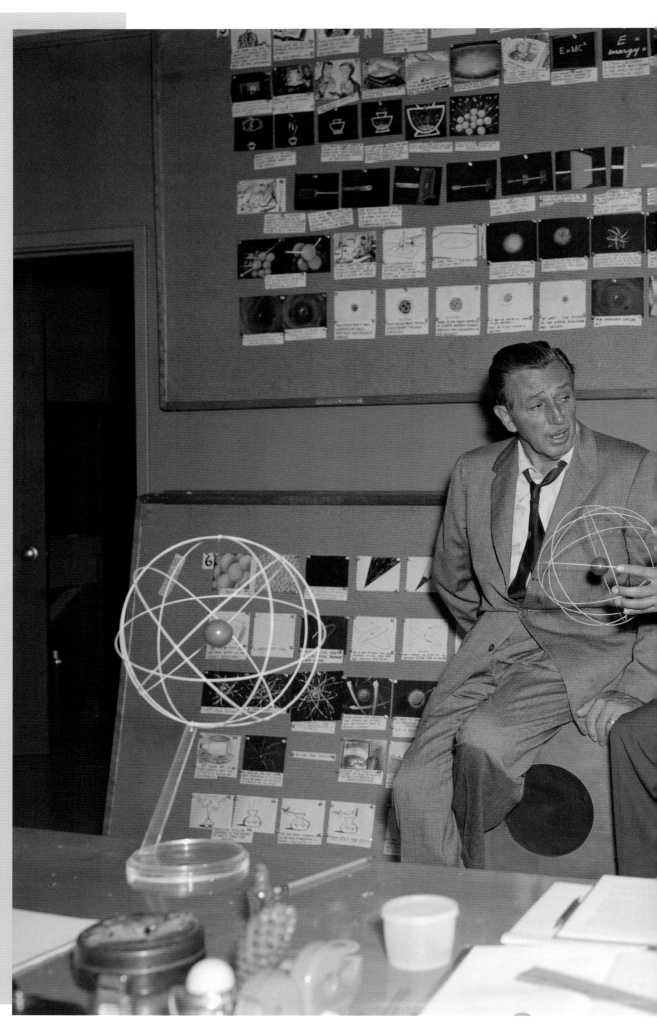

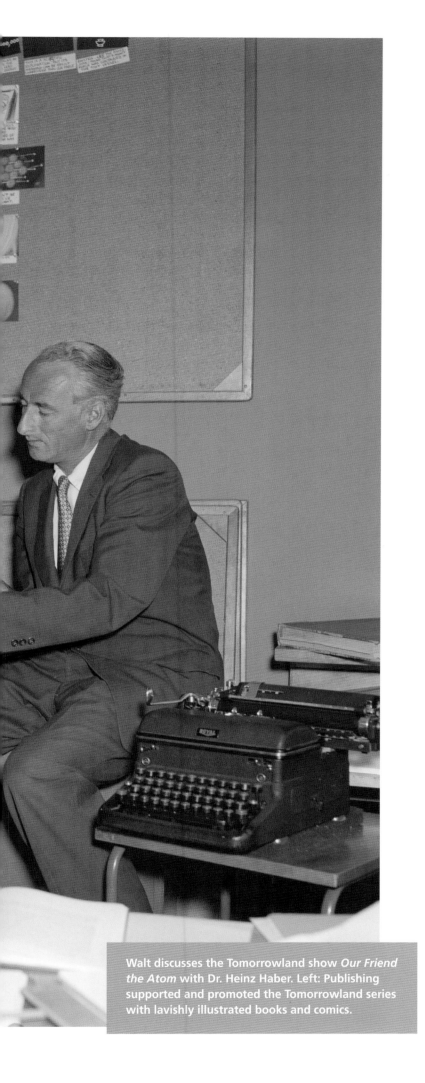

14

# ATOMIC FUSION AND YOU

**W**ALT TACKLED atomic fusion with "Our Friend the Atom," another episode for the science-factual series. Dr. Heinz Haber, a veteran of the Ward Kimball space shows, returned to the screen to compare the story of the atom to the fairy tale of the Arabian Nights about a fisherman who snares a magic lamp in his net and uncorks a powerful genie.

Haber exhibited the building blocks of atomic structures in magnified snowflake crystals, which Disneyland fans will recognize as the device later used in Monsanto's Adventure Thru Inner Space attraction. Then, in a surprisingly effective visual demonstration, Haber employed mousetraps and Ping-Pong balls to show the power of chain reaction. In one scene, he throws one Ping-Pong ball to trigger hundreds of traps and describes how an atomic chain reaction works in the same way.

Always promoting, the show ended with a non sequitur ad for Walt Disney's new feature *Westward Ho the Wagons!*, "a new and different outdoor drama, telling the exciting stories of the covered wagon families fighting their way west."

Forty-two million people saw the first show in the science-factual series. Kimball felt the gravitas of his work when, four months after the first episode aired, President Dwight Eisenhower announced that the United States would launch into space a small unmanned satellite. The morning after *Man in Space* aired,

Eisenhower called Disney to request that the show be shown to Pentagon personnel. Leonid Sedov, the head of the Russian space delegation, even wrote a letter in 1955 asking for a copy of *Man in Space* to show to his space team.[38] The American Rocket Society held its largest convention ever that year in Los Angeles, and Walt, ever the marketer, invited the six hundred delegates to visit Disneyland and screen *Man in Space*.[39]

Walt discussed a fourth space show with Kimball based on UFOs, and initially Disney was game as long as Kimball could find convincing footage. But the air force controlled all the official footage of "alien objects" and had no desire to share such information with the studio. A fourth show in the series would never happen.

Ten years after *Man in Space* first aired, von Braun wrote his friend and collaborator Disney artist Bill Bosche and invited him to bring Walt to tour the Marshall Space Flight Center in Huntsville, Alabama. "I thought you might like to have an opportunity to see just how prophetic [you were]," said von Braun.[40] So in April of 1965 Walt, Roy, Bosche, John Hench, and several of the original Disney production team visited the three chief space centers in Houston, at Cape Kennedy, and in Huntsville. Walt, at age sixty-three, "flew" a Gemini simulator to a successful docking and then piloted a LEM (Lunar Excursion Module) to a moon landing. Von Braun would later write that Walt's visit "may easily result in a Disney picture about manned spaceflight."[41] Walt, in an interview with the *Huntsville Times*, said, "If I can help through my TV shows . . . to wake people up to the fact we've got to keep exploring, I'll do it."[42]

In the same interview, Roy Disney was particularly effusive: "I was completely thrilled with what we saw. Anyone would be thrilled if he could see the fantastic effort and organization that must go behind spaceflight. . . . The whole thing lies almost beyond the comprehension of the nonscientific mind."

Ultimately nothing happened and Disney's interests in developing Epcot, California's Mineral King resort, and a full plate of his own projects would drown out the siren call of space exploration.

As a coda to the collaboration between Disney and von Braun, when the toy model of Disneyland's TWA Moonliner was released in America, it was branded as *Walt Disney's Moonliner*. But when it appeared for sale in the United Kingdom, the manufacturer Selcol dropped Walt Disney's name and called it *Dr. Wernher von Braun's Moonliner*—which was quite a transformation.

Illustrations from the 165-page tome *Our Friend the Atom*, extolling the promise of atomic power as a positive rather than destructive force, 1956.

ΔΕΜΟΚΡΙΤΟΣ

ΑΤΟΜΑ

# 15
# MAGIC HIGHWAY

O N JUNE 29, 1956, then president Dwight D. Eisenhower ("Ike") signed into law the Federal-Aid Highway Act, which would authorize $25 billion for the construction of forty-one thousand miles of interstate highway across the country. As Supreme Allied Commander in Europe during World War II, Ike saw how Germany's autobahn network of four-lane superhighways gave swift mobility to the Nazi military and later helped General Eisenhower himself move troops and supplies quickly into and through the country to win the European portion of the war.

The highways in America were a far cry from the autobahn. The only major cross-country highway was the Lincoln Highway. Early in his career, Eisenhower had taken a disastrous cross-country convoy on the two-lane highway, which was not even paved much of the way. "The old convoy had started me thinking about good, two-lane highways, but Germany had made me see the wisdom of broader ribbons across the land," he said in his memoir, *At Ease*. [43]

The interstate system would be funded with new taxes on fuel, automobiles, trucks, and tires, so the Eisenhower administration really needed to sell the benefits of the system to the American public. Although the government didn't commission a show from Disney, as it had during the war, Walt saw the vast new project as an opportunity to entertain with his vision of the future.

On May 14, 1958, Walt Disney hosted an episode of *Disneyland*

called *Magic Highway, U.S.A.,* depicting ribbons of highway linking commercial centers built by automated highway builders that transformed raw land into a wide, finished roadway in one sweep. Directed by Ward Kimball, the show was the perfect infomercial for the Interstate Highway System, touting the power of the automobile and the independence it could bring. Kimball's prediction of the future is remarkably accurate, predicting conveniences like GPS tracking, hands-off steering, and videoconferencing.

This boundlessly optimistic and even comforting view of the future is almost comical sixty years later and is emblematic of a kind of social democratic futurism that dominated the world from the postwar era until the late 1960s. But the television critic for New Mexico's *Albuquerque Tribune* wasn't a fan of the *Disneyland* program's *Magic Highway, U.S.A.* The review on May 14, 1958, proclaimed that "the future for drivers is hideous if Disney artists have their way."

**Below: Walt shares the *Magic Highway U.S.A.* story in an episode of the *Disneyland* show. Opposite: Preproduction designs, and a final frame from the same show.**

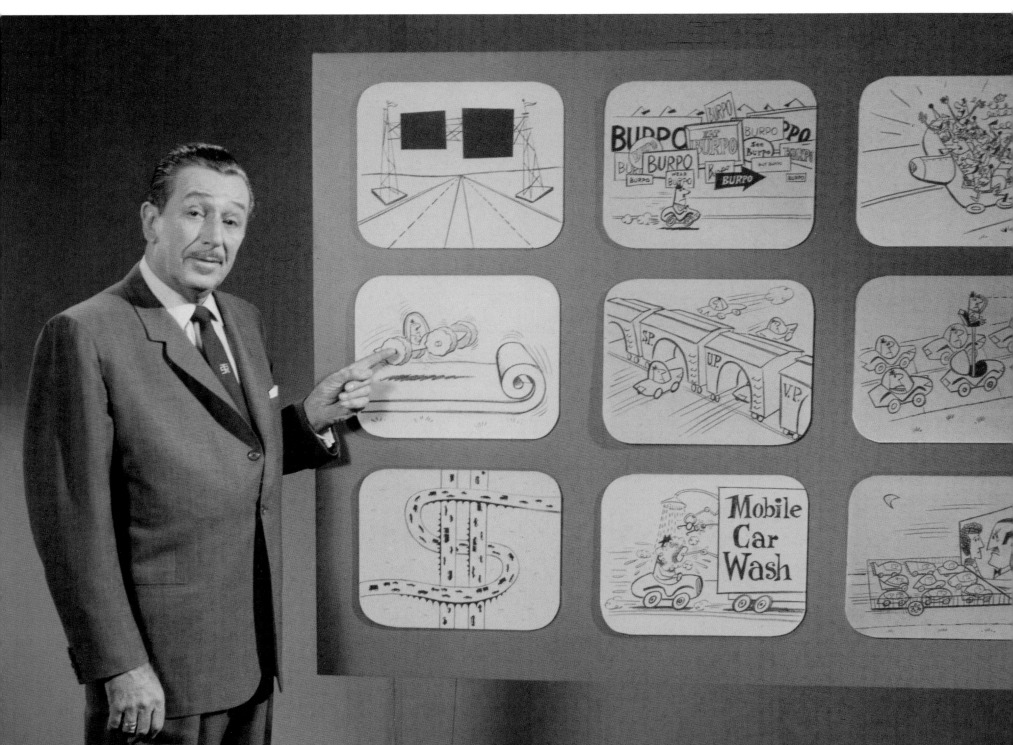

YESTERDAY'S TOMORROW: DISNEY'S MAGICAL MID-CENTURY

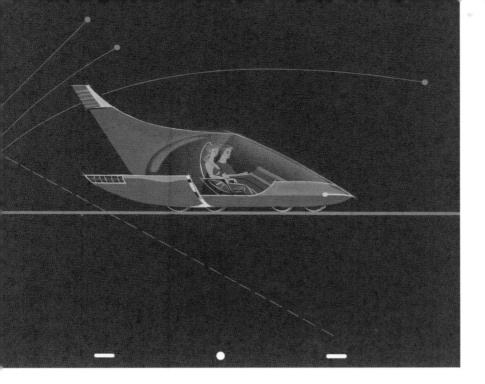

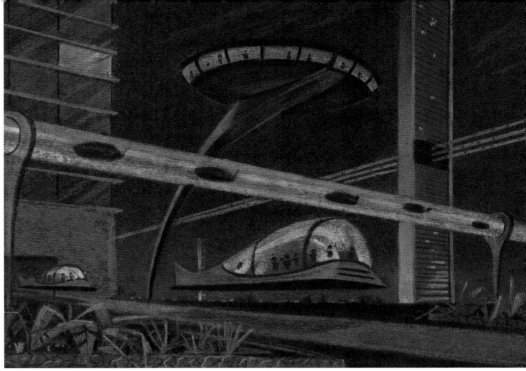

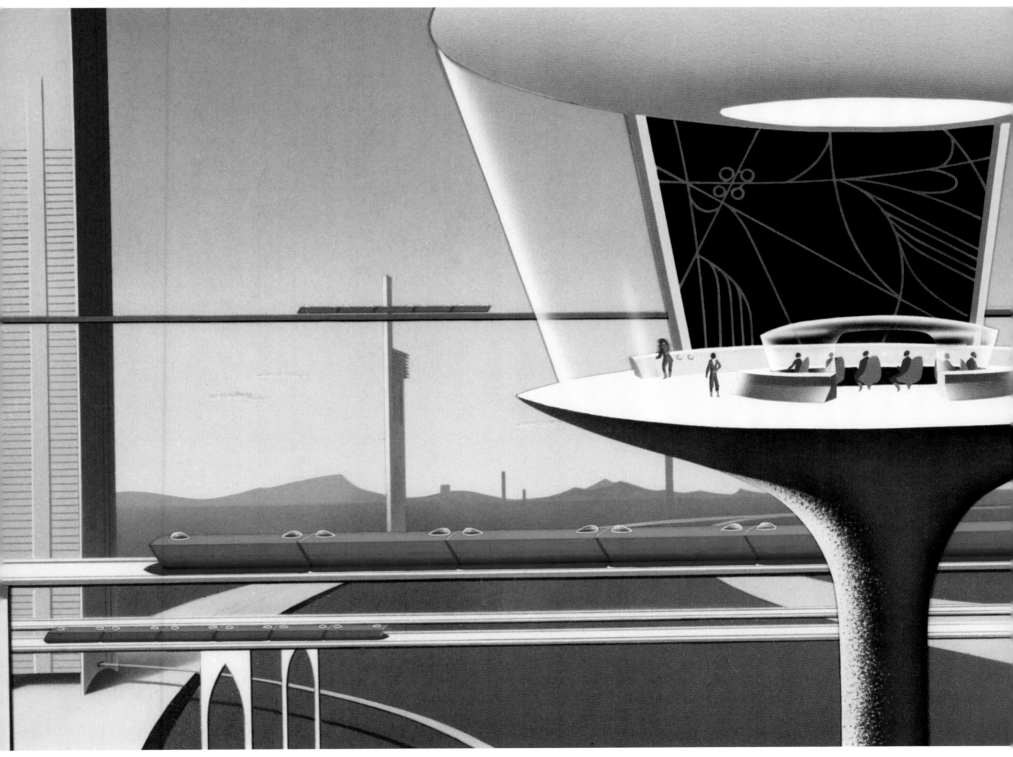

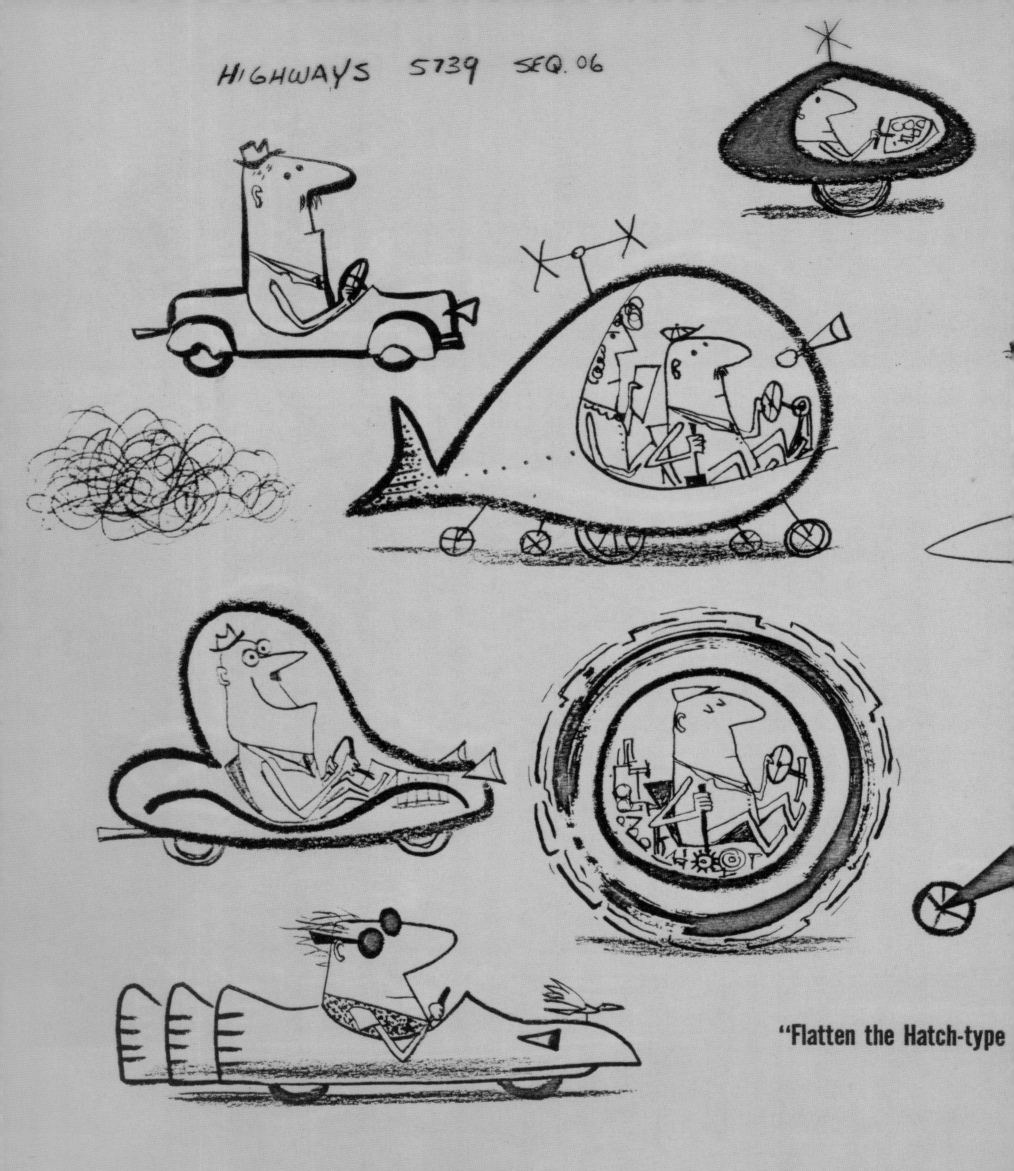

HIGHWAYS 5739 SEQ. 06

"Flatten the Hatch-type

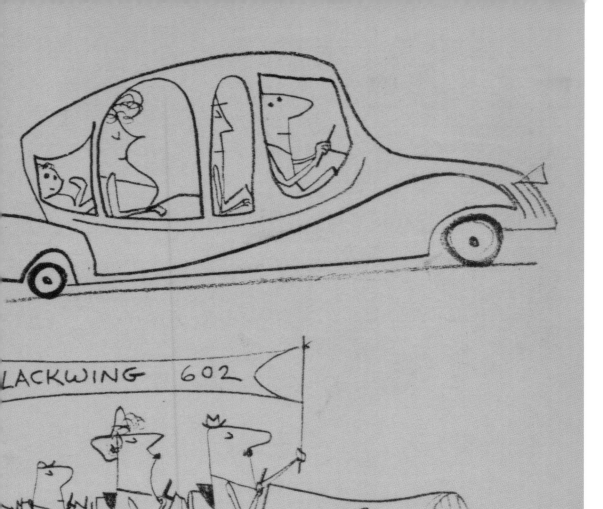

LACKWING 602

and Stiffen the Drip Line"

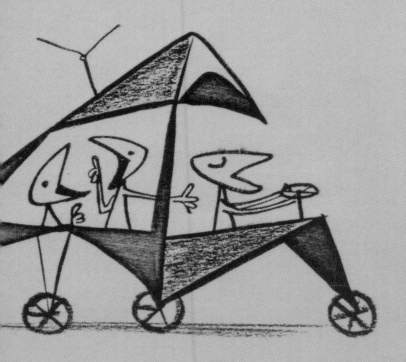

Left: Fanciful vehicle designs for *Magic Highway U.S.A.*, 1958. Above: Storyboards for *The Story of Anyburg U.S.A.*, 1957.

# 16
# CALARTS

**I**N THE 1930S Walt knew that the theatrical-shorts business was limited, and he saw animated features as a natural expansion of his animation expertise. But the skill level of his artists was limited to simple cartoon drawing and had to be elevated if they were to make feature films a new business of the highest quality. The key to elevating the success of his artists and art form was a woman named Nelbert Chouinard. Chouinard was herself an artist and graduate of the Otis Art Institute, who in 1921 founded her own school, the Chouinard Art Institute which soon was deemed one of the most respected art schools in America. For years she had offered classes to Walt's artists, sometimes for free if they couldn't pay; the artistic elite of Disney Studio—Marc Davis, Joe Grant, Mary Blair—all went there.

By 1950, however, Chouinard was in deep financial trouble, having been swindled out of tens of thousands of dollars by her accountant. Disney, out of his longstanding loyalty to the institute, started helping Chouinard navigate through their financial crisis in 1956, even sending studio moneymen Royal Clark and Chuck Romero to thoroughly check her books and financial records.

By 1957, the studio was subsidizing the school to keep it alive and virtually controlling the management of the institution for the aging Chouinard. At the same time, the Los Angeles Conservatory of Music (founded in 1883)—an acclaimed academy of music

### An Environment of Excellence

"I am not willing that this discussion should close without mention of the value of a true teacher. Give me a log . . . with Mark Hopkins on one end and me on the other, and you may have all the buildings, apparatus and libraries without him."
James Garfield,
address to Williams College Alumni,
New York, 1871

"Once upon a time education was the exposure of maturing minds to great minds. Today it is 18,000 students and 800 parking spaces."
Dorothy Parker

The definitions of education go on and on; each one as valid in its way as the multiform society they reflect. John Quincy Adams prophetically said that his generation must learn the arts of war and independence so that their children could learn engineering and architecture, so that their grandchildren might learn fine arts and painting and music.

More and more in recent years, the arts and the history of the arts have been accepted as corollaries to a liberal arts education. Nearly every university campus has its fine arts center, its visiting lecturer in the various arts. But the question remains: who will educate the student who has "professed"—the aspirant who has committed his life to the arts as a profession?

Cal Arts today is committed to answering that question by fulfilling the need

for a group of coordinated schools dedicated to cultivating the creative and performing arts.

**WAGNER'S DREAM**
The concept is not new, and has, in fact, appeared in various forms throughout history. In the mid-nineteenth century, for example, Richard Wagner felt that music, poetry, painting, sculpture and architecture had had their day as separate arts, and that the future belonged to art forms that united all these areas inseparably.

One of the most important aspects of the Cal Arts concept calls for a realization of the Wagner dream—a role based on three cardinal points:

First, awareness of the abstract "in-between" areas of the arts—those regions of overlapping creative expression which must be constantly experienced if they are to be understood and used.

Second, recognition that most of the world's great artistic talent was developed when gifted students received hand-tailored direction and personal inspiration from masters. At Cal Arts,

Music, Fine Arts, Fashion Design students will be joined by students of all the creative and performing arts in an environment of excellence.

where students and faculty will be in residence at the campus, with inter-related programs encompassing every art form, this master-student rapport will flourish.

**A CITY OF THE ARTS**
Finally, there is an increasing need for a facility or center which will allow professionals to devote their efforts to unique and experimental projects designed to advance the state of their art, with the opportunity of drawing upon student talent and capability. In such a situation, the students will benefit from the exposure to advanced thinking, and the professional from the fresh and enthusiastic approach of the students.

To bring these concepts to reality, Cal Arts is, in effect, creating a "City of the Arts," an environment which will so engrain the student with artistic and creative excellence that he will carry it with him beyond his student years, and beyond the campus into every area of future experience.

Far left (top and bottom): An idyllic view of "A City of the Arts," as presented in early CalArts recruiting brochures in staged photos shot at the Golden Oak Ranch. Above: *Winter Session '51–'52 Course Catalog* for the Chouinard Art Institute. Left: Art students at the Chouinard Art Institute (from left to right) Joe Goode, Jerry McMillan, Ed Ruscha, Pat Blackwell, 1959.

113

run by social doyenne Lulu von Hagen—was available for acquisition, so Walt took steps to combine both schools into one cross-disciplinary arts institute that would be what CalTech was to the science community. Incorporated in 1961, the combined schools would form the first college in the United States created exclusively for the visual and performing arts—the California Institute of the Arts—which became known to all as CalArts.

There were harsh protests from faculty and students, who saw a Disney-controlled art school as an abomination during an era of conceptual and nonrepresentational art. But Disney prevailed and the school planned on moving to Cahuenga Pass in Hollywood on a hilltop opposite the Hollywood Bowl venue. CalArts, the Hollywood Bowl, and a proposed Museum of Motion Picture History were meant to complement each other and be a center for music, art, dance, and film. The plan went public in an elaborate promotional film shown at the premiere of *Mary Poppins* to raise funds for the project.

The land in Hollywood, however, never materialized and instead the trustees broke ground in May of 1969 on a hilltop plot of land in Santa Clarita, California. When the school opened in 1971, its first president, Dr. Robert W. Corrigan, former dean of the School of Arts at New York University, fired most of the faculty and began reworking the combined schools into his and the boards' combined vision of a feeder school for the industry with the motto "no technique in advance of need." His colleague Herbert Blau, provost and dean of the dance school, brought in a strong faculty of established educators, but also counterculture and avant-garde voices from the art world.

Besieged initially by not only protest but also financial problems, the board of CalArts considered selling the school to the University of Southern California or the Pasadena Art Center, but soldiered on with no takers. In 1972 Walt's son-in-law William S. Lund took on the institute's presidency, fired 55 of the school's 325 faculty members, and introduced a structured schedule for classes and a balanced budget. His tenure was seen as either the salvation of the school or the end of an idealistic experiment, depending upon your point of view.

Ultimately the school from the 1970s on produced brilliant artists, such as director Tim Burton, actor Don Cheadle, Oscar-winning director Pete Docter, and others who would later lead a renaissance in the entertainment and animation industries and validate Walt's dream of higher education in the arts.

Clockwise (from top left): Music department professor Ravi Shankar in concert at CalArts; a student eating granola on display in the main lobby; a look at those at work in the electronic music lab; comedian Steve Allen delivering the school's commencement speech; and performing arts student David Hasselhoff partying in the main lobby, 1973.

# 17

# BOWLING IN THE ROCKIES

I N 1959 Disneyland was open and thriving (and the *Disney-land* television show was still on top of the ratings) when Walt and Roy Disney decided to capitalize on the biggest sports craze in America: bowling. They gathered a consortium of investors—Jack Benny, Bing Crosby, George Burns, Charles Laughton, Burl Ives, Art Linkletter, John Payne, Spike Jones, and radio stars Jim and Marian Jordan (*Fibber McGee and Molly*)—to invest a total of $6 million in a sports complex in the rapidly growing city of Denver called the Celebrity Lanes.

Diane Disney Miller said it was her dad's lawyer, Lloyd Wright Sr., who came up with the idea and assembled the investment group that included Walt and Roy. In May of 1959, the new company signed a lease for seven acres in Glendale, Colorado. Designing the center was the architectural firm Powers, Daly, and DeRosa of Long Beach, California, the darling of the bowling industry known for its extravagant and fanciful California-style bowling centers. Bowling was the firm's specialty. Plans also called for an Aqua Bowl Motel to be built across Colorado Boulevard from the complex.

So on December 14, 1959, Walt, along with Benny, Jones, and Wright, flew to Denver's Stapleton Airport, where they were escorted by motorcade to the site for the groundbreaking. Governor Steve McNichols joined the group, and each of them took shovels to the earth followed by lunch and a press conference at the Brown Palace Hotel.

Celebrity Sports Center

BOWLING 24 HRS
SWIMMING          BILLIARDS
COCKTAILS          DINING

BOWL HERE WHERE YOU SEE THE

AMF

"MAGIC          TRIANGLE"

Enterprise

PAINT

frontier

Artists
SUPPLIES

Picture
Framing

GUSHER
ARCOAL BROILED BURG

WALLPAPER

PAINT

Benny joked that Disney was "not going to miss an opportunity like this to turn a buck." Walt said the facility would fill a great recreational need for families, while acknowledging that the business did need to make a little money first. The celebrity investors hoped to attract national bowling and swimming events to the center and would incorporate facilities to broadcast such events on television.

Technology such as automatic pinsetters had helped spur bowling and turn it into the number-one pastime in America. The company that led the growth of the sport was American Machine and Foundry, or AMF. The firm had been through a number of businesses in the first part of the twentieth century, manufacturing cigarettes, sewing machines, and low-dose irradiation equipment for food. AMF even contracted with Iran, Israel, and Pakistan to build their first nuclear reactors in secret deals undisclosed to the United States government.

But when the plutonium-enrichment business became too messy, their entrepreneurial chief executive officer, Morehead Patterson, saw a demonstration of an automatic pinsetting machine and changed the course of the company. Six months after ground-

Top right: Annette Funicello poses with Dick Fletcher, manager of the Celebrity Sports Center, and the Walt Disney Trophy, 1962. Pro bowlers try out the thirty-six new lanes, serviced with $1.25 million worth in equipment, at the sports center. *Denver Post* paperboys take a plunge in the center's pool, 1961. Bottom: The mid-century building, designed by the architectural firm Powers, Daly, DeRoss of Long Beach, California, 1960. Walt tries out the lanes.

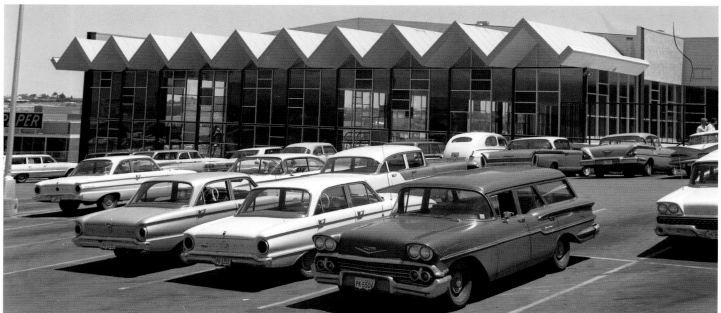

breaking, the first trucks pulled up to the site with the bowling equipment that would make the center "a bowling showplace," as the *Denver Post* said. General manager Richard Fletcher announced that night bowling leagues were 80 percent full.

The bowling equipment from AMF alone cost $1.23 million, the biggest single order for bowling equipment ever. *Life* magazine called bowling America's most popular sport, and by the mid-1950s there were twenty million regular bowlers in the United States.

Lloyd Wright told the *Post* that the complex would be the first of many such projects around the country, and Walt "hailed the

project as a 'new dimension to family participation in sports and recreation.'" It was an experiment in creating family entertainment centers away from Disneyland, indoors, in a cold-weather city. The center also promoted slot car tracks as long as 250 feet covering over thirteen thousand square feet of the basement. The Olympic-sized pool, Colorado's biggest, was so large that it hosted indoor catamaran races. Tom Murphy, the swimming coach at the University of Denver, signed on as the pool director for Celebrity, where kids could swim all day for one dollar. Mickey and Goofy would visit for photo opportunities, and baby boomer kids could enjoy

YESTERDAY'S TOMORROW: DISNEY'S MAGICAL MID-CENTURY

Left and above: Water-skiers and sailors navigate the 165-foot "bigger than Olympic"–sized swimming pool housed at the Celebrity Sports Center in Denver.

billiard rooms, bumper cars, a shooting gallery, and a German-themed "Hofbrau" room where visitors could down beer and brats between lines of bowling.

In September of 1962, Walt flew into Denver with Hayley Mills, Annette Funicello, Mickey Mouse, and Pluto to open the new Stouffer's restaurant at the center with Vernon Stouffer. They held a press conference and reception at the governor's mansion, then dedicated the restaurant at the Celebrity Lanes. But behind the scenes the management was in chaos and the vice president of operations resigned just six months after taking the job.

By now the other investors had all been bought out of the venture by Walt and Roy, not only because of the management problems, but also because the return on investment had been disappointing. The name subsequently changed to Celebrity Sports

Center to reflect the expanded facilities and new restaurant.

Employee handbooks of the era laid out dress guidelines for short hair and shined shoes for men and no jewelry or perfume for ladies. Celebrity employees watched training films of Walt explaining that like Disneyland, visitors at the center were to be treated as guests. The center became a training ground for managing a family resort and provided experience that would be valuable to the planning of the yet-to-be-announced Walt Disney World in Florida. Bob Allen, who had started at Disneyland in 1955, moved to Denver in 1964 to manage the center and turn a profit. Allen eventually went on to Florida. Disney sold the property in 1979, and the complex was torn down in the wake of a booming expansion of Denver's suburbs; by 1995 a big-box shopping center resided where the Celebrity once had.

# 18

# SKIING IN THE SIERRA

**L**EXANDER CUSHING, the owner of a struggling ski resort in Squaw Valley (in Northern California) made a bid to host the 1960 Winter Olympics—mostly as a publicity stunt to bring skiers to his struggling resort, which had one chairlift, two rope tows, and a fifty-room lodge. To everyone's shock, the International Olympic Committee accepted the bid. Squaw Valley was such a backwater that at the end of the 1956 Winter Olympics, there was no mayor or local official to accept the flag from the mayor of the previous host city as was the tradition.

In 1958, the president of the Olympic Organizing Committee had lunch with Walt at the studio and asked him to serve as chairman of the Pageantry Committee to produce both the opening and closing ceremonies. Walt drafted his son-in-law Ron Miller as pageantry coordinator and former University Southern of California bandleader Tommy Walker as pageantry director. Walker was working at Disneyland at the time and immediately hit the phones to pull in bands, fireworks companies, and entertainers to support the event. He enlisted Charles Hirt and Clarence Sawhill, the choral and band directors from USC. And after a meeting with the National Music Educators in March

Left: Ski Crown logo concept for Mineral King. Above: A sketch of the proposed ski lift. Top: U.S. Olympic figure skater Carol Heiss receives her gold medal at Squaw Valley, 1960. Opposite top: Mineral King Village concept by Herb Ryman. Opposite bottom: Walt and ski coach Willy Schaeffer (on Walt's right) entertain Governor Edmund G. "Pat" Brown (in suit and tie), who secured $3 million in federal grants to build a road to Mineral King.

Left: Ice sculptures were set up by the entrance to Blyth Arena, a major hub at the 1960 Winter Olympics. Above: The official poster for the gathering in French. Right: The opening ceremonies.

1959, more than thirty bands and seventy choral groups applied to be part of the opening ceremonies. The committee selected the final performers and distributed the musical arrangements to the participating schools, which had to raise money to fund their trips to Squaw Valley. In all, 3,680 students came to entertain.

It was the first year the Olympics sold television rights, and Walt called on friend Art Linkletter to host and John Hench to be decor director. Hench first studied ice sculptures at the Dartmouth College Winter Carnival, and then designed thirty huge statues built from snow and constructed by Floats Inc. of Pasadena. The medal platform and stage for the ceremonies was backed by another Hench design, the Tower of Nations, a seventy-nine-foot-tall grid sporting the crests of each participating nation. It was a first, since victory ceremonies were not always held for the public.

To offset the cost of turning Squaw Valley into a world-class venue, the organizers solicited sponsors for the snow statues and the thirty flagpoles, one for each nation that flanked the Tower of Nations. Disney funded a 161-bell carillon that rang out three times daily during the games.

On opening day, February 18, 1960, there were whiteout conditions and CBS host Walter Cronkite looked like he was in an arctic

blizzard. He was. Cars were backed up for twelve miles outside of Squaw Valley, and young musicians shivered in the bitter cold. The ceremonies were delayed by only fifteen minutes, though, and with the first downbeat of music, the skies cleared, the snow ended, and the sun came out.

Vice President Richard Nixon had driven forty-six miles from Reno to deliver a fifteen-word opening statement. Then, thanks to a treasure hunt by the Disney Music staff, the massed bands and choral groups performed a new arrangement of the long-lost Olympic Hymn, which had not been played since the Athens, Greece, games in 1896.

In a controversial choice of Cold War showmanship, Walt got actor Karl Malden to narrate the Olympic prayer. "Walt felt that prayer represents one of the freedoms of America and that we should definitely have it," said Walker.

After the opening ceremony, Walt and his entertainment vice president, Art Linkletter, organized live entertainment activities for guests and athletes every evening. Jack Benny, Danny Kaye, Bing Crosby, Roy Rogers, Red Skelton, and—in an unconventional choice—the Official Press Hostess, Jayne Mansfield, all kept the Olympic Village lively each night. *Variety* reporter Army Archerd

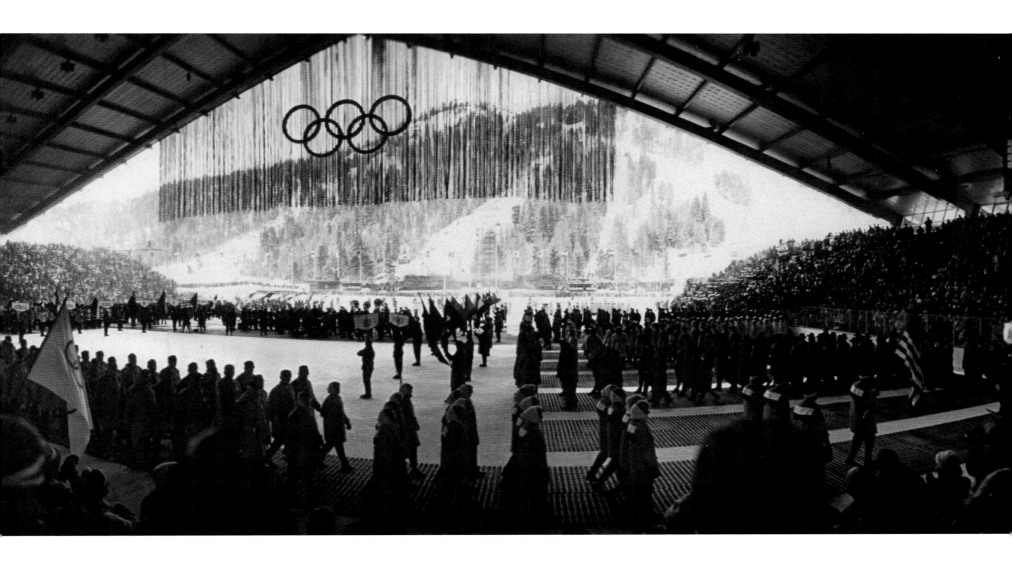

called the games "the greatest show on earth," and they were.[44]

With this success, and while secretly acquiring land for development in Florida, Walt devised plans for a winter resort in California's Sierra Nevada mountain range in a place called Mineral King.

The area was a mining district in the 1870s that eventually went bust, but the geography of a mile-wide glacial valley floor at 7,400 feet with peaks rising up to 11,000 feet or more made it an appealing venue for winter sports. The land was never annexed for the nearby Sequoia National Park, but instead was a part of the Sequoia Game Refuge, which made it available for development.

Walt proposed using the land to build Disney's Mineral King Ski Resort as a joint venture with the United States Forest Service, which would lease the land to Disney. In December 1965, Buzz Price ran an analysis on the idea and projected that the proposed resort could grow in popularity to rival nearby Yosemite. It was close to Southern California, whose ongoing growth would supply the resort with guests for years to come. After a competitive bidding process, Disney's plans prevailed. Disney's Sky Crown, as it was eventually named, was designed as a family-friendly resort with fourteen ski lifts serving three bowls and five thousand feet of vertical drop.

WED's Marvin Davis would direct the development and Olympic ski coach Willie Schaeffler would map out the trail system. The all-season resort would lure families with hiking, fishing, tennis, and swimming in the summertime. Disney characters would roam the village, and attractions like the Country Bear Jamboree (originally part of the concept for Mineral King) would entertain guests. Hotels and restaurants in all price ranges would accommodate 7,200 people, including cast members to service the year-round resort.

To avoid the traffic nightmares of Squaw Valley, cars would be banned from the valley and parked in a 3,600-space underground facility. From there, guests would board an old-fashioned cog railway and leave their everyday lives behind as they pulled into the central station in town. Disney wanted the development to resemble Zermatt at the base of the Matterhorn in Switzerland, which he had visited in 1958 during the filming of *The Third Man on the Mountain*. Zermatt was only accessed by cog train, and the village itself was entirely pedestrian with low-rise buildings in an alpine-village style.

The American Forestry Association considered the concept for the valley to be so green and forward-looking that they honored

the Sky Crown design team with an award for outstanding service in conservation of American resources in 1966. In all, it was a $35 million investment with plans to open as early as 1973.

In the promotional brochure for the resort, Walt says, "When we go into a new project, we believe in it all the way. That's the way we feel about Mineral King. We have every faith that our plans will provide recreational opportunities for everyone. All of us promise that our efforts now and in the future will be dedicated to making Mineral King grow to meet the ever-increasing public need. I guess you might say that it won't ever be finished."

As design work continued, California conservation group the Sierra Club came out against the development, saying that the Forestry Service had not followed its lease term regulations in granting Disney the right to develop the region. There was also concern that the main access road to Mineral King would need to cross through the fragile natural resources of Sequoia National Park. In the end, Walt's passing in 1966—and the subsequent lawsuit and focus on Florida and Walt Disney World—led Disney to abandon the project, and Mineral King was annexed into Sequoia National Park in 1978.

**Top: A drum major bundled up during opening ceremonies. Below: CBS sports crew loads up equipment to televise the Olympics for the first time. Opposite: The massed bands from area schools march to the opening ceremonies in a blizzard.**

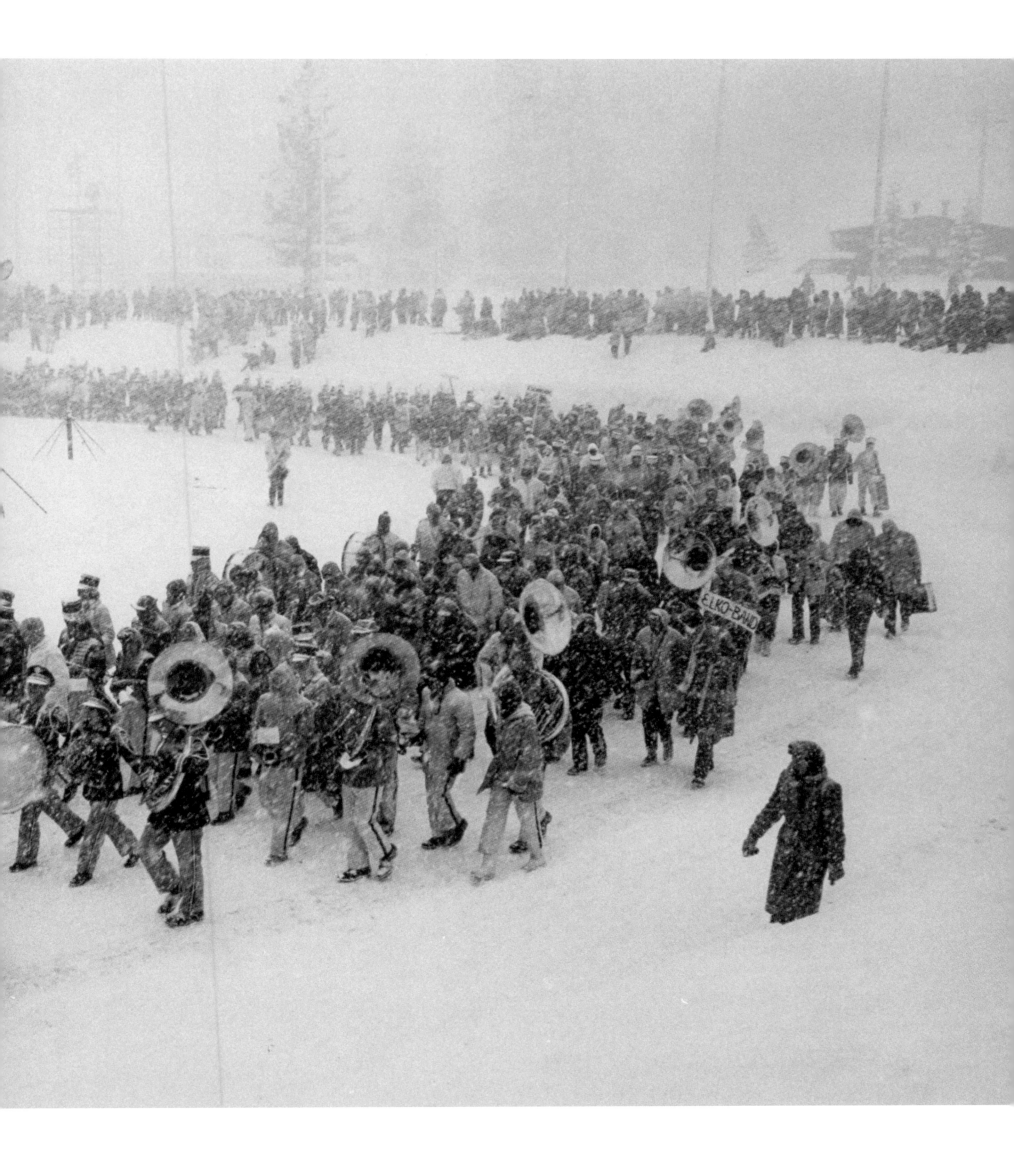

## 19

# MEET ME AT THE FAIR

**W**ALT'S FATHER, Elias, had worked as a carpenter on the World's Columbian Exposition in Chicago in 1893, which was seen as the world's fair that changed America forever. There, and at subsequent world's fairs in St. Louis, Buffalo, San Francisco, and Seattle, the world was introduced to electric lighting, television, telephones, and breathtaking visions of the future.

Today a world's fair seems like a dinosaur from another era, but in the early part of the twentieth century they were *the* place for cultural exchanges and exhibitions of new technology and design.

Walt used the fairs as a place where he, too, could innovate with new techniques to entertain and even educate his audience. One of those new techniques would debut as the centerpiece of the United States Pavilion at Expo '58 in Brussels.

New York architect Edward Durell Stone designed a huge drumlike round structure to house a circular theater playing Walt Disney's *America the Beautiful*. The rest of the pavilion was a showcase of Americana with hot dog carts and voting booths and a vast mural depicting American life by artist Saul Steinberg.

*Time* magazine was critical of the building:

The U.S. Pavilion, with its open plaza, reflecting pool[,] and splashing fountains, has become a star attraction. But what is inside the lofty, translucent drum designed by

Architect Edward D. Stone has become the subject of a running controversy, at home and abroad. Main reason is that the U.S., setting out to give its interpretation of a new humanism tailored to fit the Atomic Age, decided it could win more friends by using the soft sell.[45]

*America the Beautiful* was humanistic in that it celebrated the values of goodness in people, but it was not exactly a soft sell. The film, made at the height of the Cold War, immersed viewers in the wonder of an idealized America, culminating in a symphonic finale of "America the Beautiful" played to images of a fireworks display over the Statue of Liberty in New York Harbor. It was a hit, so much so that when it was moved to a giant geodesic dome at the 1959 American National Exhibition in Moscow, it was once again one of the most popular attractions.[46]

Circle-Vision (first called Circarama) wasn't the first cinema in the round. The 1900 World Exhibition in Paris had an experimental system with ten 70mm projectors arranged in a full 360 degrees around a viewing platform. Cineorama, as it was called, lasted only three days and was shut down by the police because the extreme heat from projectors caused patrons to faint. In 1955 a Circle-Vision film called *A Tour of the West* was produced for Disneyland for sponsor American Motors, a nascent corporation formed by the unlikely mash-up of Hudson automobiles and Nash-Kelvinator appliances. The theater was an asphalt-paved room lined with cars and kitchen appliances. *Tour of the West* was replaced in 1959 with *America the Beautiful.*

In September of 1962, Walt and his family flew to Seattle to take in the newly opened Century 21 Exposition. It was a family trip just for fun, but Walt ducked out for a short visit alone on Friday night after his flight landed, then came back with his family on Saturday and Sunday. It was a busy weekend that included an appearance by astronaut Neil Armstrong, who dedicated a new exhibit on the X-15 rocket plane. The *Seattle Times* wanted Walt to compare the fair to Disneyland, but the idea of a fair was always different from his concept of Disneyland. "Disneyland is a place of fantasy and adventure. It is built around a carousel," he responded. "The fair is built around the Science Pavilion, the Coliseum[,] and the Space Needle."[47]

Disney and his family enjoyed Seattle; the only overt complaint was that the fairgrounds weren't large enough. The seventy-four acres set aside for the Seattle fair were smaller in size than what prior fairs had, which led Walt to say, "I think that [seventy-four] acres is too skimpy. You lack settings for these astounding buildings," he told the *Seattle Post-Intelligencer*. [48]

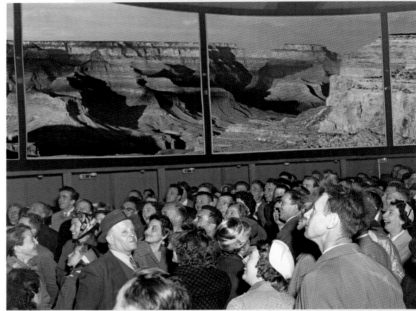

Top: the Circlevision crew prepares to fly in their custom B-25. Above: Disneyland guests take a "Tour of the West" in Circarama, 1955. Opposite top: Walt and Lillian Disney tour the Seattle World's Fair (1962) with their family. Opposite bottom: Seattle fair poster by Harry Bonath. Illustration of a proposed Circlevision attraction (right) at Walt Disney's Riverfront Square in St. Louis.

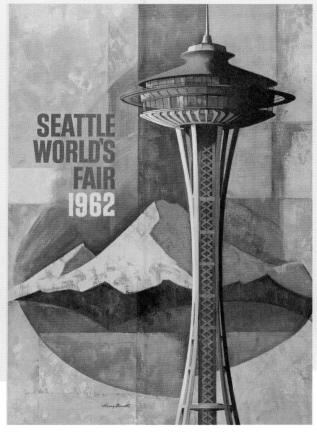

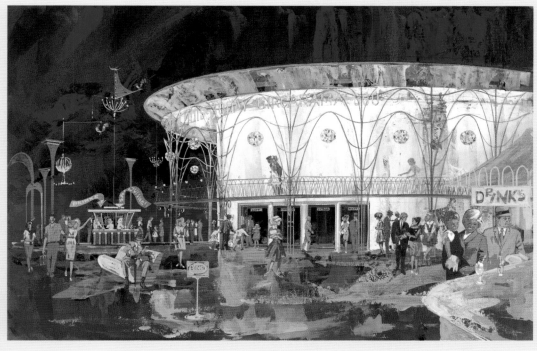

# 20
# WALT AND MOSES

**ALT, MEANWHILE,** was about to encounter Robert Moses, the larger-than-life character long at the center of mid-century urban planning in New York City. Moses was a Yale- and Oxford-educated man whose ham-fisted style and solutions for the problems facing American cities were seemingly in stark contrast to Disney's more creative, forward-thinking manner.

Moses was a nonelected autocrat who used his roles as Park Commissioner and City Planning Commissioner to wield incredible power over the use of city bond money without any legislative oversight, and he was driven.

"When Moses began building playgrounds . . . there were 119," writes his biographer, Robert Caro. "When he stopped, there were 777."[49] That, plus skating rinks, bridle paths, 288 tennis courts, and 673 baseball diamonds. He was a prophet of the automobile whose marks on the city included Lincoln Center, the United Nations, nearby Jones Beach (in Long Island), several roadways, and the Central Park Zoo, which not only left a lasting legacy, but uprooted more than half a million people and destroyed entire neighborhoods in the process. In one year he angered the owners of the Brooklyn Dodgers and the New York Giants to the point that they both left for California after the 1957 season.

Opposite top: Robert Moses. Opposite bottom: The Unisphere, the center-piece of the New York World's Fair at Flushing Meadows in Queens, New York. Top: Walt shares a ride in the Ford Pavilion with Henry Ford and Moses. Above: "it's a small world" exhibit model with Walt, UNICEF president Helenka Pantaleoni, Moses, and Pepsi-Cola president Herb Barnet.

In the autumn of his career, Moses was elected president of the organizing committee for the 1964–65 New York World's Fair, which brought together fifty-eight countries and fifteen organizations to a former ash dump in Flushing Meadows (a section of New York's Queens borough), once the site of the 1939 fair, also a Moses project. He now had his eye firmly on Disney to transform the land into an East Coast Disneyland, and began meeting with Walt as early as 1960.

When Moses flew to meet with Disney, Walt was way ahead of him and had already been talking to exhibitors promoting WED to design their pavilions. WED veteran Marty Sklar felt that Walt was using the fair as a trial balloon to see if audiences on the East Coast would warm to his brand of entertainment. And even before Moses landed in Burbank, a deal was already closed to develop a pavilion for the Ford Motor Company.

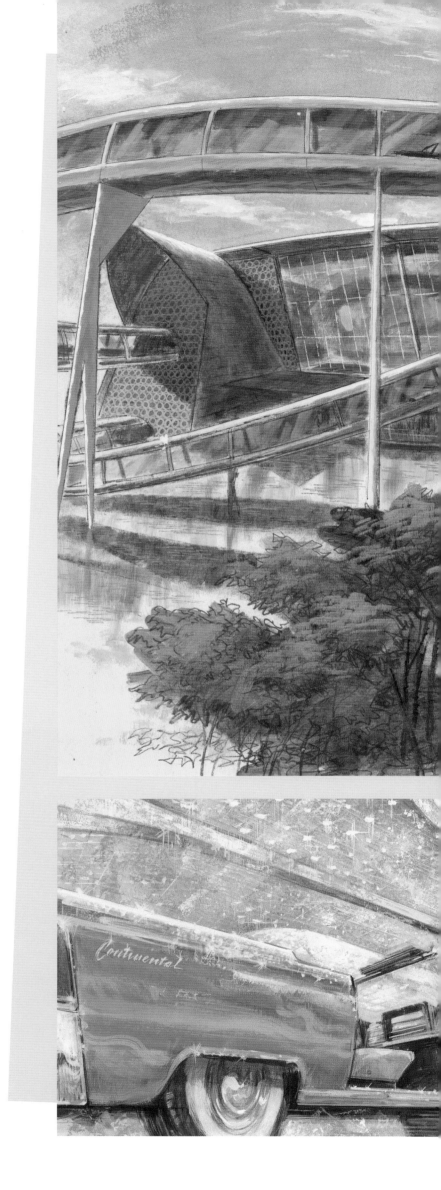

# 21
# MAGIC SKYWAY

**T**HE 1939 New York World's Fair had left a very bad taste in the tank of the Ford Motor Company. Their attraction was second fiddle to the star exhibit of that year, Futurama from rival General Motors. In the buildup to the 1964 fair, General Motors announced intimidating plans for a bigger, better Futurama that left Ford in the backseat once again. So, they turned to Walt Disney.

Once again Walt's friend and visionary architect Welton Becket came through, designing a space large enough for two simultaneous shows and allowing for four thousand guests per house. The result was a vast structure with a glass rotunda 235 feet across and 56 feet tall. For Ford executives, the "Wonder Rotunda" was a way to pay tribute to the unique and iconic Ford Rotunda Building in Dearborn, Michigan, which had burned down just two years earlier.

At the topping off ceremony, Moses called the Ford building an important milestone in the construction of the fair. "There is bound to be a great exhibit when Ford and Disney get together," he said. Inside the vast rotunda, the Imagineers led by Disney veteran John Hench[50] were in the driver's seat. On the ground floor, Henry Ford's quadricycle was displayed side by side with the

**Top right: An early John Hench illustration of the Ford Pavilion entrance. Below right: Guests ride in new model Ford vehicles propelled on a track, a system that was later adapted into the WedWay PeopleMover at Disneyland (as rendered by Sam McKim).**

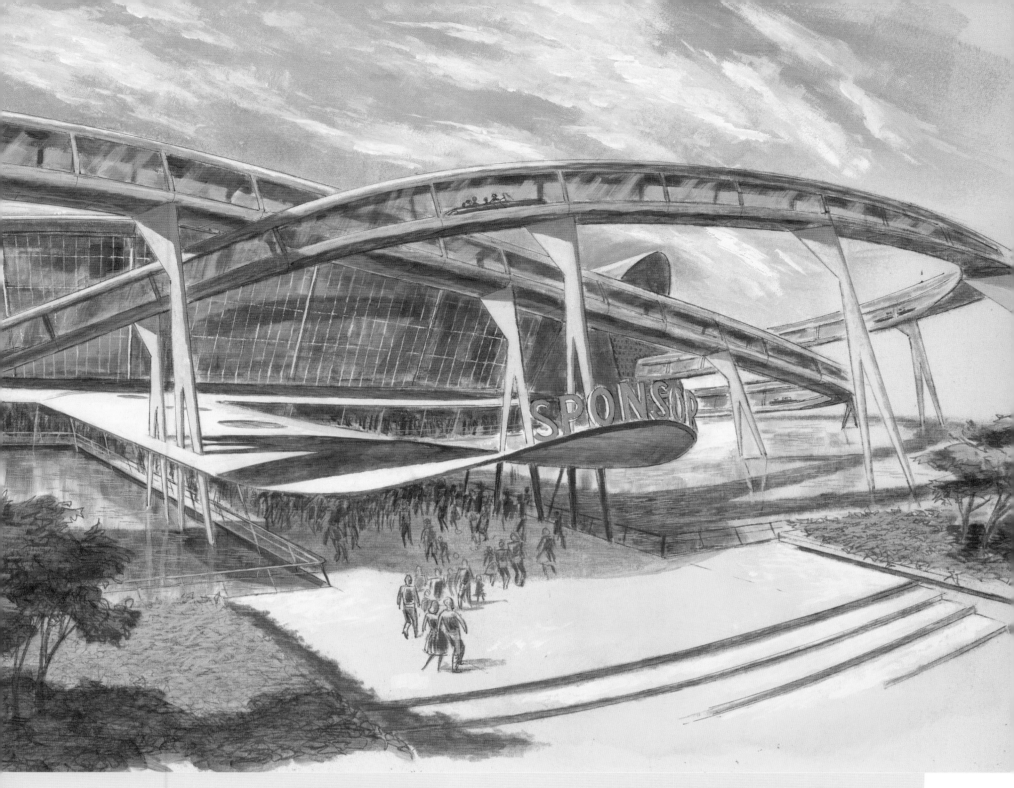

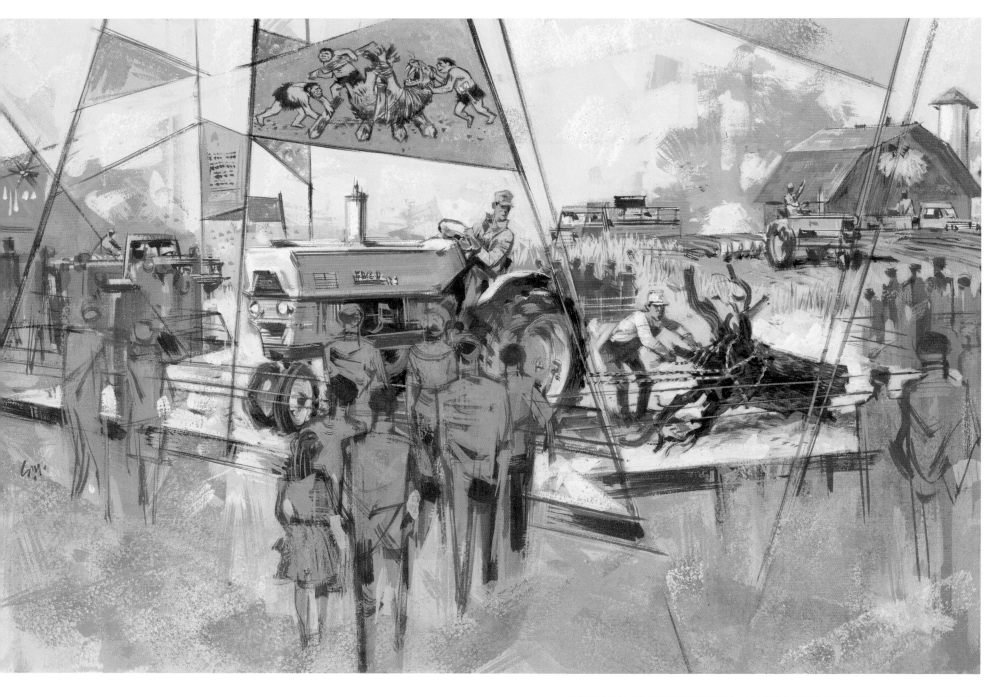

new Mustang and other current models in a "product salon."

Disney designed miniature scenes of cities around the world like something one might see today in Legoland. The Auto Parts Harmonic Orchestra, made of Ford auto parts, played for guests as they made their way to the upper level loading zone and the star attraction: the Magic Skyway.

The ride element, the Magic Skyway, was a clever line of more than one hundred new Ford convertibles that, stripped of their engines, would carry tourists through the story of transportation with narration coming from the car radio along with the theme song "PDSQ"—performance, dependability, style, quality.

Henry Ford II greeted the guests on the audio track played through the car's stereos. The world of the dinosaurs was the first diorama of the journey, suggesting the formation of fossil fuels. The scene had cute baby triceratops breaking into the new world,

Top: Farm equipment on display, by Sam McKim. Above: Ken O'Connor's proposal for a display of a new innovation: seat belts.

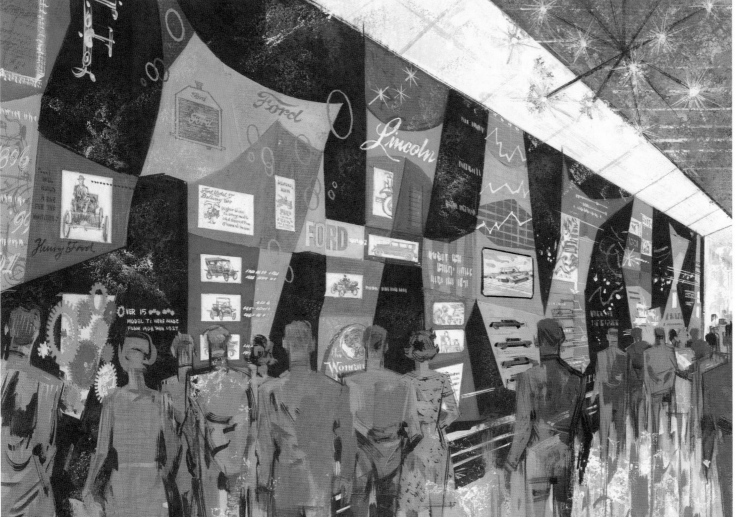

137

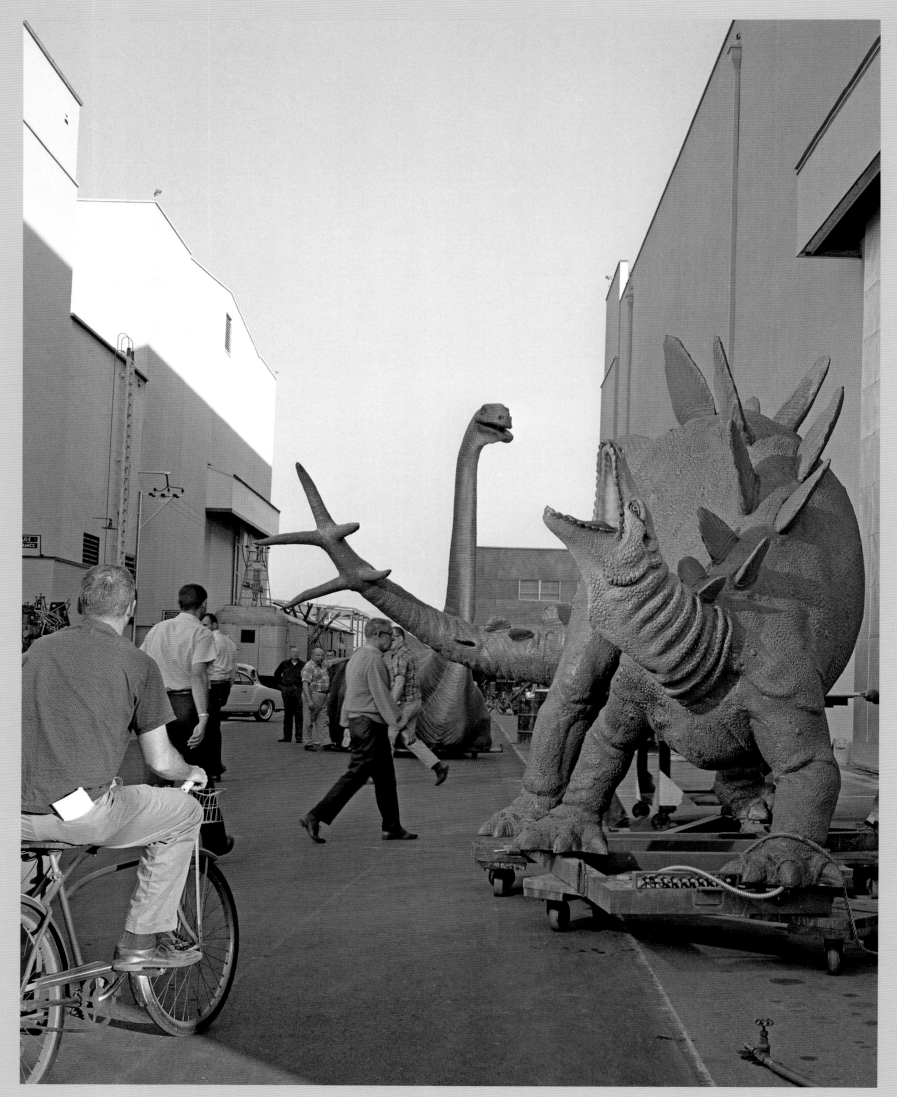

Dinosaurs wait outside soundstages on the Disney back lot in Burbank before being shipped to the fair in New York.

YESTERDAY'S TOMORROW: DISNEY'S MAGICAL MID-CENTURY

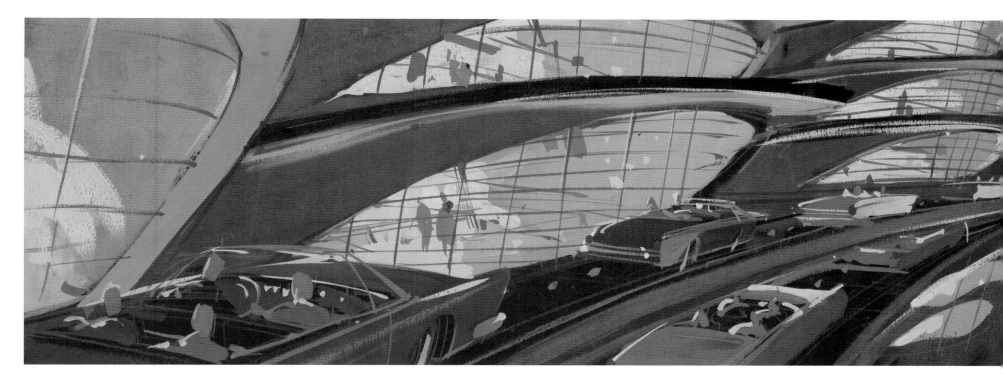

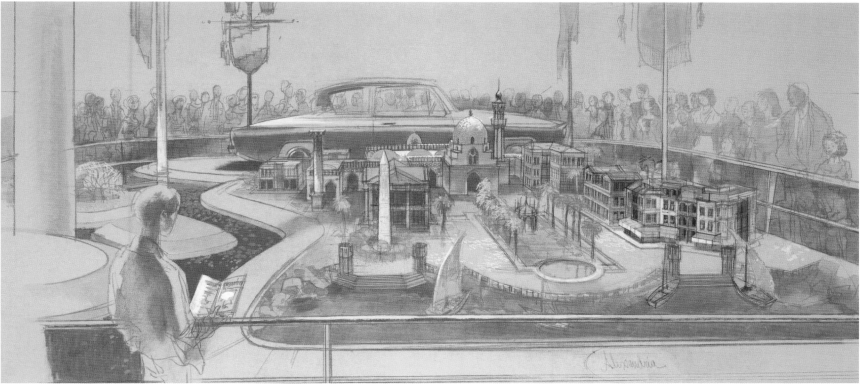

Top: Attraction ride system illustrated by Herb Ryman. Above: Ryman's sketch for the International Garden in the exhibit space.

and a climax of a T. rex in mortal combat with a stegosaurus.

The Stone Age was depicted with realism and humor, showing the caveman painting cave walls and eventually inventing the wheel, thus freeing and unchaining man from his cave; he was now free to move . . . assuming his wife provided the power.

The final scene of the future left guests in a showroom of new Ford products. In a promotional film for Ford, the narrator described the fair: "Man's dreams of today are given substance, foretelling the dreams of tomorrow. For millions of visitors, the New York World's Fair will be the experience of a lifetime."

As clever as the Magic Skyway ride system was, and as breathtaking the content, Ford still lost out to GM's Futurama, which reigned as the fair's most popular attraction. Walt offered Ford Motors a reimagined attraction at Disneyland, but they declined. The ride system was adapted to the new PeopleMover, which debuted at Disneyland in 1967, and only the dinosaurs of the primeval world diorama made it from Ford's World's Fair attraction to the West Coast, becoming part of Disneyland in July 1966.

# 22

# MR. LINCOLN

*There will be a plastic Abraham Lincoln programmed by tape in a central control room, like a missile. Lincoln sits, stands, moves his tongue, moves his lips, clears his throat, frowns, smiles, looks skeptical, sad, happy, raises either or both eyebrows, registers a total of fifteen facial expressions, makes a speech of six minutes, and steps back to his chair, whereupon his motors are turned off and choirs burst into song.*

—David Brinkley,
*Huntley-Brinkley Report* [51]

**R**OBERT MOSES visited Disney Studios in April 1962 for an update on the General Electric and Ford pavilions. Walt used the opportunity to showcase some new ideas, including a show concept called "One Nation Under God." It was a multimedia show that began as an idea for Disneyland but had grown in ambition to include figures of all of the American presidents, culminating in a speech by Abraham Lincoln.

"Robert Moses decided he wanted to see this Mister Lincoln, since he'd talked the state of Illinois into buying it," recalled animation master Marc Davis in a 1989 interview.[52] Moses, along with his

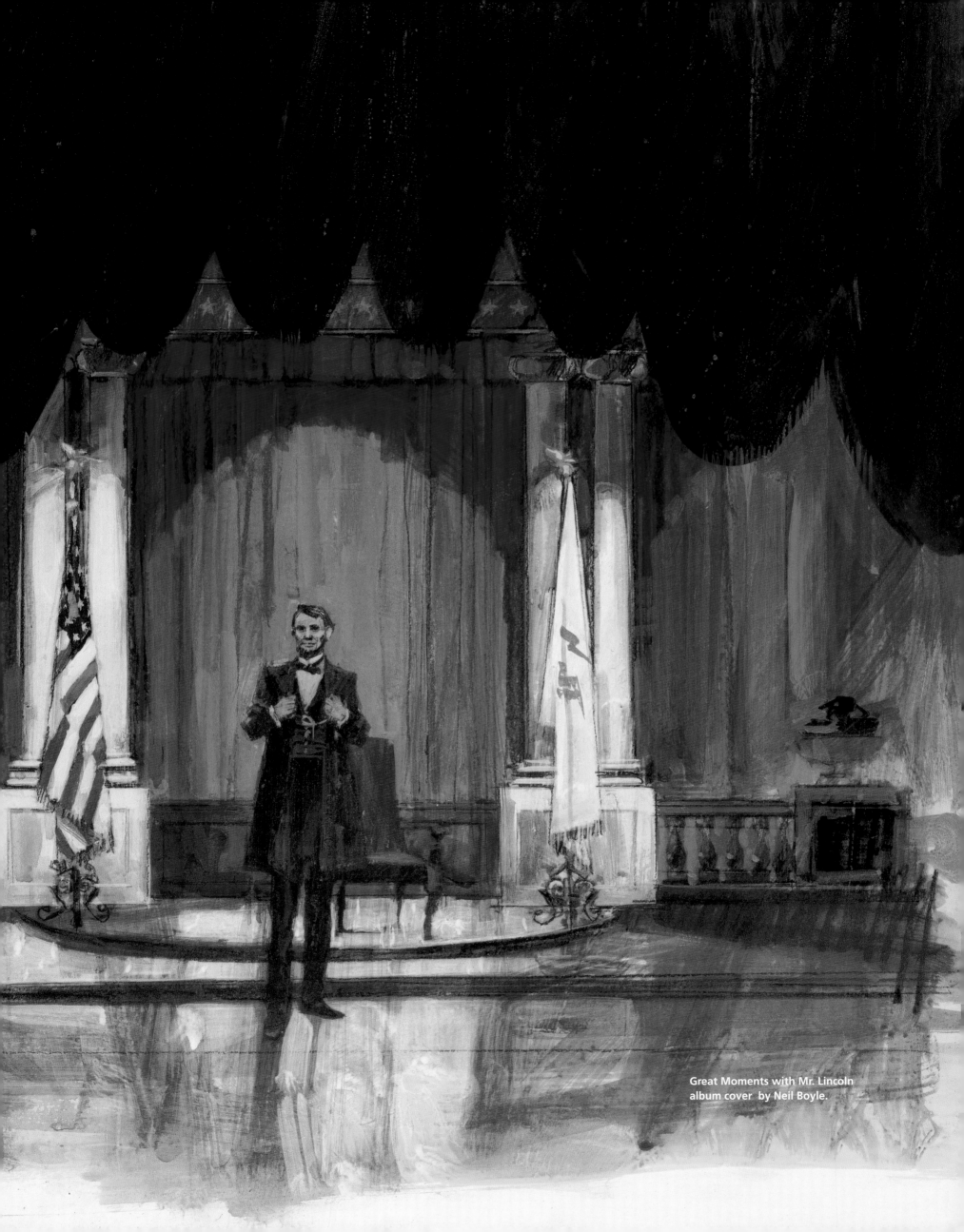

Great Moments with Mr. Lincoln
album cover by Neil Boyle.

Lincoln preshow illustration by Sam McKim.

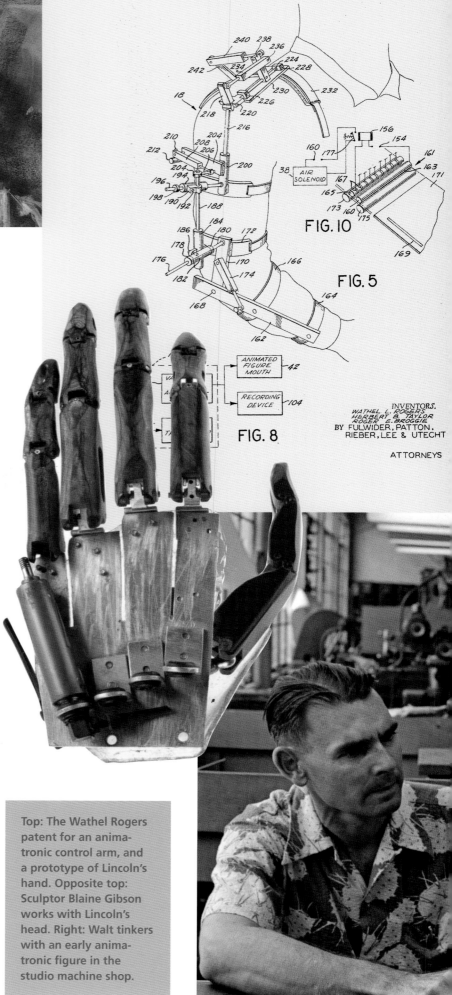

assistant General William E. Potter, onetime head of the Panama Canal, arrived at 11 a.m. with an entourage of executives and their wives. Walt was there to greet them along with Marc and Dick Irvine.

"Mister Lincoln went through his performance . . . and God . . . not one glitch! We wanted to hug him!" continued Davis. "The only thing was, you couldn't go up and hug a big pile of machinery like that because it could kill you. This thing had five hundred pounds of hydraulic pressure . . . it could kill you."

Moses was smitten with the Lincoln prototype and set out to find a sponsor for the idea at the fair. The obvious sponsor for the show would be the United States government, who Moses thought would be crazy not to take "One Nation Under God" as the primary show of the Federal Pavilion. But the cost of building the show expanded and was prohibitive for the U.S. pavilion. Walt scaled the show down to feature only Lincoln, partially for budget reasons but partially because they could barely get the solitary Lincoln figure to work reliably, much less a hall of presidents.

After the Coca-Cola Company passed on the show, Moses began pitching the idea to the state of Illinois and the temporary chair of the state's World's Fair Commission, Fairfax Cone. Cone was a brilliant ad executive who saw the benefit of using Lincoln as the pitchman for Illinois. On April 5, 1963, he arrived at the studio in Burbank to see the demonstration of the Lincoln figure and later wrote Walt, "I am sure you know that I was overwhelmed by the realism of the Lincoln figure that you showed Mrs. Cone and me last Friday. The possibility of our using the Lincoln figure and the effect of this upon visitors to the New York World's Fair have not left my mind during any of my waking hours since I saw it."[53]

In the spring of 1963, Ralph G. Newman was appointed as the permanent chairman of the Illinois pavilion. Newman was a college

Top: The Wathel Rogers patent for an animatronic control arm, and a prototype of Lincoln's hand. Opposite top: Sculptor Blaine Gibson works with Lincoln's head. Right: Walt tinkers with an early animatronic figure in the studio machine shop.

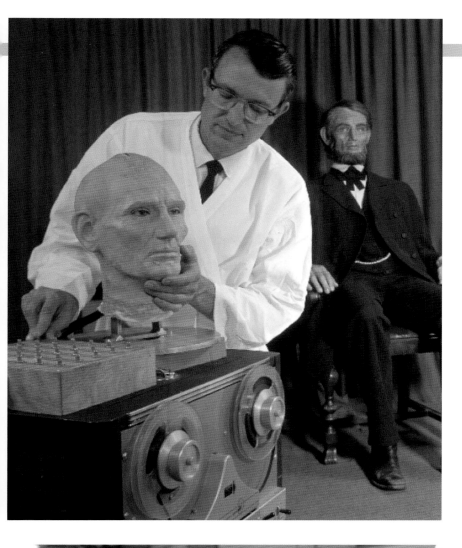

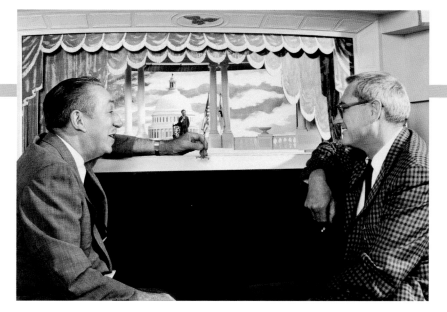

Walt and WED art director Victor Greene discuss the model for the attraction.

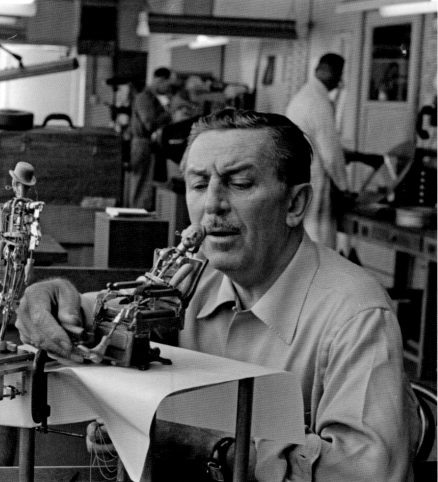

dropout but expert Civil War historian who ran the Abraham Lincoln Book Shop in the Chicago Loop and was an immediate cheerleader of the Lincoln figure. Newman advised on the script, made of excerpts from several of Lincoln's speeches.

When Illinois governor Otto Kerner made the pilgrimage to Burbank, the figure was still an unreliable prototype. Imagineer Neil Gallagher recalled operating the figure manually during the visit and demonstrated a few gestures as Walt played excerpts for the speech that Lincoln would deliver. The deal was sealed, though there was one problem . . . it didn't work.

"You know, Walt was about ready to cut his own throat, and we were ready to jump off the bridge with him," said Marc Davis. "You know it was horrible! You can't believe . . . here we were, stuck with something, and Walt didn't have the technology to have accepted that assignment at that time. It was like working on the first automobile or the first airplane or whatever and you didn't know whether it was going to fly or not." [54]

Davis finally concluded that their approach was wrong. "We weren't building a mechanical man," as he put it, "we were building an illusion. An illusion of a man. That took a while to soak into me and into everyone else."

The show ultimately did open when the fair did, playing five times an hour, from 10 a.m. to 10 p.m. To twenty-five thousand people a day, Lincoln rose to his feet and captivated. "Some audiences he holds in spellbound silence," the Associated Press marveled. "Others he sets to cheering wildly." [55] Abraham Lincoln, dead for nearly one hundred years, came back as the star of the New York World's Fair. He was so popular that his twin Audio-Animatronic figure debuted in Disneyland's Main Street Opera House on July 17, 1965, while the New York Lincoln was still onstage.

# 23
# PROGRESSLAND

**G**ENERAL ELECTRIC had a bumpy ride with Walt and an idea he was developing about the history of electricity in the home. During the July before the fair opened, GE executives flew to Burbank and decided to dump the nostalgic idea and write their own script for the attraction. Walt bristled and sent them away, even trying to get out of the contract, but GE capitulated and the show went forward as planned.

Progressland began with a stunning futuristic dome designed by Welton Becket. The fabric dome of the structure was supported by steel pipe laid in an intersecting pattern that sloped inward toward the center, all constructed with 140 tons of steel (supplied by sponsor Bethlehem Steel) and no internal support pillars. This "pop-up structure" was purposely expressing a countercultural idea of "green" buildings that would be erected quickly, reconfigured, or disassembled. It was a way to showcase design ideas that couldn't be built yet as permanent structures.[56]

The underside of the dome was sprayed with asbestos for smoothness and use a projection screen. The mid-level was a carousel of six individual theaters built to rotate slowly around six stationary stages, while the lower level was the entrance and exit to the pavilion.

**Attraction poster for General Electric's Progressland.**

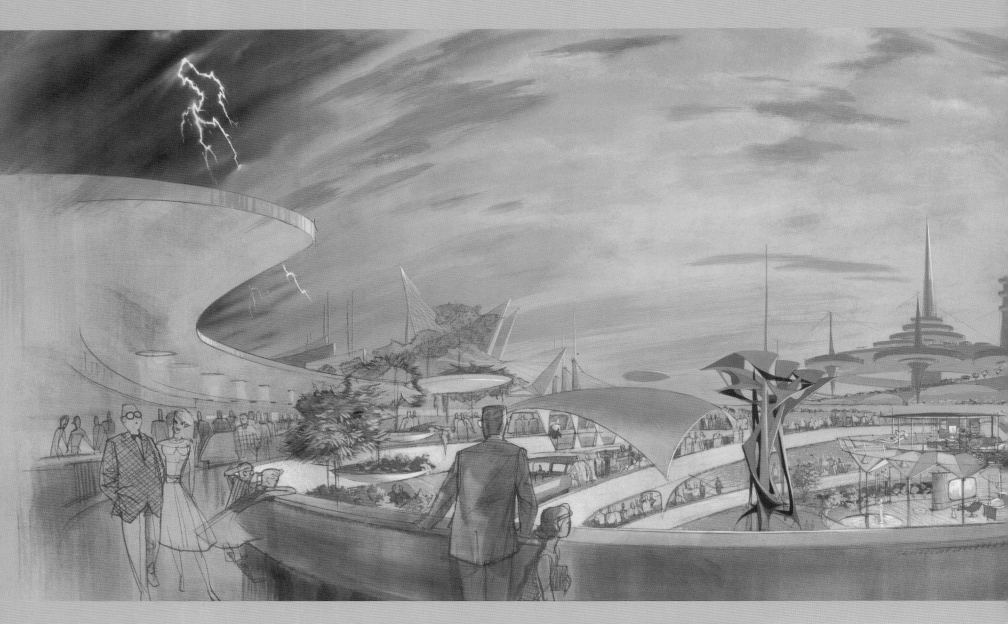

Above: John Hench concept for the Skydome Spectacular and display area in the GE pavilion. Right: The GE Pavilion as envisioned in Tomorrowland at Disneyland. Far right: Scenes from the past as featured in the Carousel of Progress show.

The Carousel of Progress was Walt Disney's contribution to the pavilion. As the theaters, each holding 250 people, rotated from stage to stage, the Audio-Animatronic characters told the story of the American family with Disney regular Rex Allen voicing the father, from the pre-electricity days of the 1880s to the second stage and the boom time of the 1920s. On a third stage, the same characters, now in a postwar 1940s setting, continued the story, culminating in a house of the future with every imaginable convenience in an all-electric house.

The brochure for Progressland says, "The message is this: too often we take the wonders of electricity for granted. Electricity has introduced undreamed-of convenience, comfort[,] and enrichment into our family living. And even today, most of us are not really availing ourselves of all the opportunities electricity has to offer."

Richard and Robert Sherman were assigned the task of bridging the times that the carousel rotated between scenes with a song. The song couldn't give away what was coming, but at the same time the melody needed to be malleable enough to be arranged as ragtime, Dixieland, big band, and so on as the story progressed.

In the final act of the show, the audience sprang out of their seats and up a 160-foot-long corridor of mirrors where simulated stars and color photographs of GE's research were projected on screens etched within the mirrors. Finally, the guests were deposited on the upper terrace of the building to see the Skydome Spectacular, a series of eighty-seven projectors filling the dome with the long struggle of mankind to harness energy—first fire, then steam, then electricity, then the atom—to control his universe.

And as the show ended the crowd circled the center well of the building to see "the first public demonstration of controlled nuclear fusion." On the ground floor was *Medallion City*, a GE infomercial that showcased the "all-electric promise of today." Art director Dick Irvine had always dismissed the pavilion as a show to sell appliances, but Walt took it very seriously and was deeply invested in the pavilion for its innovative ride system and Audio-Animatronics.

Disneyland's Joe Fowler remembered, "There was more of Walt in the Carousel of Progress than in anything else we've done."[57]

More than twelve million people experienced this popular attraction before it moved to Disneyland in July of 1967 to coincide with the overhaul of the park's Tomorrowland area.

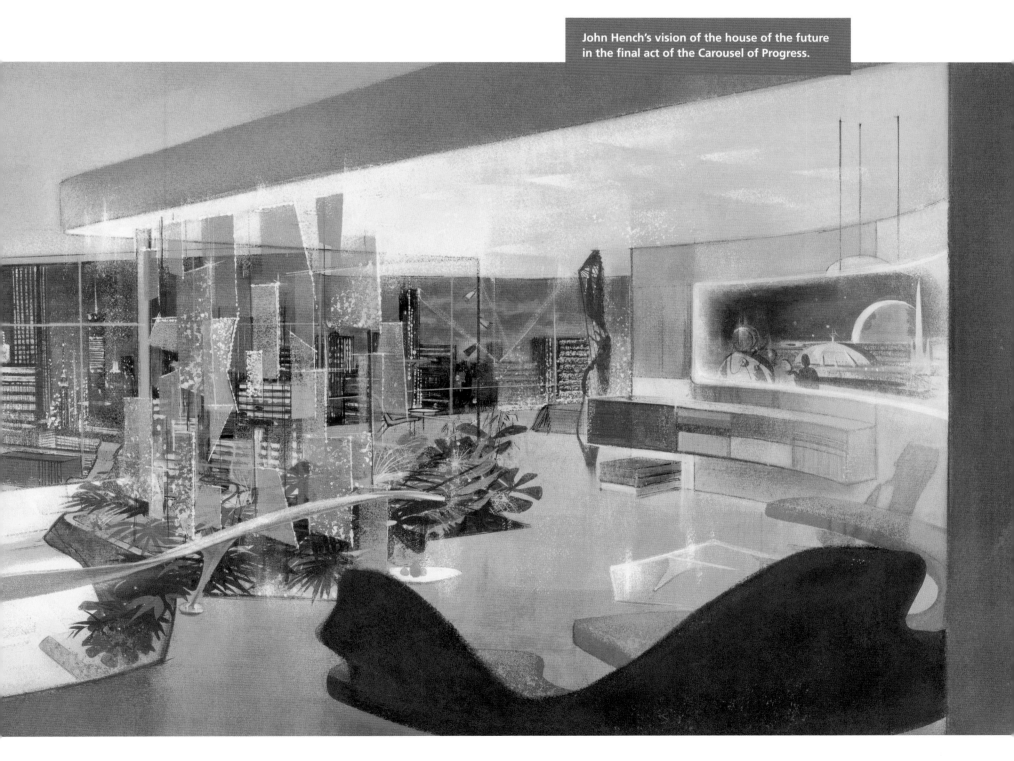

John Hench's vision of the house of the future in the final act of the Carousel of Progress.

# 24

# SMALL WORLD

**R**OBERT MOSES was working with Pepsi and the United Nations Children's Fund (UNICEF) to cosponsor an exhibit as a salute to the children of the world. Pepsi's board dragged their feet on the decision, and at the last minute board member Joan Crawford reached out to Walt for help with just a year left until the opening of the fair. WED was filled to capacity with work on the other three pavilions it had committed to and didn't need the pressure of another.

"One Day Walt pulled all of the show designers in, and he said, 'There's one more piece of real estate that they've offered to us. And I've got this idea for a little boat ride that maybe we can do," recalled Imagineer Rolly Crump. "And we thought, *a little boat ride?*" [58]

They were already deep into Carousel of Progress and the Illinois pavilion, both of which featured Audio-Animatronic figures. With the ambitious Ford Pavilion and a new ride system to work through, Imagineers thought they already had more than they could handle with the amount of innovation and quality that Disney required.

The boat ride for UNICEF would be a salute to the kids of the world. Disneyland stalwart Arrow Manufacturing in Mountain View, California, had been working with Bob Gurr on all the ride systems. Gurr recalls, "Arrow was trying to get a boat ride figured out, and I remember discussing it with them. I drew up a configuration for a

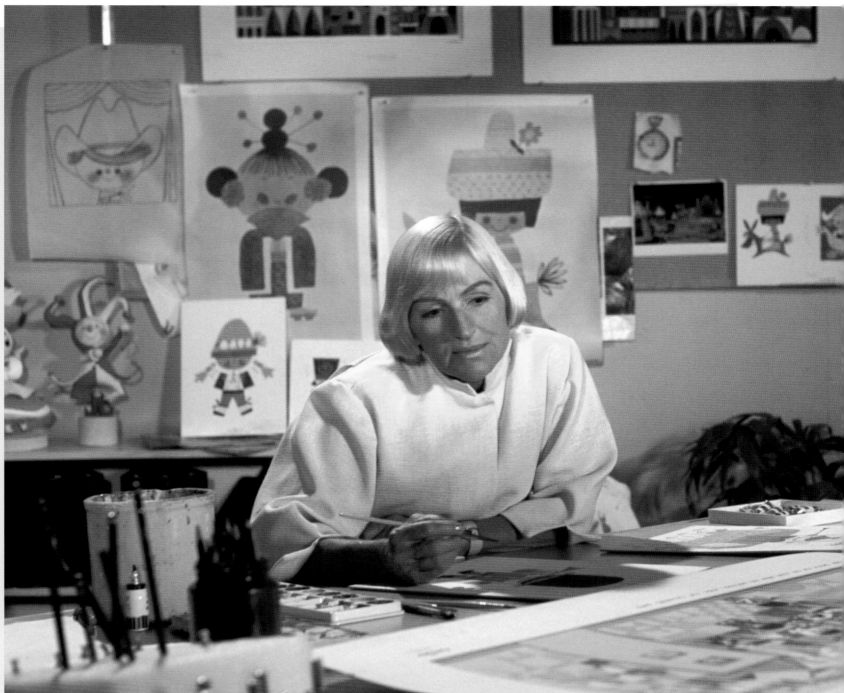

Opposite (top): Ride vehicles are tested at Arrow Development in Mountain View, California. Opposite bottom: Joan Crawford welcomes guests to "It's a Small World." Above: Mary Blair works on color and design for the attraction. Left: Arranger Bobby Hammack rehearses the choir as the Sherman brothers look on during the recording session for the attraction.

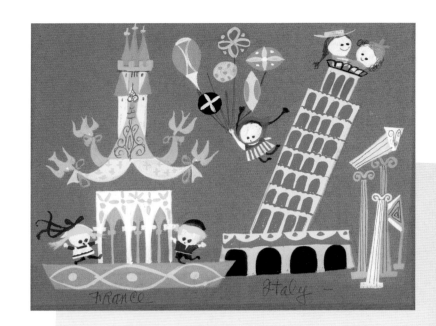

trough that had a center-post wheel in it that they used. And they figured out all the water pump stuff. Then all of a sudden that boat was adopted for the Small World ride."

Construction on the building for the attraction itself was under way; but instead of the architectural showplace so typical of the New York fair, this building was simple corrugated siding with an asphalt floor. "It was the ugliest building you ever saw in your life," Crump observed.

When Disney showed preliminary plans for the show to the board of directors at Pepsi, the reaction was poor. It was symptomatic of the board's inability to commit to any idea, and now with only months left, they were about to pass on Disney's design. But once again Joan Crawford stepped in and forced the point, pushing the board to approve Walt's plan, which they did out of fear that they would have nothing at the fair.

The concept was simple: a boat tour of the world with children singing and performing in their local costumes. The Audio-Animatronic children would need to be individually costumed, then placed into stylized settings of their homelands. The overall design fell to Mary Blair, whose sense of simplicity and love of folk art influenced the look of the ride. Other WED stalwarts like Marc Davis would contribute ideas for each setting. The costuming fell to Marc's wife, Alice Davis, who plundered the Los Angeles Fashion District for fabrics, buttons, feathers, bangles, and beads. Crump designed the Tower of the Four Winds in front of the building, and T. Hee, once a venerable story man at Disney, was called back to work on the toys and figures for the attraction.

One of the brilliant features of Small World was the combination of lifelike child figures that sang and danced with caricatured "toy" figures that were very simply animated and decorated not with clothes but with paint and beads and anything that you might find on a kid's favorite toy.

The children and their toys together created a very innocent and optimistic view of the human race through the eyes of a child. Audio-Animatronics was still a new art for the Imagineers. The music, singing, dialogue, and sound effects all had to be recorded on a single one-inch magnetic tape with thirty-two channels that controlled more than four hundred separate actions for the figures in the attraction.

Walt brought the Sherman brothers to the WED headquarters in Glendale, California, to show them the attraction. Walt needed the musical glue to unite the entire story, and it was not going to

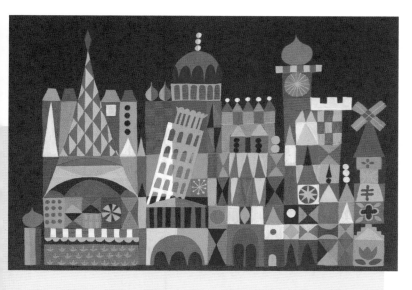

work to have each nation use their own national anthem. Their answer, "It's a Small World," was a masterstroke that turned the unifying song into a round (like "Row, Row, Row Your Boat") where chorus ("It's a small world after all") and verse ("It's a world of laughter, a world of tears") could be sung simultaneously and each scene of the ride could feature an ethnic arrangement of the song while still blending with the overall musical chorus.

The song would be played at a constant tempo so that it would always be in sync anywhere in the attraction. The audio speakers were built into the sets and not in the boats themselves, so as the guest "sailed" from scene to scene around the world, the music from that scene stayed in that part of the world, with the music fading out of the past scene and into the next scene in a very natural way.

The Shermans weren't sure the song would work, since it sounded so simple. When they played it for Walt they had two additional songs in their pocket for the pavilion. But Walt liked "Small World" and a piece of theme park history was born.

The initial track was sent to instrumentalists around Los Angeles to see how distinctly they could identify each country by the orchestration alone. Arranger Bobby Hammack would tell the story with his instrumentation by adding bagpipes to Scotland, or writing the melody in a pentatonic scale for Japan. The final recording used fifteen kids and eight adults singing the chorus. The ride itself was mocked up on the Disney lot in Burbank, where audio levels and music cues had been set in preparation for installation in the warehouse in New York.

Imagineers had designed dark rides with plywood cutouts and black-light paint on characters, but this would be different. Small World was brightly lit, so color and costume would play a more important role. Blair was instrumental in setting color palettes for the ride, and the theatrical lighting designers had to work closely with her to ensure that the colors worked in the actual building. The child characters were sculpted and cast in vinyl, and then the vinyl skin was placed over the Audio-Animatronic mechanism that would make the character sing or dance to the music.

Top: Mary Blair's designs and color concepts. Middle: Herb Ryman's illustration of the pavilion exterior and Tower of the Four Winds, which was designed by Rolly Crump. Bottom left: Blair works with Alice Davis, who costumed the figures for the attraction. Bottom right: Walt visits with Marc Davis and Blair.

**Above and opposite: Mary Blair's designs for the attraction.**

# 25
# THE PARTY'S OVER

**T**HE FAIR was meant to be the perfect confluence of technology, freedom, convenience, and modernism, which Robert Moses hoped would remain as "a vast Colosseum dedicated to new friendships . . . the hopes and aspirations of a New York."

The fair was not without its critics. It became the target of civil rights protestors who planned to disrupt the April 22, 1964, opening day to call attention to job discrimination, police brutality, and poor schools. "The World's Fair portrays an image of peace, tranquility[,] and progress—the American Dream. We want to show that there is also an American nightmare of the way Negroes have to live in this country," said Herbert Callendar of the Bronx, New York, chapter of the Congress of Racial Equality.

As President Lyndon Johnson gave opening remarks to a VIP audience, including Robert Moses, former president Harry Truman, Walt Disney, New York city mayor Robert Wagner, New York governor Nelson Rockefeller, and others, his amplified voice was drowned out by the protest of two hundred socially engaged college students.

The protesters had no immediate claim of discrimination against the fair, nor did the fair have power to reform civil rights, but it was an incredibly visible venue for protest. The press picked up the story, making it one of the best-publicized protests ever, yet commentators largely condemned the protests as unreasonable. Politicians chimed in, as Mayor Wagner did, saying the protests were "a gun held to the heart of the city."

By the close of the fair in October of 1965, fifty-one million people had gone through the turnstiles. The aftermath was embroiled in legal disputes that vilified Moses, and the fair returned only twenty cents on the dollar to investors. Small World and GE's Carousel of Progress moved to Disneyland as complete attractions. Lincoln and a few dinosaurs from the Ford Pavilion were moved as well.

Walt briefly considered developing the fairgrounds in Flushing Meadows into an East Coast version of Disneyland. Though dropped, the radial plan of the fair, and discussions about turning the fairgrounds into a permanent city of the future around a central hub, were ideas that stuck with Walt.

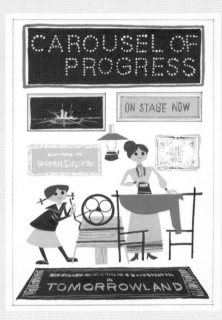

Opposite top: Carousel of Progress relocated to Disneyland. Opposite bottom: Marketing guru Jack Lindquist sorts through water samples from around the world. Top left: Walt dedicates the attraction at Disneyland, 1966. Bottom left: The Pepsi-Cola Pavilion, in ruins after the fair. Above: Poster concepts for the Carousel of Progress announce its new home at Disneyland.

# 26

# THE CITY OF TOMORROW

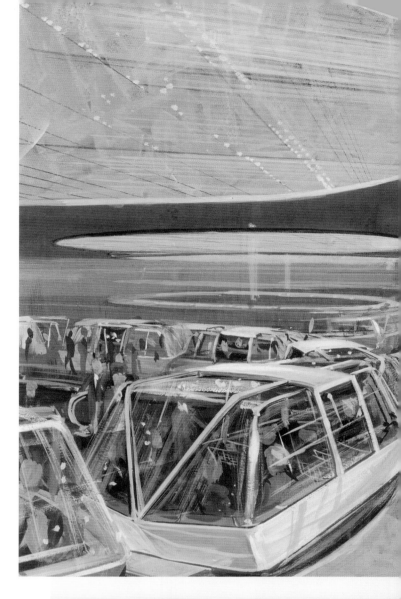

*Nothing dates faster than people's fantasies about the future.*

—Robert Hughes[59]

**T**ALKS OF a planned city predate the 1964–65 New York World's Fair. Walt and Roy were in secret talks with Palm Beach, Florida, billionaire John D. MacArthur, who had acquired huge tracts of land[60] and was proposing a co-venture with Disney, RCA, and NBC to build a second Disneyland there. The Palm Beach proposal included a "Community of Tomorrow" as part of the development, which also included a Disneyland theme park.

And art would imitate life in an odd way when United Artists released a Frank Capra film called *A Hole in the Head*. In it, Frank Sinatra plays a Miami hotel owner and promoter who has a scheme to buy land in Florida and build a second Disneyland there.

MacArthur needed the Palm Beach project to be self-sustaining financially, and when RCA bailed out, the deal dissolved. But the seeds had been planted for a development that Disney called Progress City, and although never built, the vision of a utopian urban environment was on its way. Assuming that bureaucratic organizations, corporations, and government entities could take advantage of the brightest and best ideas from Walt and his team to make

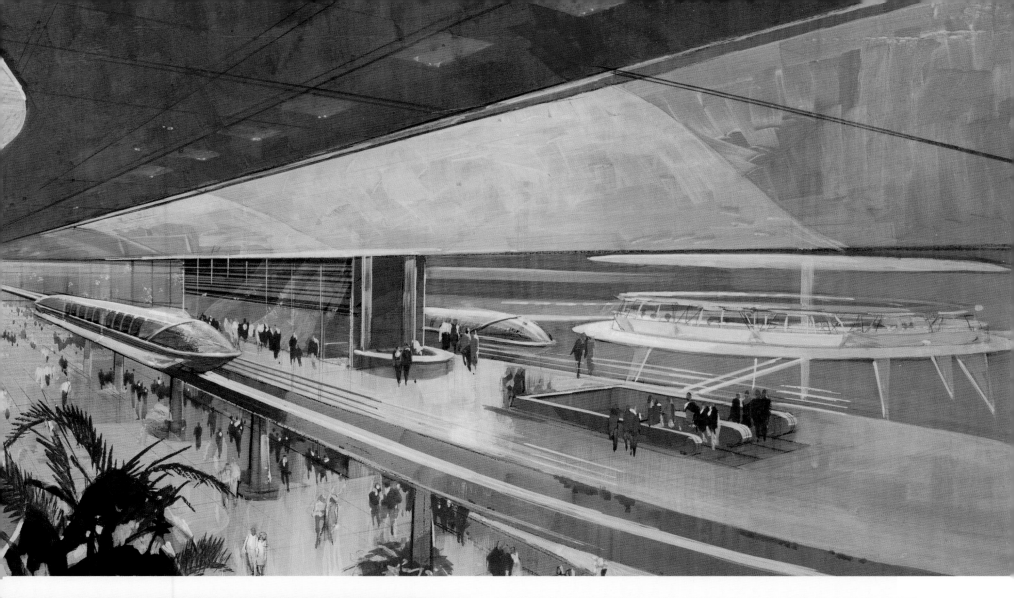

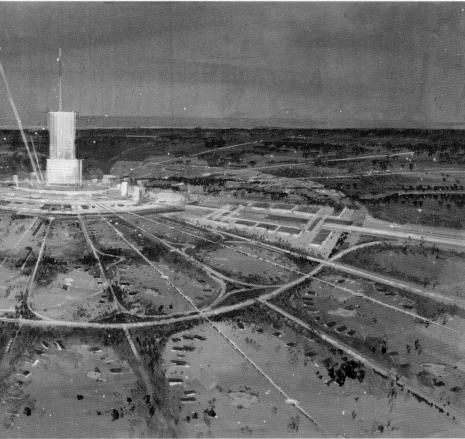

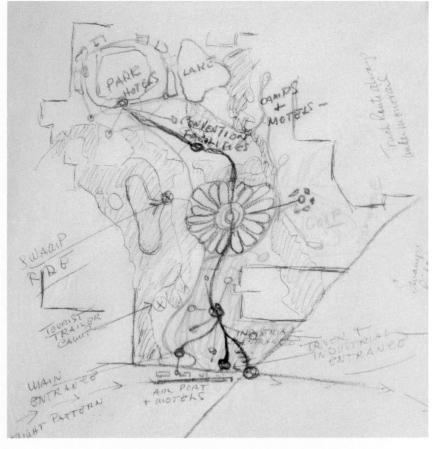

Above left: EPCOT as designed around a hub with radiating "spokes." Top: Transportation centers for cars, monorails, and people movers were centrally located in hubs. Above right: Walt's sketch of the Florida project layout. You had to pass EPCOT to get to the Magic Kingdom.

cities not only habitable and functional but also reflective of the joy and optimism possible in a well-planned community, you need only look at Disneyland as a reflection of what urban planning could bring to everyday life.

In 1965 Disney quietly purchased land in Kissimmee, Florida. Disney was nothing if not a builder. From his physical studio, a masterpiece of mid-century modern architecture, to Disneyland, Walt, like his father, loved building.

In November of 1965, Walt and Roy appeared with Florida governor Haydon Burns to announce Disney's development plans in Central Florida. The announcement was about Walt Disney World and it had the press and public thinking "Disneyland," but Walt had the bigger picture in his sights. Yes, a Disneyland-like park would be the attraction that would draw guests to visit the property, but EPCOT—the Experimental Prototype Community of Tomorrow—would be the jewel in the crown of Walt Disney World.

"Walt was so smart," said Dick Nunis, head of park operations at the time. "He said, 'We've got to put Disneyland, which everybody will know, at the very upper end of the property because that will be the weenie.' Then whatever we build after that, the public will have to drive by to get to the Park."[61]

Florida and EPCOT would be the final and fantastic windmill for Walt to joust with now, in the autumn of his life. He knew it would be game changing if he could pull it off. In October 1966 he stood in the EPCOT war room as a crew filmed his pitch in front of a great map of the Florida property. He talked about the challenges facing cities, and how with the help of the Department of Housing and Urban Development—and major corporations—this experimental prototype community of tomorrow would tackle the issues of urban living.

In a few weeks' time President Lyndon Johnson signed the Demonstration Cities and Metropolitan Development Act of 1966. This model-cities act was meant to expand housing, job, and income opportunities, plus improve urban living. It gave further validation to this newly defined need. Congress echoed Walt's declaration that urban renewal was "the most critical domestic problem facing the United States."[62]

WED's elite designers—most of whom had helped design Disneyland—committed ideas to paper and debated the options with Walt. The hub of EPCOT was a fifty-acre town center with shopping, offices, hotels, and convention facilities. Radiating from that central hub would be low-rise office space, parkland, apartments, and houses, all connected with monorails and the new

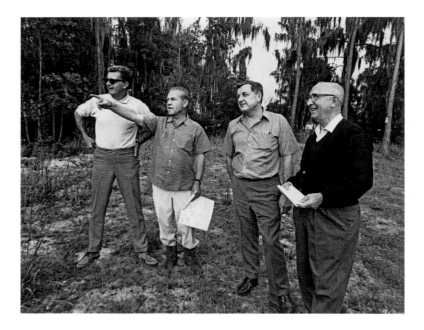

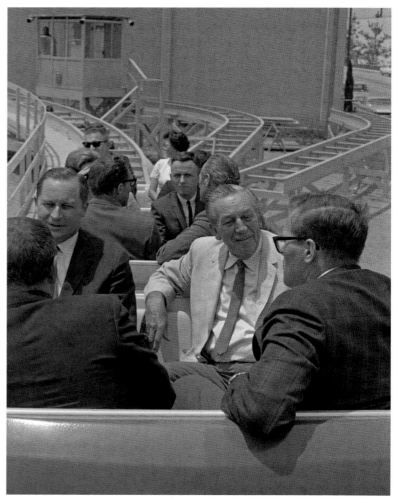

Top: Card Walker, Joe Potter, Don Tatum, and Roy O. Disney survey part of the twenty-seven thousand acres the company bought in central Florida in 1965. Above: Walt takes executives on a WedWay PeopleMover test track ride.

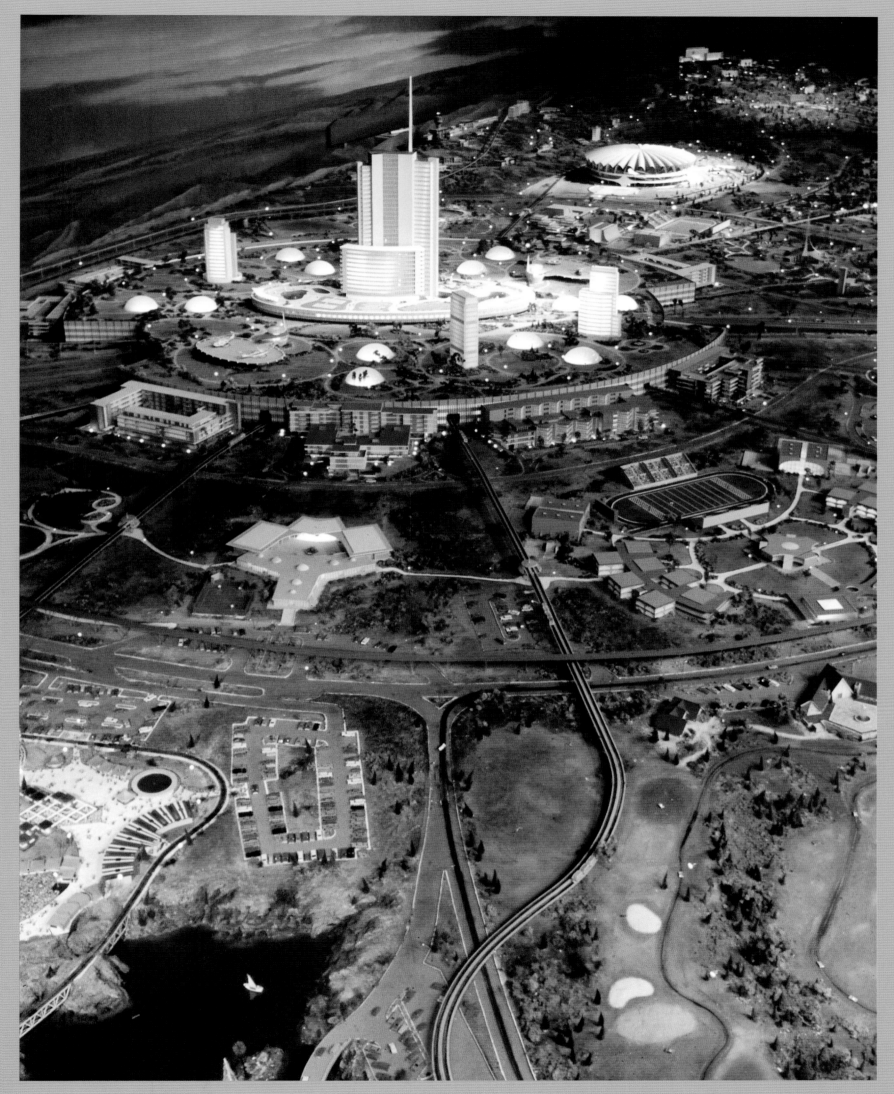

The model for Progress City on the second floor of the Carousel of Progress.

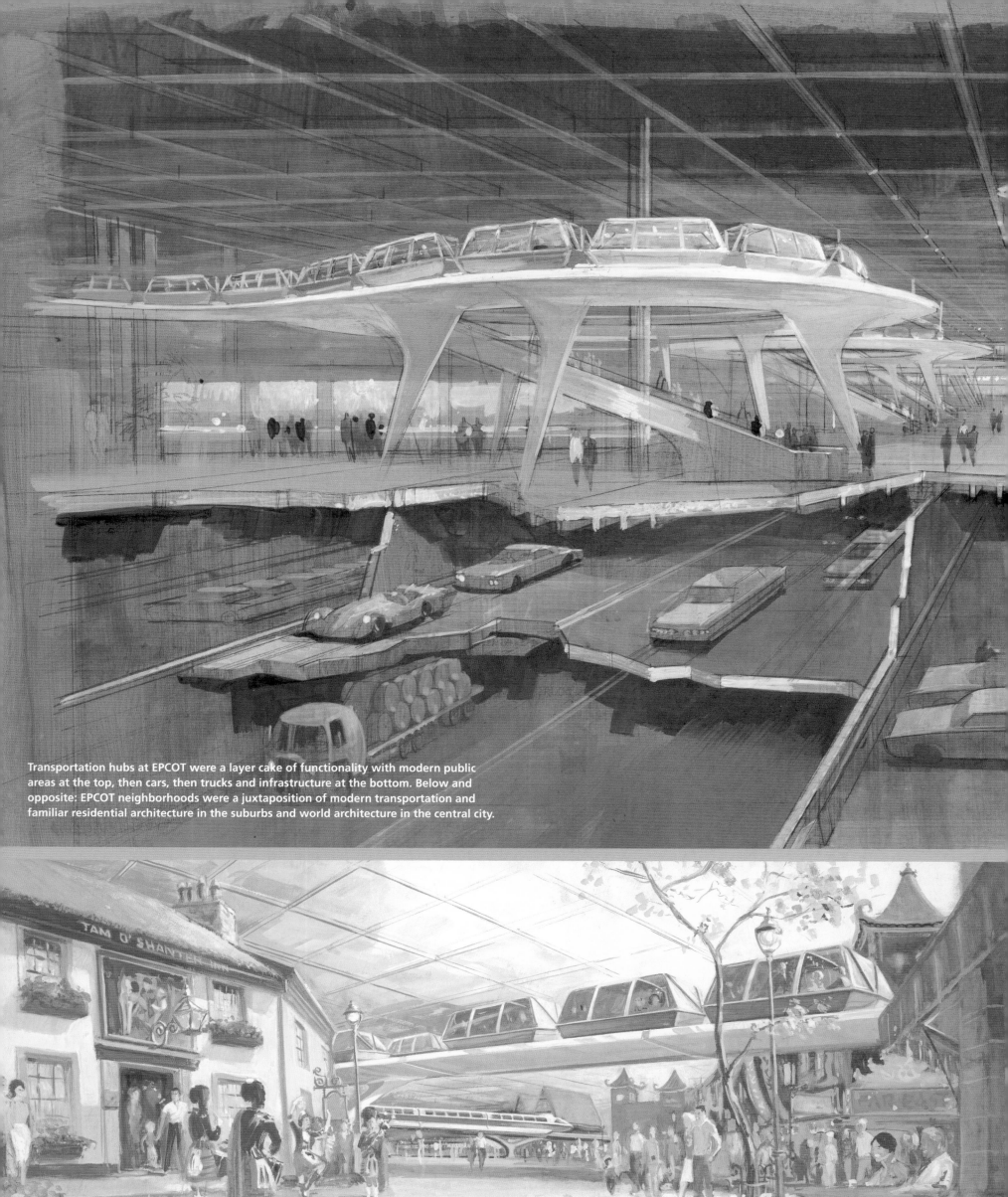

Transportation hubs at EPCOT were a layer cake of functionality with modern public areas at the top, then cars, then trucks and infrastructure at the bottom. Below and opposite: EPCOT neighborhoods were a juxtaposition of modern transportation and familiar residential architecture in the suburbs and world architecture in the central city.

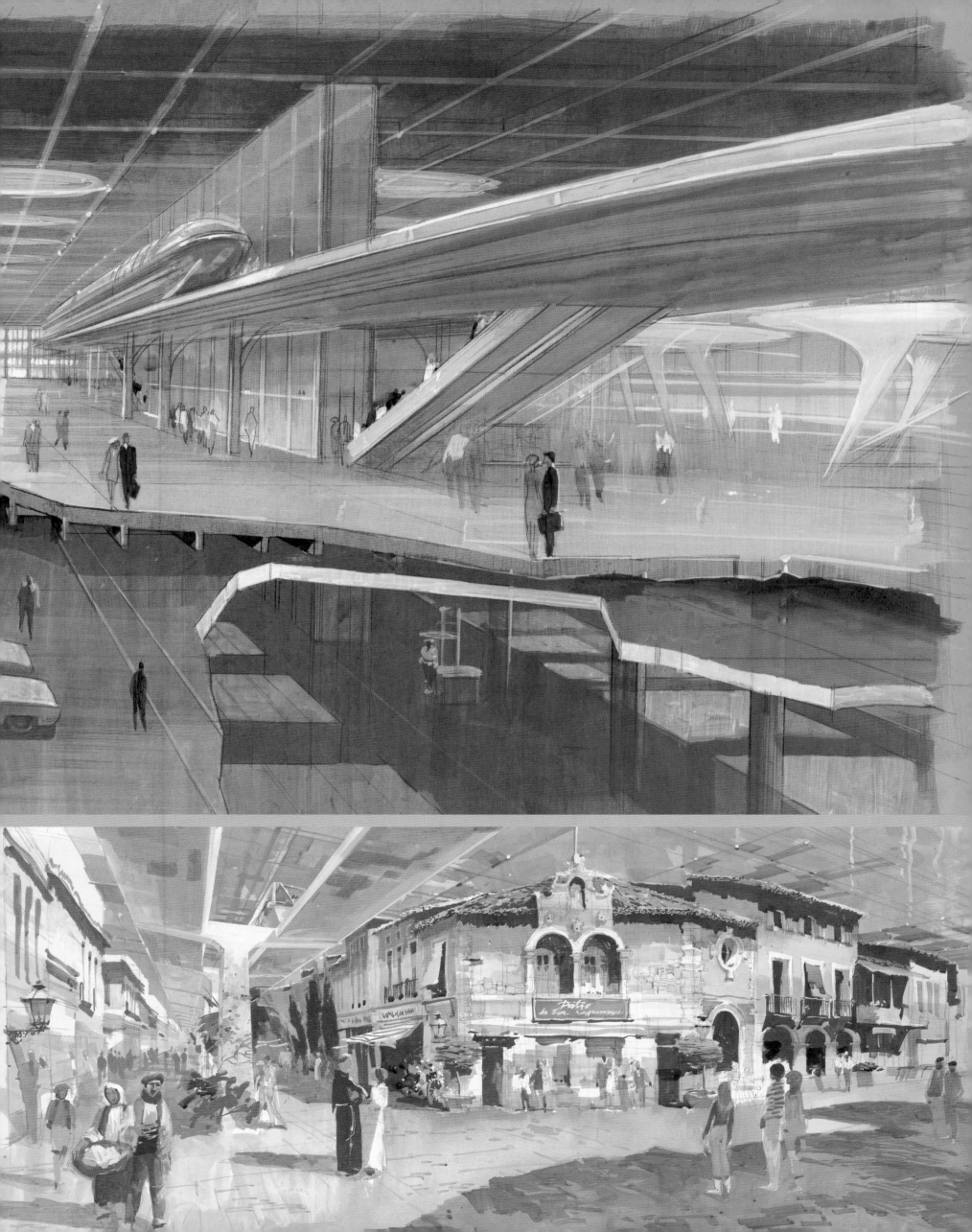

WEDway PeopleMover designed by WED Transportation Systems, Inc. "He was fixated on transportation," Marty Sklar said. "We spent so much time and energy on figuring out new ways to move people."[63]

So much of Disney's thought on the subject was formed by architect Victor Gruen, who called the current urban city the "anti-city." Disney had Gruen's book *The Heart of Our Cities: The Urban Crisis: Diagnosis and Cure*. Gruen's book, which was released in 1964, broke ground by challenging city-planning theories with logic and artistry on various fronts: sociological, historical, and psychological. To Gruen, and to Disney, the simplest form for a city was a hub with radial spokes.

Gruen also felt that urban problems were due to the specialized interests of individuals and the limited effect that local government can have on the overall objective of a successful urban environment.

Developer James W. Rouse validated Disney's approach when at the 1963 Urban Design Conference at Harvard University he said, "I hold a view that may be somewhat shocking to an audience as sophisticated as this: that the greatest piece of urban design in the United States today is Disneyland." Walt later visited Rouse's developments in Reston, Virginia, and Columbia, Maryland, both experimental towns designed with a similar philosophy to EPCOT.

Disney looked tired when he filmed the EPCOT announcement. The show was so important to him that he called in friends Welton Becket and his two sons, now architects themselves; actor Walter Pidgeon; and his close friend Art Linkletter to critique his presentation as he prepared.

He died in December of 1966, leaving EPCOT to his lieutenants and heirs. Without Walt, the vision of EPCOT floundered with worries of the potential cost and legal implications of building and governing a community. Still, Walt Disney World and EPCOT Center (now Epcot) in Orlando were successful in dealing with many of the issues, but in the more totalitarian way made possible when a corporation can design and manage a property with minimal interference from residents.

Walt Disney, ever the showman, sells the idea of EPCOT and the Florida Project to an eager viewing audience, 1966.

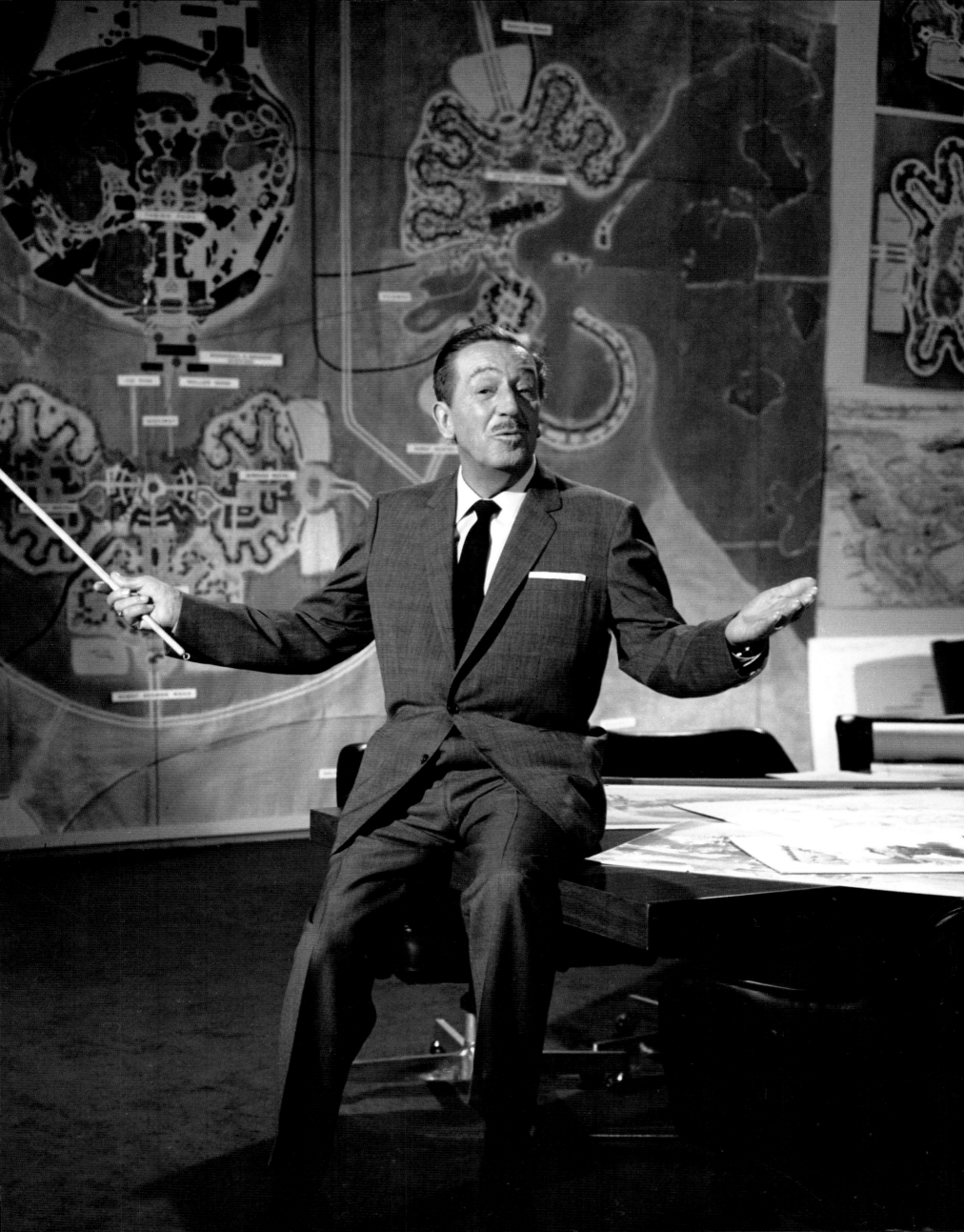

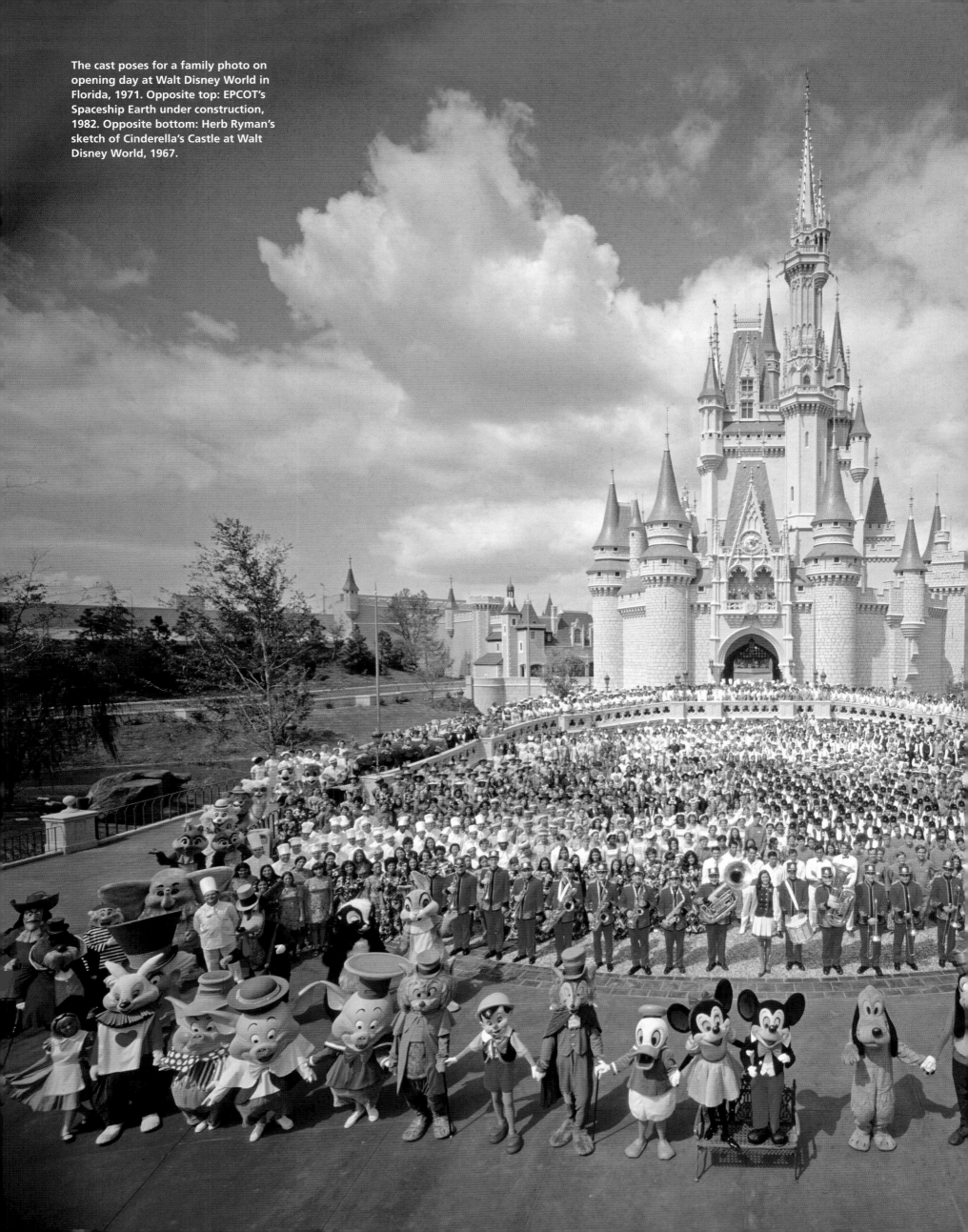

The cast poses for a family photo on opening day at Walt Disney World in Florida, 1971. Opposite top: EPCOT's Spaceship Earth under construction, 1982. Opposite bottom: Herb Ryman's sketch of Cinderella's Castle at Walt Disney World, 1967.

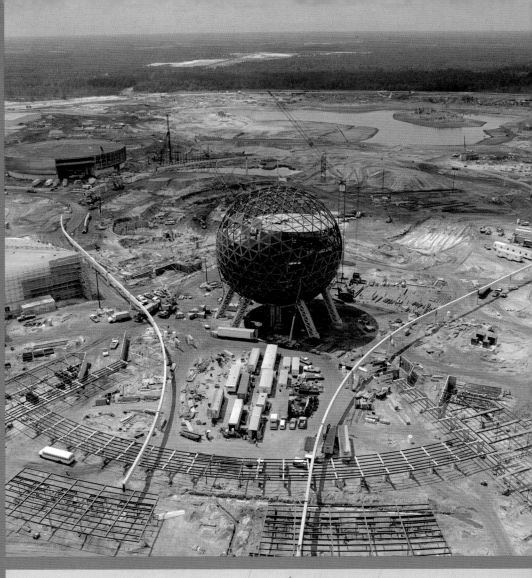
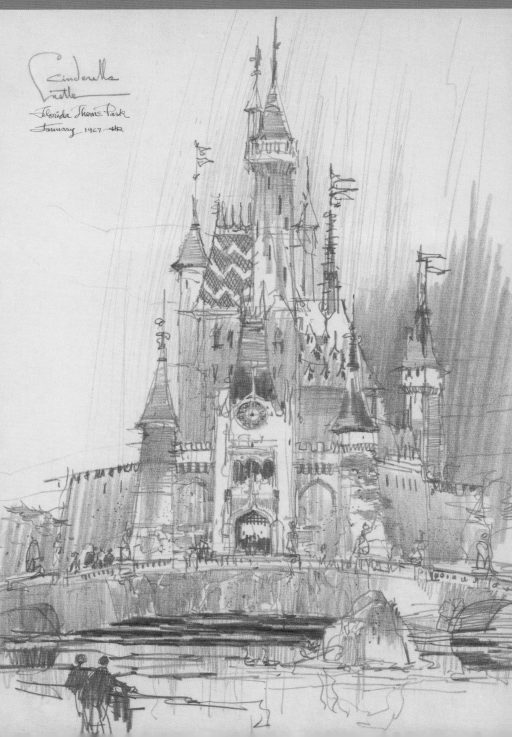

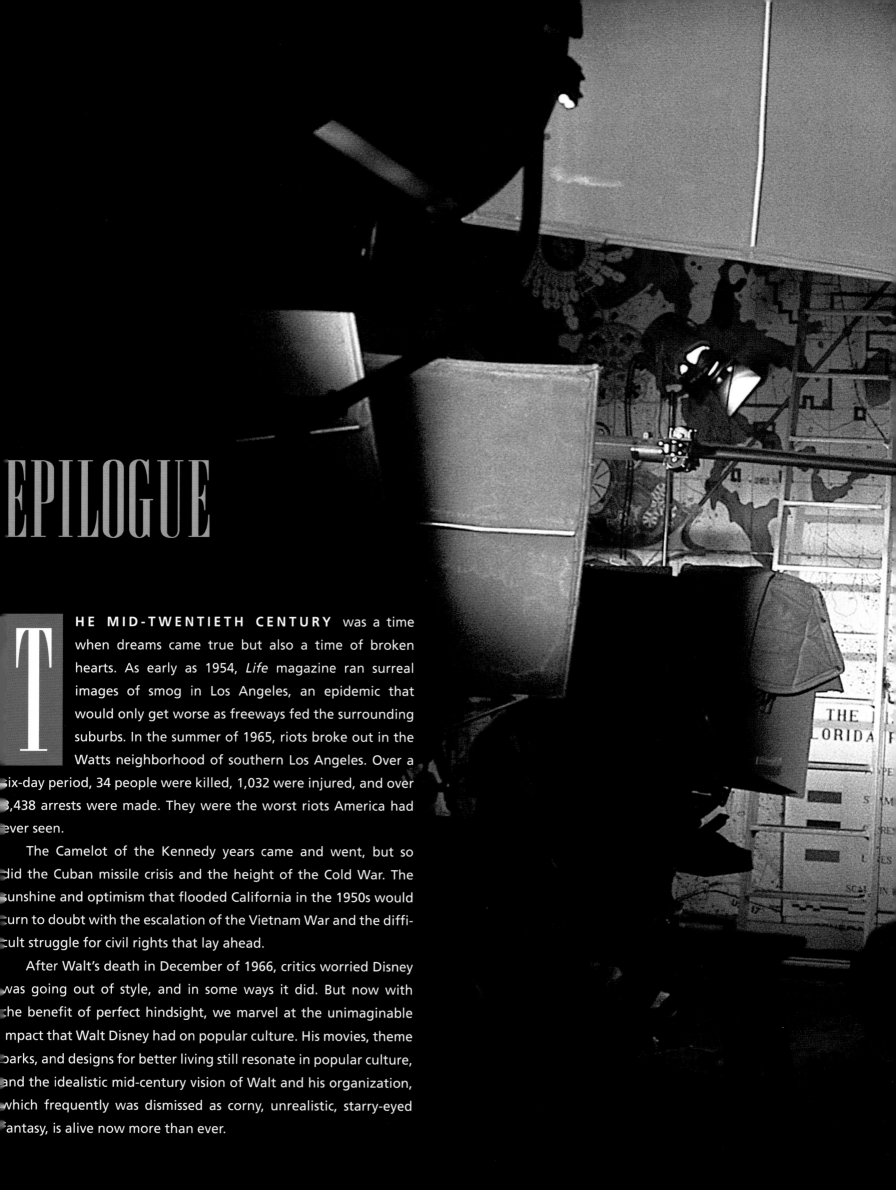

# EPILOGUE

**T**HE MID-TWENTIETH CENTURY was a time when dreams came true but also a time of broken hearts. As early as 1954, *Life* magazine ran surreal images of smog in Los Angeles, an epidemic that would only get worse as freeways fed the surrounding suburbs. In the summer of 1965, riots broke out in the Watts neighborhood of southern Los Angeles. Over a six-day period, 34 people were killed, 1,032 were injured, and over 3,438 arrests were made. They were the worst riots America had ever seen.

The Camelot of the Kennedy years came and went, but so did the Cuban missile crisis and the height of the Cold War. The sunshine and optimism that flooded California in the 1950s would turn to doubt with the escalation of the Vietnam War and the difficult struggle for civil rights that lay ahead.

After Walt's death in December of 1966, critics worried Disney was going out of style, and in some ways it did. But now with the benefit of perfect hindsight, we marvel at the unimaginable impact that Walt Disney had on popular culture. His movies, theme parks, and designs for better living still resonate in popular culture, and the idealistic mid-century vision of Walt and his organization, which frequently was dismissed as corny, unrealistic, starry-eyed fantasy, is alive now more than ever.

SECTION THRU EPCOT

AUTO COMMERCIAL SERVICE AREA

Walt on the set filming his
Epcot film, one of his last
film appearances, 1966.

# ENDNOTES

1   D. J. Waldie, *Holy Land: A Suburban Memoir* (New York: W. W. Norton and Company, 1996).

2   ". . . And 400 New Angels Every Day [photo essay]," *Life* magazine, July 13, 1953, pages 23–29.

3   Bosley Crowther, "White Regrets Film," *New York Times*, November 28, 1946. This movie review quotes NAACP executive secretary Walter White's press release on *Song of the South*.

4   "Black Actors Who Have Won Oscars," *Jet* magazine, March 6, 1995, page 57.

5   Brian J. Robb, *A Brief History of Walt Disney* (London: Little, Brown Book Group, 2014).

6   Leonard Mosley, *Disney's World* (Lanham, MD: Scarborough House, 1990), page 264.

7   Didier Ghez, *Walt's People: Talking Disney with the Artists Who Knew Him*, Volume 9 (Bloomington, IN: Xlibris, May 2010), page 254.

8   Didier Ghez, *Walt's People: Talking Disney with the Artists Who Knew Him*, Volume 9 (Bloomington, IN: Xlibris, May 2010), pages 248–269.

9   "Exploring the World of Animated Films and Comic Art, Interviews with Frank Thomas and Ollie Johnston" (1987), *www.michaelbarrier. com.*

10  Craig McLean, "The Jungle Book: The Making of Disney's Most Troubled Film," *The Telegraph*, July 30, 2013, *www.telegraph. co.uk/films/2016/04/18/the-jungle-book-the-making-of-disneys-most-troubled-film* (accessed 14 March 2016).

11  Sue Harper and Vincent Porter, *British Cinema of the 1950's: The Decline of Deference*, (New York; Oxford University Press, 2003), pages 121–122.

12  Jeff Kurtti, "Walt Disney and Live Action Films," The Walt Disney Family Museum, *www.waltdisney.org*, January 11, 2011.

13  Joseph Titizian, "Riding the Rails with Walt Disney," The Walt Disney Family Museum, *www.waltdisney.org*, Oct. 17, 2011.

14  David Riesman, *The Lonely Crowd* (New Haven, CT: Yale University Press, 1950).

15  Gladwin Hill, "Disneyland Reports on Its First Ten Million," *New York Times*, February 2, 1958.

16  Kelly Comras, *Ruth Shellhorn*, (Athens, GA: The University of Georgia Press, 2016)

17  Ruth Patricia Shellhorn Papers, 1909–2006, Charles E. Young Research Library (Library Special Collections), UCLA, Los Angeles.

18  Fritz B. Burns, *Architectural Record*, April 1946.

19  Ibid.

20  "The Place They Do Imagineering," *Time* magazine ad, February 16, 1942, page 59. (*Imagineer*: a term "invented" by the Alcoa Corporation around 1940 and later used by Disney to describe the unique skills of design, engineering, and imagination required to build Disney's parks and attractions.)

21  Hugh Hart, "Fearless Futurist Bob Gurr," *Dot*, April 25, 2016, *www.artcenter.edu/connect/ dot-magazine/articles/fearless-futurist-bob-gurr.html* (Accessed May 7, 2017).

22  Robert Reynolds, *Roller Coasters, Flumes and Flying Saucers: The Story of Ed Morgan and Karl Bacon, Ride Inventors of the Modern Amusement Parks* (Walton-on-the Hill, England: Northern Lights Publishing LTD, 1999).

23  Pat Williams and Jim Denny, *How to Be Like Walt: Capturing the Disney Magic Every Day of Your Life* (Deerfield Beach, FL: Health Communications, Inc., 2004).

24  Ibid.

25  Christopher Finch, *The Art of Walt Disney from Mickey Mouse to the Magic Kingdoms and Beyond* (New York: Harry N. Abrams, 2011).

26  Horace Newcomb, *Museum of Broadcast Communications Encyclopedia of Television* (Chicago: Fitzroy Dearborn Publishers, 1997).

27  "American Broadcast Company's Major Role in the Beginnings of Disneyland," *Disney Digest*, August 27, 2016, *dsny-digest. co.uk/disney-digest/abcs-critical-role-in-the-beginnings-of-disneyland/21/8/2015* (accessed March 14, 2016).

28  "Archive of American Television," Fess Parker interviewed by Don Carleton, July 24, 2000, in Los Olivos, CA. *www.emmytvlegends.org/ interviews/people/fess-parker* (accessed May 7, 2017).

29  Jim Korkis, "ABC and Disneyland 1955," *Mouse Planet*, June 24, 2015, *www. mouseplanet.com/11056/ABC_and_ Disneyland_1955* (accessed March 14, 2016).

30  "Music-Record Store Mapped for Disney-land," Billboard, May 28, 1955, page 35

31  Jimmy Johnson, *Inside the Whimsy Works: My Life with Walt Disney Productions* (Jackson, MS: The University Press of Mississippi, 2014), page 75.

32  Randy Liebermann, "Wernher von Braun and Collier's Magazine's Man in Space Series," Thirty-seventh Congress of the International Astronautical Federation, Innsbruck, Austria, October 4–11, 1986.

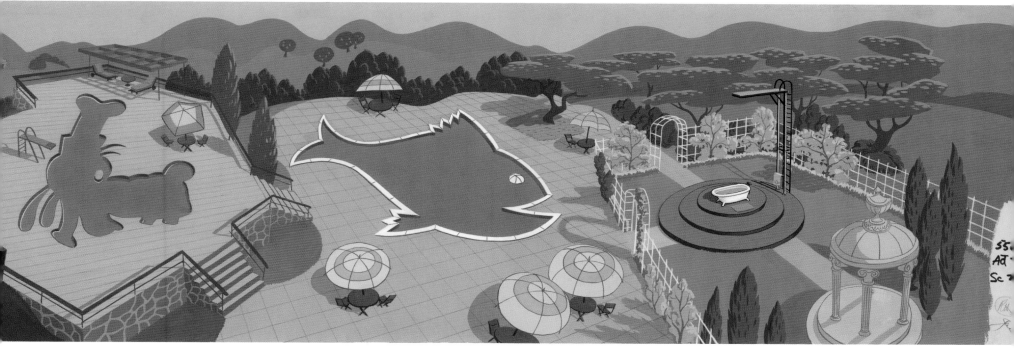

**Background art from _The Goofy Success Story_, 1955**

33 Adrian Perkins, "The 1950's, a Pivotal Decade," _Spaceflight_, July/August 1983, page 323.

34 David R. Smith, "They're Following Our Script: Walt Disney's Trip to Tomorrowland," _Future_, May 1978, page 55.

35 Ibid.

36 Ernst Stuhlinger, Interviewed by Mike Wright, NASA Marshall Space Center History Office, December 17, 1992, Huntsville, AL.

37 Walter A. McDougall, _The Heavens and the Earth: A Political History of the Space Age_ (Baltimore: The Johns Hopkins University Press, 1997), page 100.

38 Letter from L. Sedov to F. C. Durant, September 24,1955. "The Disney–Von Braun Collaboration and Its Influence on Space Exploration," by Mike Wright, NASA, Marshall Space Flight Center History Office, _history.msfc.nasa.gov/vonbraun/disney_article.html_ (accessed March 14, 2016).

39 John W. Herrick, "Los Angeles Meeting Attended by Over 500," _Jet Propulsion, Journal of the American Rocket Society_, March 1955, pages 652–654.

40 Letter from Wernher von Braun to William Bosche, January 8, 1965. (Mr. Bosche was one of von Braun's key contacts during his involvement with Walt Disney Studios). NASA Marshall Space Flight Center History Office, _history.msfc.nasa.gov/vonbraun/disney_article.html#44_ (accessed March 14, 2016).

41 Handwritten note from Wernher von Braun to Bart Slattery, March 6, 1965, NASA Marshall Space Flight Center History Office _history.msfc.nasa.gov/vonbraun/disney_article.html_ (accessed May 7 2016).

42 Bob Ward, "Walt Disney Makes Pledge to Aid Space," _Huntsville Times_, April 13,1965, page 1.

43 Dwight David Eisenhower, _At Ease: Stories I Tell to Friends_, (New York: Eastern Acorn Press), 1981.

44 Michael A. Crawford, "New Heights: Walt and the Winter Olympics," January 18, 2012 (accessed March 14, 2016).

45 "Art: Americans at Brussels: Soft Sell, Range & Controversy," _Time_, June 16, 1958, page 72.

46 Neil Gabler, _Walt Disney: The Triumph of the American Imagination_ (New York: Vintage Books, 2006), page 574.

47 "Disney's Here for Fair," _Seattle Times_, September 22, 1962, page A.

48 "Disney Lands on Bored Sophisticates," _Seattle Post-Intelligencer_, September 23, 1962, page 24.

49 Robert A. Caro, _The Power Broker: Robert Moses and the Fall of New York_ (New York: Alfred A. Knopf, 1974).

50 "John Hench (1908–2004)," _Los Angeles Times_, February 6, 2004. (In a sixty-four-year career with Disney, Hench worked on animated and live-action films, played a key role in the creation of Disney theme parks at Walt Disney Imagineering.)

51 David Brinkley, "Huntley-Brinkley Report on the World's Fair," Time-Life magazine, 1964.

52 "Designing Disneyland with Marc Davis," _The E-Ticket_ magazine, Issue No. 7, Summer 1989, page 8.

53 Paul F. Anderson, "Disney and the 1964 New York World's Fair," Persistence of Vision magazine, Double Issue 6 & 7, 1995.

54 Designing Disneyland with Marc Davis," _The E-Ticket_ magazine, Issue No. 7, Summer 1989, page 8.

55 "Lincoln Still Holds Hearers Spellbound," _Chicago Tribune_, July 24, 1964 (Associated Press) Section 1, page 3.

56 _"World's Fair Preview,"_ Bethlehem Steel Company, promotional booklet, October 1963

57 Neil Gabler, _Walt Disney: The Triumph of the American Imagination_ (New York: Vintage Books, 2006), page 577.

58 Ibid., page 582.

59 Paul F. Anderson, "Disney and the 1964 New York World's Fair," _Persistence of Vision_ magazine, Double Issue Nos. 6 & 7, 1995, page 200.

60 _The Shock of the New—Trouble in Utopia_, BBC television in association with _Time-Life Films_, presented by Robert Hughes (episode 4, 1980).

61 Chad Denver Emerson, _Project Future: The Inside Story Behind the Creation of Disney World_ (Orlando, FL: Ayefour Publishing, 2010).

62 Michael Barrier, _The Animated Man: A Life of Walt Disney_ (Berkeley and Los Angeles, CA: University of California Press, 2007).

63 Lyndon B. Johnson, Sixth State of the Union Address, January 14, 1969. (President Johnson is quoting Public Law 89-754, called the Demonstration Cities and Metropolitan Development Act of 1966, Section 101.)

64 Matt Patches, "Inside Walt Disney's Ambitious, Failed Plan to Build the City of Tomorrow, _Esquire.com_, May 20, 2015, _www.esquire.com/entertainment/news/a35104/walt-disney-epcot-history-city-of-tomorrow_ (accessed March 14, 2016).

C-7776

SHOOT FOR FINISH
SAME SIZE

OUTSIDE BACK COVER
FOR VOL IV NO. 5. (AVG.)

# ACKNOWLEDGMENTS

With gratitude to Wendy Lefkon for her guidance, patience and inspiration, and to Hans Teensma for bringing this book to life with his brilliant design work. Thanks also to the team at Disney Editions, Jennifer Eastwood, Monica Vasquez, and Marybeth Tregarthen.   Profound appreciation to Lori Korngiebel, whose research and treasure hunting skills brought extraordinary new imagery to light and to Maggie Gisel, Stephen Yao, Scott Watts and the team at Stone Circle.

Thanks to the gifted archivists who deserve much of the credit for illustrating and supporting this book:

**The Walt Disney Archives:** Rebecca Cline, Kevin Kern, and Justin Arthur

**Walt Disney Photo Archives:** Michael Buckhoff and Holly Brobst

**Walt Disney Imagineering:** Vanessa Hunt and Michael Jusko

**The Animation Research Library:** Mary Walsh, Fox Carney, Ann Hansen, Jackie Vasquez, Tori Cranner, Mathieu Fretschel, Mike Pucher, and
   Tita Venegas

**Walt Disney Publishing:** Ken Shue and Danielle Digrado

**The Walt Disney Family Museum:** Kirsten Komoroske, Michael Labrie, and Caitlin Moneypenny-Johnston

**Walt Disney World:** Alyce E. Diamandis

And the Institutions and archivists around the world who lent expertise and images to us: Don Ballard, Karen Baxter, Petyr Beck, Patrick Blackwell, Eliza Brownjohn, John Bulakowski/Igor I. Sikorsky Historical Archives, Jackie Burns/The Getty Center, Paul Camarata, Colorado Heritage Magazine, Victoria Conley, Warren Crone/Ford Images, David Eppen, David Forsyth, Dexter Francis, Getty Images, Didier Ghez, Bob Gurr, Halley Hair/LIFE Photo Archives, Stuart Hinds, History Colorado Center, Michael Jang, Kelly and Andrea McGuire, Lucas Seastrom, Paula Sigman Lowrey, Stuart Hinds/The Special Collections and Archives, University of Missouri, Kansas City, PepsiCo Archives, Ward Verheyen/Fine Arts Museum Brussels.

And finally my heartfelt thanks to the artists of Walt Disney Studios, past and present, who have contributed so much to the culture and life of audiences everywhere.

— DON HAHN

Paul Hartley illustration for
*Walt Disney's Magazine.*

# ART CREDITS

Walt Disney Imagineering (WDI)—Jacket, 2–3, 5, 40–41, 44, 45, 46, 47, 48, 52, 53, 57, 60, 64–65, 68, 69, 122, 123, 131, 132, 134, 135, 136, 137, 139, 140–141, 142, 143, 144–145, 146, 147, 148–149, 150, 151, 152, 153, 155, 156, 157, 158–159, 162–163, 167, 168–169, 175

Walt Disney Animation Research Library (ARL)—Jacket, 19, 20, 21, 22–23, 24, 25, 26–27, 80, 81, 82, 83, 92, 94, 95, 96, 97, 98, 99, 105, 109, 110, 111, 170–171, 174–175

Walt Disney Photo Library—Jacket, 8–9, 12, 22, 27–28, 29, 30–31, 32, 33, 34, 35, 36, 37, 38–39, 42, 43, 46, 50, 56–57, 65, 69, 70, 71, 73, 76, 77, 79, 88–89, 90–91, 93, 99, 108, 116–117, 118–119, 120, 130, 138, 143, 151, 156, 157, 160, 164–165

Walt Disney Archives—6, 32–33, 37, 42, 43, 92, 95, 101, 102, 104, 133, 176

Walt Disney Publications—18

Disneyland Resort—42, 45, 51

Walt Disney World Resort—53, 147

Walt Disney Records—87

The Walt Disney Family Museum—17, 24–25, 79, 97, 102, 123, 124, 152, 153, 154

Kevin Kidney—Jacket, Endpapers, 7, 106–107, 109, 172

The J. Paul Getty Museum, Los Angeles—William A. Garnett, *Finished Housing, Lakewood, California*, 1950, gelatin silver print. 7 3/8 x 9 7/16 in. © Estate of William A. Garnett—10–11

Los Angeles Public Library/Security Pacific National Bank Collection—11

Ford Images—Jacket, 12

Shorpy—12

CBS Television—12

J. R. Eyerman/The LIFE Picture Collection/Getty Images—13

Gene Lester/Archive Photos/Getty Images—13, 14–15, 61, 102–103

Don Hahn—16, 17, 18, 173

University of Missouri–Kansas City Libraries, Dr. Kenneth J. LaBudde Department of Special

Collections—16

Amid Amidi—20

Joe Campana—20, 50

Victoria Aragon Conley—20

Peter Stackpole/The LIFE Picture Collection/Getty Images—32

Tony Walton—37

ABC Television—42

Dean Conger/National Geographic Creative—49

Kelly Comras—50

Los Angeles Times Photographic Archive. Department of Special Collections, Charles E. Young Research Library, UCLA—52, 85

Ralph Crane/The LIFE Picture Collection/Getty Images—54–55, 126, 127

Goody Clancy—56

Bob Gurr—58–59, 60–61

United States Patent and Trademark

**Background art from *How to Have an Accident at Work*, 1959.**

*A Cowboy Needs a Horse*, title card by X. Atencio and Ralph Hulett, 1956.